Céline: Beyond the Image

Céline

Beyond the Image

Photographs by Laurent Cayla

Text by Diane Massicotte

Foreword by Céline and René

ECW Press

I dedicate this book to my two sons, Bruno and Frédéric, and to my parents and brothers.

Table of Contents

FOREWORD .9

PREFACE .11

PROLOGUE .13

PART 1: *LOVE STILL EXISTS* .14

PART 2: *THE WORLD IS STONED* .20

PART 3: *THE BUSINESSMAN'S BLUES.* .23

PART 4: *I'M ALIVE* .74

PART 5: *SEDUCES ME* .224

PART 6: *IF IT WERE ENOUGH TO LOVE* .336

EPILOGUE .341

ACKNOWLEDGEMENTS .344

SONG LIST .347

PHOTO LIST .348

Foreword

It takes a lot of courage to tell the story of one's descent into a hell of drugs in the hope of inspiring others who want to escape a similar fate.

When Laurent told us about his idea for a photo book, we saw an opportunity to turn a difficult situation into a message of hope that might help someone, somewhere, who just needs somebody to believe in them again.

Telling his story required a great deal of sensitivity and discipline. That's why we suggested to Laurent that he work with Diane Massicotte, a talented journalist whom we trust. Her text, accompanied by photos taken by Laurent between 1997 and 2006, paints a true picture of his journey through life with and without drugs.

This was our way of helping him. His friend Marc-Antoine Pelletier also helped by guiding Laurent through this venture into the world of book publishing.

Give a man work and you give him the tools he needs to make his way in life.

Laurent needed a new path. All we did was to give him the means to find his way.

We're proud of him today.

Céline and René

Preface

At the heart of this story are two people who are polar opposites. One is famous; the other is not. One leads an exemplary life; the other is an ex-junkie. Two extreme paths in life! But over a period of 10 years, their trajectories will meet. Beyond the image, both are resilient in their own way, endowed with an inner strength through thick and thin, one going as far as saving the other's life.

Diane Massicotte

This book exists today so that a story of suffering and endurance can be told.
Without this story, and Céline and René's support,
I sincerely believe that I would not be alive.

Laurent Cayla

Prologue

I had the privilege of working closely with René Angélil and Céline Dion from 1997 to Christmas 2006 as their personal photographer. I accompanied them on public and private trips, to performances and media interviews, to everyday events and family reunions. I have sifted through more than 25,000 photos to bring you a selection of images that, for the most part, have never been published before. I have always worked with 35 mm film. None of these photos has been retouched. I prefer instead to keep every moment authentic as captured by the camera.

In December 2007, I showed René and Céline a draft of this book.

We were in Céline's dressing room, a few minutes before the start of her show, *A New Day...*, at The Colosseum at Caesars Palace in Las Vegas. I was nervous and fretful. I had been waiting for this moment for months — hoping to get Céline and René's approval to publish my photo book.

Before I could say a word, Céline came up to me and asked, "How are you, Laurent? How is your health?"

I told her briefly what I had been up to since we had last seen each other, almost a year earlier. I said that I was doing a lot better. She was very touched by the news. It took her just a few seconds to realize how important this project was to me.

After looking at the mock-up, she exclaimed, "This is fantastic!"

"Do you want to remove any photos?"

"No. This is your book, Laurent."

"It's the story of your life!" René added.

He had no idea just how right he was.

Love Still Exists

Toutes mes années de déroute
Toutes, je les donnerais toutes
Pour m'ancrer à ton port
La solitude que je redoute
Qui me guette au bout de ma route
Je la mettrai dehors.
　　　　　　　— "L'amour existe encore"

It was December 17, 2006, and we were at Le Mirage golf club for the Dion family's annual Christmas party. I was in the grand entrance hall, two cameras slung around my neck. I was buzzed. I had been smoking up every 10 minutes. All I wanted to do was get to my car for another fix . . . My arm was so shot up that I had trouble bending my elbow to take a picture. I was in such bad shape that I felt near death. Then I heard her before I saw her.

"Laurent, I'm the one who wanted you to be here today. I hear you're not well."

Céline touched the cross that I wear around my neck, the same way she always did whenever we saw each other. She looked straight into my eyes: "Laurent, take the love I'm offering. You'll pull yourself out of this . . ."

As she said the words, I felt a powerful karmic connection between us, as if all the love of her millions of fans was flowing into me, an almost supernatural force that touched my very soul.

Even today, I often think back to that decisive moment and the breath of life that Céline gave me. The memory is intact. I don't need a photo to recall it — the image is in my heart.

I left the party early, with only six rolls of film.

The following day, her voice came back to me, the words playing over and over again in my head. Another voice could be heard above hers, saying, "If you don't hold onto the strength she gave you, you won't make it this time."

On Monday, December 18, I decided to go alone to the Centre Dollard-Cormier, Quebec's largest rehab centre for drug, alcohol, and gambling addiction. When the emergency doctor saw my arm, he said, "You could lose it; it's that infected!"

I wasn't even scared. This wasn't my first time in detox.

I checked out of the rehab centre on Thursday, December 21, feeling out of control. I went to shoot up coke with someone I knew only too well. My last fix!

I really thought that it would be the last. All addicts share this powerful obsession . . . and, too often, it leads to relapse after relapse. Drug addicts have a strong ego: they are resilient and believe that they can control when and how much they use. On that lucky day, Céline's words stayed with me. I replayed the scene over and over in my head. I held on tight to it and felt it in me. There really was a current between us. I connected with her energy and knew that I had reached a turning point.

That same day, accompanied by my mother and my ex-wife, I agreed to be checked into Maison de thérapie Choix et Réalité, a treatment clinic located in the small Laurentian town of La Minerve, about 30 minutes from Mont-Tremblant. I was completely drained. I had been high on cocaine for two months.

The clinic practised Reality Therapy and Choice Theory, strategies perfected by Dr. William Glasser. The cure emphasized a personalized, holistic, and non-directed approach. The treatment was gentler than many of the others I had been subjected to, ones where patients were forced to wash floors with toothbrushes. The goal was not to break patients with aggressive and confrontational techniques, but to make them understand, deep down, how powerful a motivator despair can be.

On Thursday, December 28, I walked out of the clinic of my own free will. Snow was gently falling, and I felt better and full of optimism. I hoped that I would never have to set foot in the clinic again. What I did not know back then — but was already wishing for — was that I would be able to claim, "Yes, I quit."

I revisit my life in flashbacks, like a movie plot unfolding, and try to understand what brought me to destroy it so willingly. Life's consequences are often invisible at first glance. With hindsight, I now realize that emotions were a determining factor in leading me to what I call the needle's path . . .

I come from a middle-class family: my parents are from France, but I was born in Quebec. As far back as I can remember, I always felt different, an outsider, rightly or wrongly. I'm the youngest of four boys — my brothers always looked upon me as the little guy, too young to share in their activities. From an early age, I wanted to impress them. I did everything to be the centre of attention. I wanted to be loved, to be accepted into their group, but instead I got on their nerves. I still remember the present they gave me for my 13th birthday: a teddy bear! I was insulted and ran to my room to cry. All my life, I have tried to avenge my brothers' rejection by hanging out with friends who are older than me.

As early as second grade, I had problems learning. During dictation, I had to sit at the front of the class, beside the teacher. I felt humiliated, rejected. I was born on March 10, 1960. Back then, no one talked about dyslexia. I found it difficult to express myself — I only started talking when I was three. I was absent-minded. In grade 5, the principal offered to put me in a class for students with learning disabilities, but my mother refused because she thought it was the easy way out. She called Sainte-Justine Hospital in Montreal, which offered services for children with language difficulties. She drove me to the hospital once a week for six weeks so that specialists could assess my problem. I was put through a battery of tests. The specialists concluded that "Laurent is absent-minded and inattentive. When he reads, his attention jumps quickly to the next syllable." No one mentioned that I had a hard time reading and recognizing different words and sounds! No matter, my mother was reassured. Not surprisingly, I didn't like to read, and my grades were mediocre. I was particularly bad at reading comprehension. But I made myself useful in other ways. Even today, when writing, for example, I hesitate between "expect" and "except." When I read, I jump too quickly to the next syllable, skipping entire words. I reverse the order of numbers. I don't know how to write properly.

The only reason I got as far as CEGEP (post-secondary studies in Quebec) is that I copied other students' homework and cheated on tests.

I'm not trying to make excuses for my drug addiction. I'm just trying to understand why it happened, to explain how I got on that path. Maybe it's simply that all my problems can be traced back to growing up with a silver spoon in my mouth. Unlike Céline, who grew up in more modest circumstances, I never felt that visceral need to succeed through sheer will and discipline. I had a golden childhood in the suburbs and a protective mother who never scolded me enough when I got into mischief. I never developed a work ethic. My only goal in life was to smoke a joint, have fun, and party.

From all appearances, I was a normal child. At nine, I started delivering newspapers. I joined Cub Scouts and then Scouts. At 12, I started caddying at Mount Bruno Country Club. I was attracted by the precise and fluid strokes of the golfers. I loved the beauty of the surrounding nature. I started playing golf and taking photographs. I was fascinated with the birds. I developed my own negatives.

In my teens, I bought Jimi Hendrix and Janis Joplin records while my brothers listened to Moustaki and Barbara. I went to see Genesis, Jethro Tull, Supertramp, and Pink Floyd live. I sold the photos I took during those concerts to friends at Collège Français, my high school. I also took black-and-white photos of homes in Saint-Bruno and sold them to the homeowners. I was proud of my enterprising spirit. It helped me deal with the rejection I felt when my brothers scoffed at my taste in music.

Today, I still brag about the first album I ever bought — when I was 10 years old: the Jimi Hendrix Experience's *Axis: Bold as Love*.

In the summer of 1976, the Olympic Games came to Montreal, and I got a job in a photo shop. It was the first time that I wasn't my own boss. The manager collected pins from all the participating countries, so I made him a deal: I'd give him pins in exchange for fake overtime hours. Looking back, it's obvious that, even at that age, I had no respect for authority and a certain ability to manipulate others.

Soon after, a one-hour photo shop opened in my neighbourhood. I jumped at the opportunity. Every weekend, I went to golf courses and photographed golfers who were thrilled to have a souvenir of their game so quickly. I sold each photo for $2, adding to my other income . . .

You could say that I was resourceful. To hide the problems I was having at school, I copied other students' homework, cheated on exams . . . or gave the best student in the class a gram of hashish in exchange for doing my French homework. I started smoking hash and pot in grade 10. At 15, I realized that if I couldn't be the best at school, I'd be the best at smoking drugs. I covered up my lack of self-confidence with arrogance. Things quickly escalated. Within two months, I was taking mescaline, THC pills, LSD, and speed. My clients were high school students during the week and bar patrons in Saint-Bruno on the weekend. I was drinking too, of course, and making money. For example, I would pay $1 for a THC pill and then sell it for $3. I was netting about $200 a week and I still had enough drugs left over for my personal use.

The party almost ended in grade 11.

Before class every morning, I would drink a tall beer and smoke some Colombian hash. Then at 8:45 a.m., I would head off to school. Amazingly, once I even passed a poetry test while high on acid.

At the end of May, the principal, Louis Portal, called me to his office. He was flanked by the vice-principal of discipline, Mr. Laral, a private detective . . . and my father.

"Laurent, we know you're dealing drugs," Mr. Portal said.

"No, I'm providing a service," I confidently replied.

A discussion ensued. They debated whether to expel me from school. My father was an insurance salesman. Many of the school's teachers were his clients, and he knew how to reassure them. At his insistence, Mr. Portal agreed to let me finish the school year.

On the way home in the car, my father told me to keep my mouth shut, adding, "Don't you dare breathe a word of this to your mother."

I got away with it that time. All the while we were talking, I had mescaline and hash in a leather pouch in my pocket.

I stopped dealing drugs at school, but not in Saint-Bruno. Dragonfly, a small ingestible blotter of LSD, was very popular. I could easily sell 150 of them in a weekend. I bought them for $1 each and sold three for $10. I took nine a day, four of them in the morning.

One day, I was barely home from school when the phone rang. It was the police. The cop ordered me to come to his office the next morning. I was worried. I told my mother that the police wanted to see me because they thought I was selling drugs. "Go!" she said. I suspect she thought I would finally learn my lesson.

"Laurent, judges take LSD trafficking very seriously," the cop told me. "That stuff can kill. You're 17, Laurent, and under the law you're considered a minor. You have to tell us who your supplier is."

I told the truth, that my supplier had gone to California.

"We're going to give you a chance, Laurent. You're not 18 yet, so we're going to let this one go."

I was really scared. At that moment, I decided that I would never sell dope again.

I kept using, though. I even started smoking heroin, Brown Sugar, like the title of the Rolling Stones song, just to see what it was like . . . The first time I smoked it, I got sick and threw up. Then I felt like I was flying, semi-conscious, sheltered from all emotion. Nothing bothered me anymore, to the point that I forgot my self-doubts. It took three days of smoking in a row to get hooked. After the three days were up, you needed to smoke more, or you would become sick again. In the end, you were hooked and needed it constantly.

I couldn't get enough.

I became addicted to heroin at 17. From the ages of 24 to 27, I smoked or shot up heroin on a daily basis. Whenever I quit, I'd be sick for 10 days straight because of withdrawal.

This was the first time I quit. It lasted two months.

I continued my studies at CEGEP in Rouyn-Noranda, in the Abitibi region of Quebec. I chose the forestry technician option because a friend was taking it and because I wanted to get out of my parents' house.

During my first semester, there was a fire at the college and classes were cancelled for a month and a half. Then, during my second semester, the students went on strike. Needless to say, I learned nothing. I couldn't tell the difference between a fir tree and a spruce tree, but I could open a bottle of beer using another bottle. I bought some speed, an amphetamine in powder form, from a dealer in Montreal.

From the ages of 17 to 24, I threw up every second morning, but it didn't stop me from going to the tavern in the afternoon. The only time I was sober was when a friend and I went on a three-day canoe trip in Abitibi. That was the only time that I didn't drink or take drugs. It felt great!

At 18, I knew that I was an alcoholic.

The World Is Stoned

J'ai la tête qui éclate
J'voudrais seulement dormir
M'étendre sur l'asphalte
Et me laisser mourir.
 — "Le monde est stone"

I don't know how I made it to my mother's house.

It was August 7, 1989, and I was in Carré Saint-Louis, in the centre of Montreal's Latin Quarter, barely dragging myself around, weak and totally decimated. I had to admit it. The drugs had finally destroyed me. I didn't even know my own name. I looked at my driver's licence, which I had managed to pull out of my pocket, and recognized my photo. Wow . . . I was really scared, scared of not surviving the mix of heroin and cocaine.

I was out of drugs.

It didn't matter. Nothing gave me pleasure anymore.

I tried everything.

Rum in Martinique, using my French passport.

Uncut cocaine in Barbados at the villa of one of my rock idols.

Syringes of heroin every day for three years.

I needed a $40 hit every morning just to get going.

I had a $150-a-day habit.

My dealer lived with me.

Customers, some in business suits, paraded in and out of the apartment every 15 minutes.

My girlfriend worked the streets. I followed her in my car and watched out for her.

I was a heroin addict; my real love was the needle, and it always came first.

I panhandled on the streets.

I was a 6'2", 138-pound junkie.

A guy shared his syringe and I got hepatitis C.

I was constantly looking for a fix.

I had hit rock bottom.

I was walking on a tightrope strung over a precipice, being drawn into the black hole; it gave me a thrill.

But one incident should have steered me away from the needle's path. It was December 1987, and I was partying at the home of a friend's father in Highwater, Quebec, on the Vermont border. I was surprised by the looks friends were giving me. One of them rushed to phone one of my brothers. A few days later, all three brothers showed up unannounced at my Montreal apartment, the one I shared with my dealer and my girlfriend. They had the decency to ring the doorbell. I opened the door.

"We're taking you to rehab."

Against my will, they marshalled me out of the apartment and to a detox centre in Saint-Gabriel-de-Brandon.

By that point, I was shooting a quarter gram of heroin a day.

At the clinic, I was in total withdrawal. I spent the first 10 days without any sleep. I turned green, then yellow.

They sent me to the hospital in Joliette for a liver biopsy. I was diagnosed with hepatitis C. Back then, the disease had no name and no treatment. They called it "non-A, non-B."

"I don't know how you can still walk," a doctor said.

I didn't give a damn. I didn't want to go anywhere anyway.

For 10 days, I was anxious and in physical pain, alone in my hospital room.

Alone except for the nurses!

Then I was sent back to detox.

It was 10 more days, which seemed like an eternity.

I couldn't deal with the loneliness.

I checked myself out after a month of being clean.

I was supposed to stay for six to 18 months.

A therapist told my brothers that they should toss all my camera equipment and photos.

Extreme punishment.

I went to my first addiction support group meeting.

I stayed with a therapist.

I found a job. With my first paycheque, I bought a 10-ounce bottle of Southern Comfort, Janis Joplin's favourite. I looked up my dealer, who sold me a quarter of a point of Thai heroin, a third of the dose that I had been used to taking. But after detox and two months of abstinence . . . Wow! It was a lot more powerful than I imagined.

The trip from Montreal to my therapist's place in Granby took four hours; normally it takes 45 minutes. When he saw me, he refused to let me in for the night. Instead, he gave me a thin lead cross, which I still wear around my neck to this day.

It's clear to me that this attempt at detox was a failure because I was taken there against my will, to please my brothers and parents. Not for me.

I returned to Saint-Gabriel-de-Brandon in August 1989, after hitting my breaking point in Carré Saint-Louis.

I stayed sober until 2001. Twelve and a half years.

The Businessman's Blues

J'ai du succès dans mes affaires . . .
J'suis pas heureux mais j'en ai l'air . . .
J'aurais voulu être un artiste . . .
Et vivre comme . . . un millionnaire.
— "Le blues du businessman"

I was living the good life thanks to my love of golf and photography.

The work brought me in contact with people from all walks of life: businessmen, top athletes, people who seemed to have made it in society. Business was going well, very well. I was making an honest living. Over the years, I bought several luxury vehicles, including four Jaguars and a Range Rover, and a big house in Saint-Bruno. I created a sports scholarship to encourage young people to take up golf. I had a team of 12 freelance photographers helping me fulfill all my contracts, up to 400 golf tournaments a season. Professional success came first. I no longer found time to go regularly to my addiction support group meetings. I thought I was cured . . . If only I had known, I would have attended every meeting. Relapses happen so quickly.

I came up with an idea for an artistic photo. I wrapped coloured Christmas lights around a golf club and, as the golfer executed his downswing, I released the camera shutter for barely a half-second exposure. Once the swing was completed, I snapped a flash photo, lighting up the golfer who had been in darkness. A flash of bright light, captured live. It had to be shot in total darkness to create circles of colour around the golfer. The special effect was magical. I called the photo "Rainbow Swing." I couldn't wait to offer this original photography to my clients. I bought a black opaque tent and an air conditioner and carted them around from course to course. But the idea was not as successful as I had hoped it would be. I had forgotten that only 10% of golfers can claim to have a fluid swing. I didn't

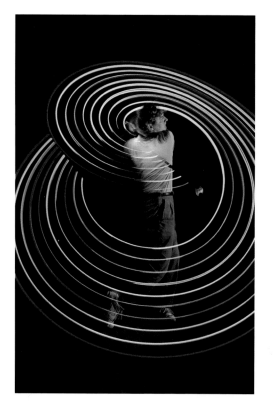

know then that, three years later, I would get the chance to show my creation to René Angélil, who was impressed by it. Thanks to that photo and to professional golfer Daniel Talbot, who was won over when he saw it, I was hired as the official photographer of the 1994 Skins Game, a major golf event held for the first time near Montreal at the Vallée du Richelieu golf club. That year, I had the opportunity to photograph some of the best golfers in the world: Tom Watson, Nick Price, Lee Trevino, and Fred Couples.

One of the personalities that I ran into often on the greens was René Angélil. During one of our casual conversations, I told him about my new business venture, importing cigars from the Dominican Republic and selling them under my personal brand, Lorenzo. I explained that many golfers were cigar smokers, including Payne Stewart, who had bought two boxes from me during the Canadian Open when it was held at the Royal Montreal golf club. To encourage me, René agreed to stock my cigars for sale in the shop at Le Mirage golf club, which he owned in Terrebonne.

In August 1997, I was working at a high-profile tournament on Montreal's north shore. There were more than 300 golfers on the course to photograph. My phone rang and it was René Noël, manager of Le Mirage. He asked if I could be at the club in an hour. I explained that I was in the middle of a tournament.

"René and Céline are expecting a visit from Muhammad Ali, and they would really like you to take some souvenir photos," he confided.

I managed to reach one of my freelance photographers, who agreed to cover for me, and I sped over to Le Mirage in my Jaguar.

Céline Dion was already a well-established, international star. A few months earlier, she had sung "The Power of the Dream," composed by David Foster, at the opening ceremonies of the Summer Olympic Games in Atlanta. After that performance, sales of her albums increased tenfold.

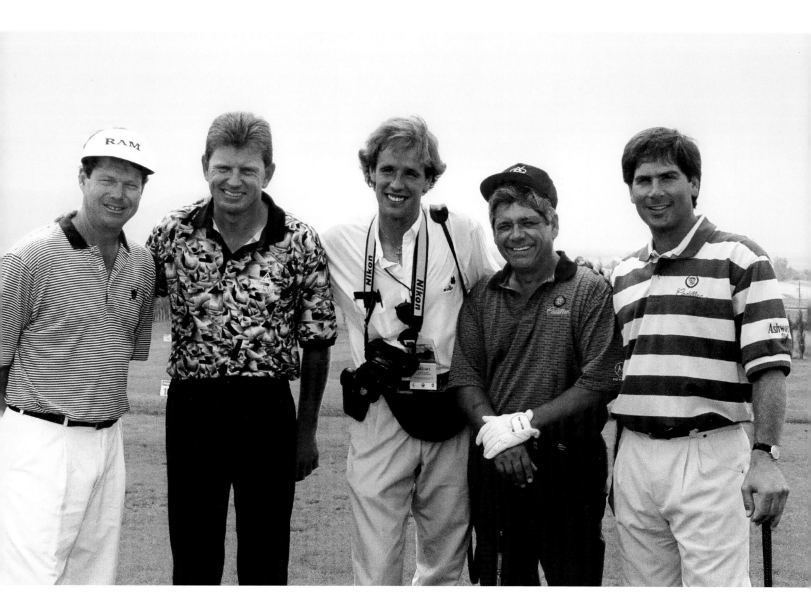

In spite of Céline's stardom, I was more excited by the prospect of meeting Muhammad Ali. In addition to his reputation as a boxing legend, I knew that he was also a staunch fighter against drugs. That knowledge comforted me in my choice of a new life. He symbolized the ability to succeed against all odds. Ali was a boxer who won his matches because he had a burning desire to win, something I identified with. As for Céline, I was aware of her popularity, but for someone who dreamed of photographing the Rolling Stones, let's just say that I wasn't into her songs at the time.

When I got to the golf club, René thanked me for coming and introduced me to Céline. That was the first time we met. She was skinnier than I had imagined. She was wearing little makeup and her hair was tied back in a natural look suited to her private life.

While waiting for Muhammad Ali to arrive, René told me how excited he was to greet his idol. He proudly announced that they were both born in 1942, René on January 16 and Ali on January 17. He added that he had had the privilege of meeting and talking with Ali at the Oscars the previous March, when Céline was invited to perform for the third time at the awards show. She had sung "Because You Loved Me."

Ali's limousine arrived. As soon as the driver opened the door, René and Céline were there to greet him. I saw Céline go up to Ali and embrace him warmly. I couldn't help noticing how spontaneously they formed a bond. It was as if they had always known each other!

We moved to Le Mirage golf club's main dining room. René had asked the chef to prepare every dish on the menu so that his special guest would have a choice. Céline sensed an unease, an embarrassment on the part of Muhammad Ali. Instinctively, she called, "Bring out all the dishes!"

I was immediately won over by her warmth and simple no-nonsense style.

René then spoke up and explained that offering many dishes is an Arab custom, typical of his Syrian roots. Everyone seemed satisfied with the explanation, and the atmosphere became more relaxed, so much so that, without hesitation, Céline started cutting

the meat on Ali's plate as if they had shared many meals before. I noticed that there was no alcohol, wine, or beer on the table, and I thought to myself, "This is perfect for me — they're clean."

Near the end of the meal, I worked up the nerve to tell Céline that I wanted a photo of the two of us with Ali as a souvenir. She graciously accepted. I'm proud of that photo of the three of us. Céline loves photos; she once told me that she had never been able to tear one up; even if the photo wasn't perfect, it held precious memories.

When it was time to leave, René said, "We'll be seeing each other again, Laurent!"

I hurried back to the golf tournament. Once there, I told some people that I had just experienced a special moment: I had photographed Muhammad Ali. They looked at me in a whole new light. And yet, I was still the same guy. That was the first time I realized the importance of perceptions.

I developed the photos, placed them in an album with sleeves made to look like picture frames, and sent them to the offices of René's production company, Productions Feeling. A few days later, I was pleased to find a message from René on my answering machine.

"Laurent, I'm very impressed by your work, by the beauty of your photos. Thank you again for all the effort you put into them. See you soon!"

He even went so far as to leave me the phone number of his hotel room in New York. I admit that I kept that message for a long time. I listened to it several times for encouragement and to boost my confidence.

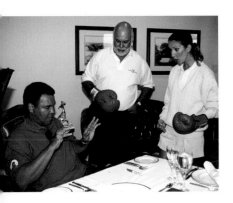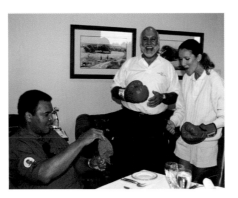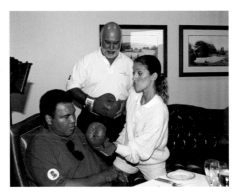

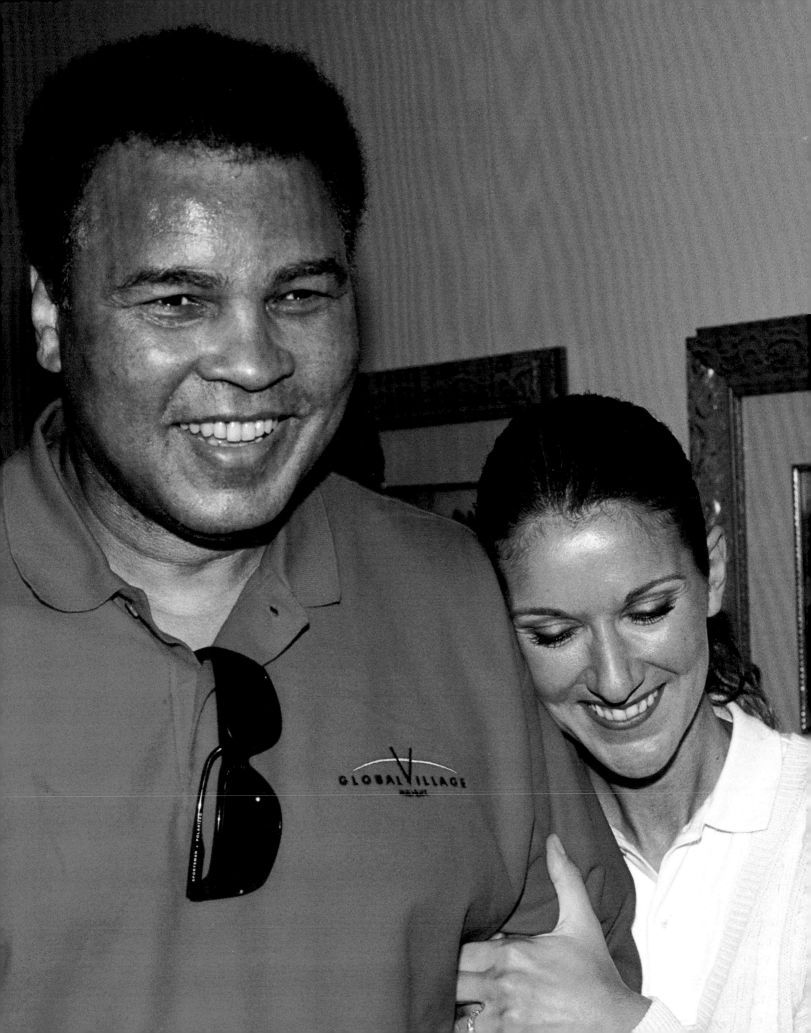

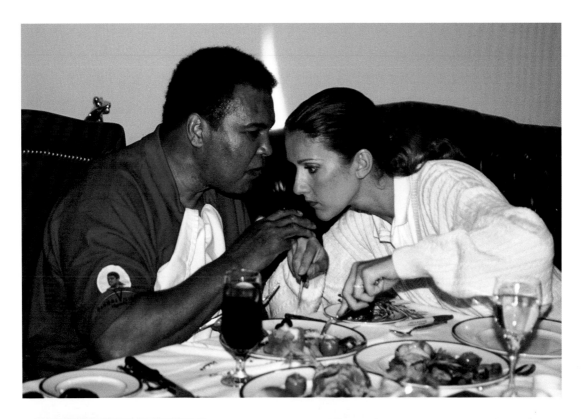

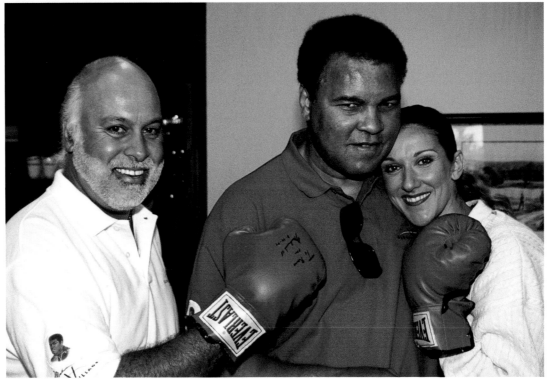

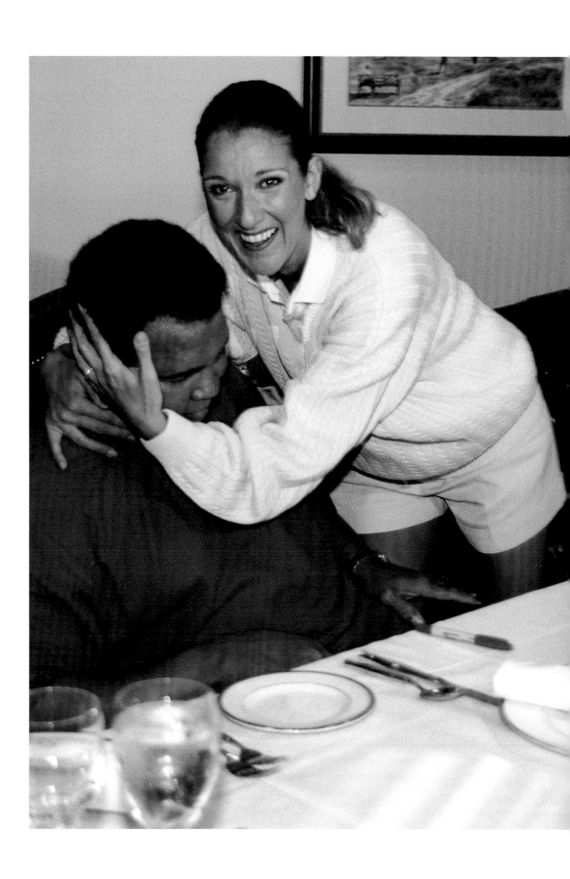

WITH MUHAMMAD ALI AT LE MIRAGE GOLF CLUB, 1997 **31**

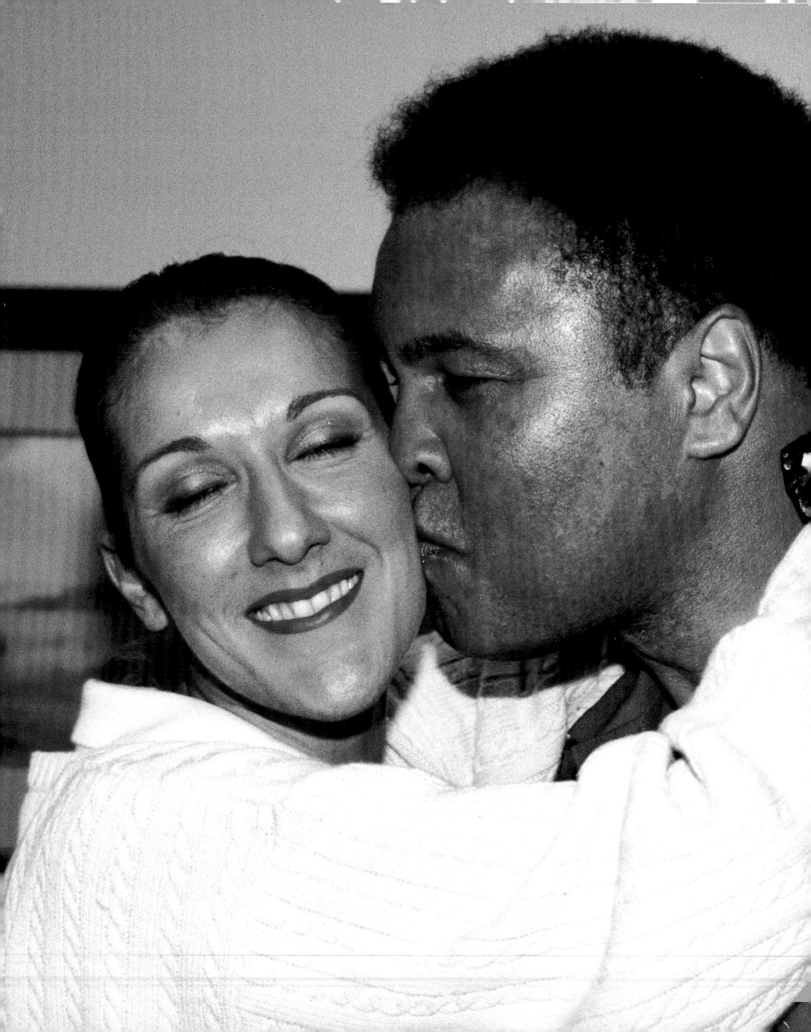

A little less than a year after my meeting with Muhammad Ali, I was back at Le Mirage to take photos of Céline, who was being featured on a segment on the Golf Channel. This time, I took lots of shots of Céline the golfer. She has a great swing and an obvious gift for the game. This is not a singer pretending to play golf; she really loves the game. She puts 100% into everything she does and loves to outdo herself. In golf, unlike tennis, the challenge is to hit a stationary ball in a competition against yourself, not someone else. Céline had been playing for less than a year, but had already broken 100. Only about 10% of golfers can claim that feat.

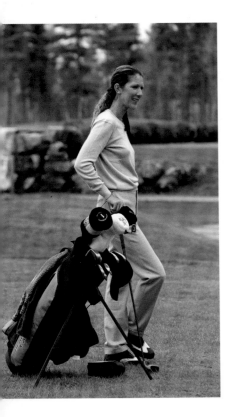 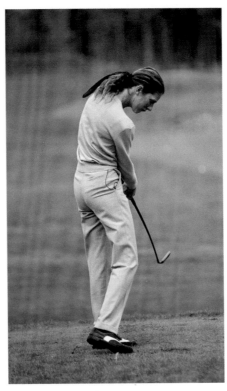 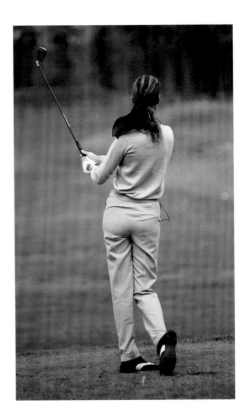

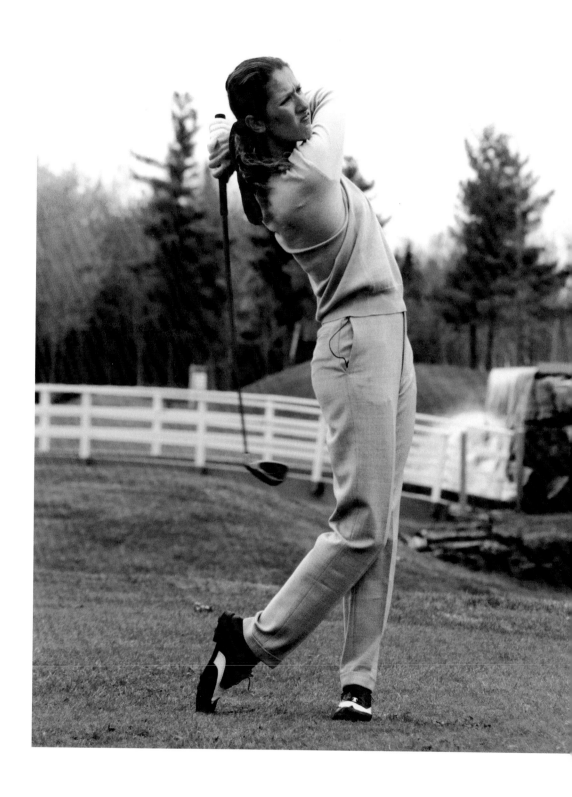

A photo from this shoot appeared in such popular magazines as *Sports Illustrated*, *Golf Digest*, *Cigar Aficionado*, and other Condé Nast publications. In another coup, another photo I took of Céline that day was featured in an ad for Callaway, the renowned California golf equipment maker. Thanks to Céline, some of my photos made it around the world!

On that day in May 1998, René told me that *Golf International* magazine also wanted exclusive photos of Céline. He said, "I told the editor, 'On two conditions: I approve all the photos and Laurent Cayla takes them.'"

The shoot was scheduled for the following week. The assignment was for two front-page photos of Céline, one for *Golf International* and the other for *Golf Digest Woman*, as well as additional photos for the inside of the magazine. I arrived at Le Mirage at 9 a.m. It was a sunny day. While waiting for Céline, I spent time studying the light and play of shadows on the course. When she arrived at noon, the sun was at its zenith, making all my planning obsolete. She spent a few minutes signing autographs and then turned to me and said, "René tells me you're the best. Unfortunately, I only have about 10 minutes for the shoot."

I was feeling stressed out. This was just the third time that we had met. We walked over to a sand trap. I climbed a six-foot ladder and asked Céline to show me her swing. I worked quickly and felt sure that I had some good photos for the magazines. She asked me to take a few extra shots for her. I photographed her leaning on her golf bag, next to a tree. She seemed relaxed. I was happy, too. In the end, the shoot lasted an hour and I took more than 200 photos.

Shortly afterwards, as always, I put together an album and showed it to René.

The second he saw the photos, he exclaimed, "I can't believe it. They're really great!"

He was especially pleased because Céline had recently had a less than enjoyable experience during a previous photo shoot on the golf course. The resulting photos had been disappointing.

He made me an offer. "Laurent, I'm going to buy all your photos so we don't have to negotiate every time. In other words, I'll buy the rights. If a magazine contacts you directly for one of your photos of Céline, just tell me which one and, with my permission, you can sell it to them."

This was the first of many times that I witnessed René's generosity.

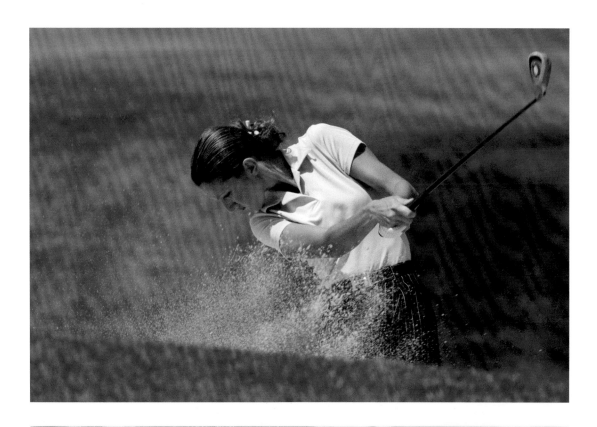

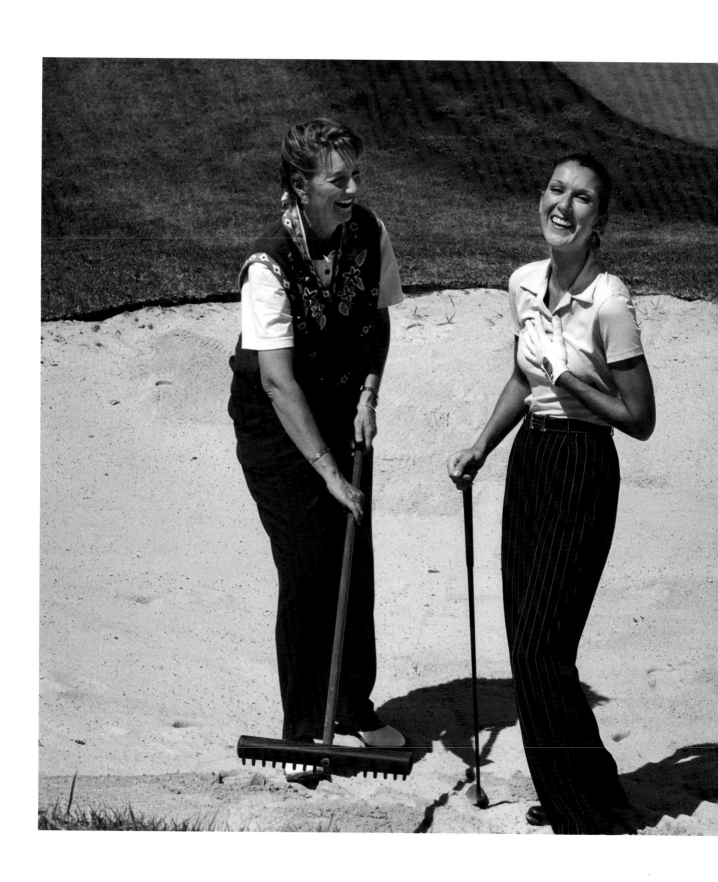

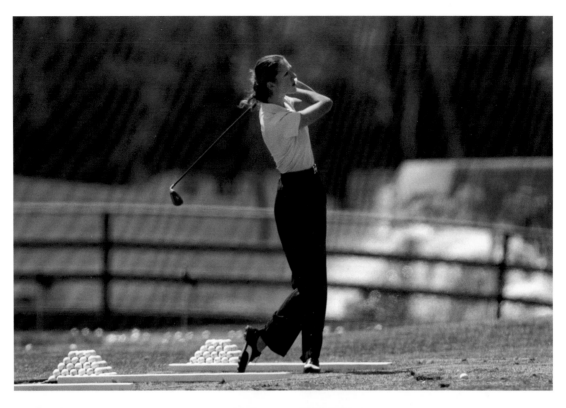

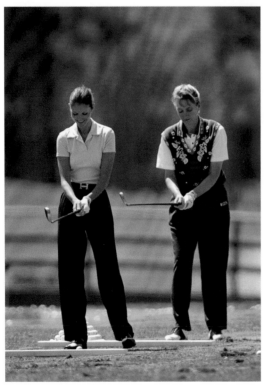
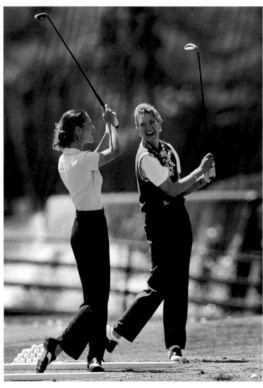

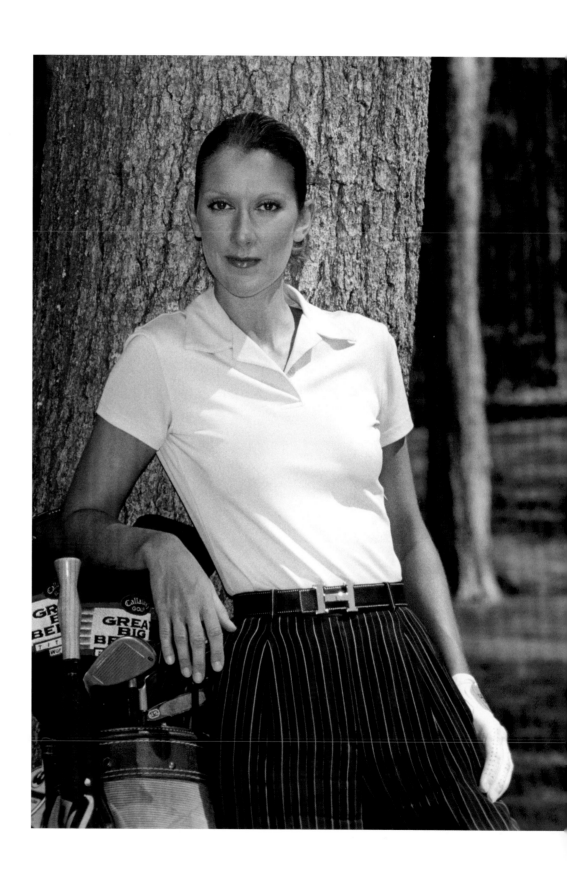

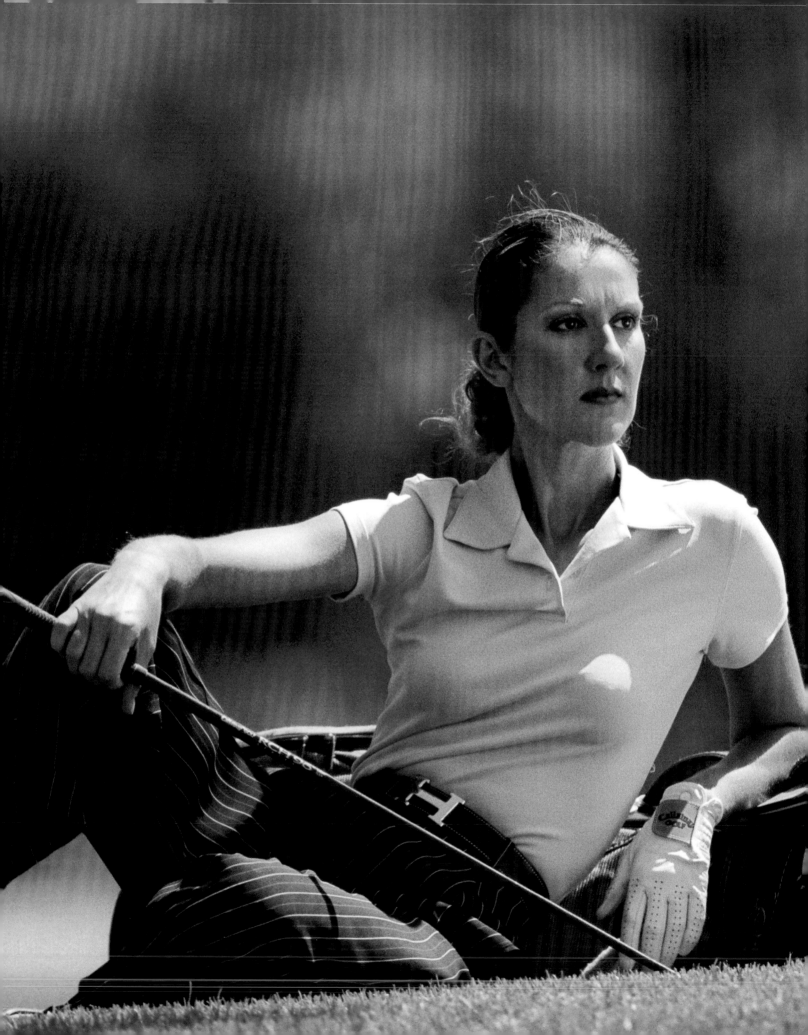

"Céline told me once that, had she not been a singer, she would have liked to have been a model. Whenever I photograph her, she strikes a pose spontaneously. I rarely have to give her direction."

The following June, Sylvester Stallone came to Montreal for the official opening of a new Planet Hollywood restaurant, the chain he founded in 1991 with Bruce Willis and others. I was alerted beforehand that he had been invited to play golf at Le Mirage. He arrived early in the morning and dropped in at the golf shop. Knowing that he liked cigars, I offered him a Lorenzo, explaining that I imported them. It was his idea to hold the cigar with the logo on the band clearly displayed. He smiled and said, "Go for it!"

I took a few shots, thanked him, and said, "Enjoy the game!"

The following week, Bruce Parker, the vice-president of Callaway, came to play golf with René and Céline. Parker is a great guy. He told me how taken he was with my photo of Céline, which the company was using in their image ads. He gave me $50,000 worth of golf bags to use as promotions for the Golf Québec Association, which benefits junior golfers. Later, he invited me to his home, and I have golfed with him on several occasions at some of the top-rated U.S. golf courses.

Whenever I had the pleasure of seeing Bruce, he would repeat how amazed he was at Céline and René's kindness and hospitality. I benefited from that warm relationship. Thanks to him, I met Jack Nicholson on a golf course in Beverly Hills.

I saw him on the course and thought, "Wow! My favourite actor!" I immediately thought of going up to talk to him, but I didn't dare ruin his concentration. Thoughts can be a powerful magnet . . . That evening, I happened to see him at a basketball game. This time, he was closer to me. "There are millions of people in L.A. and I see him

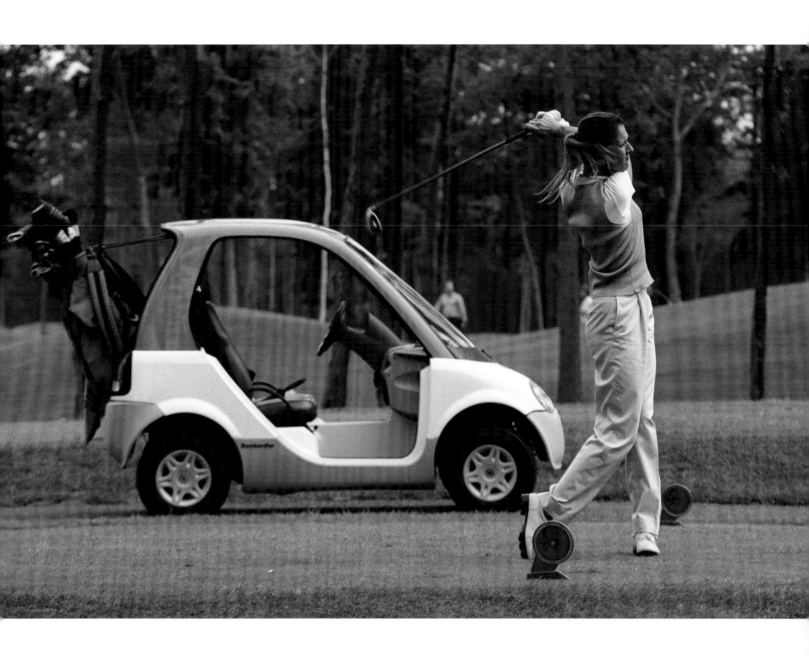

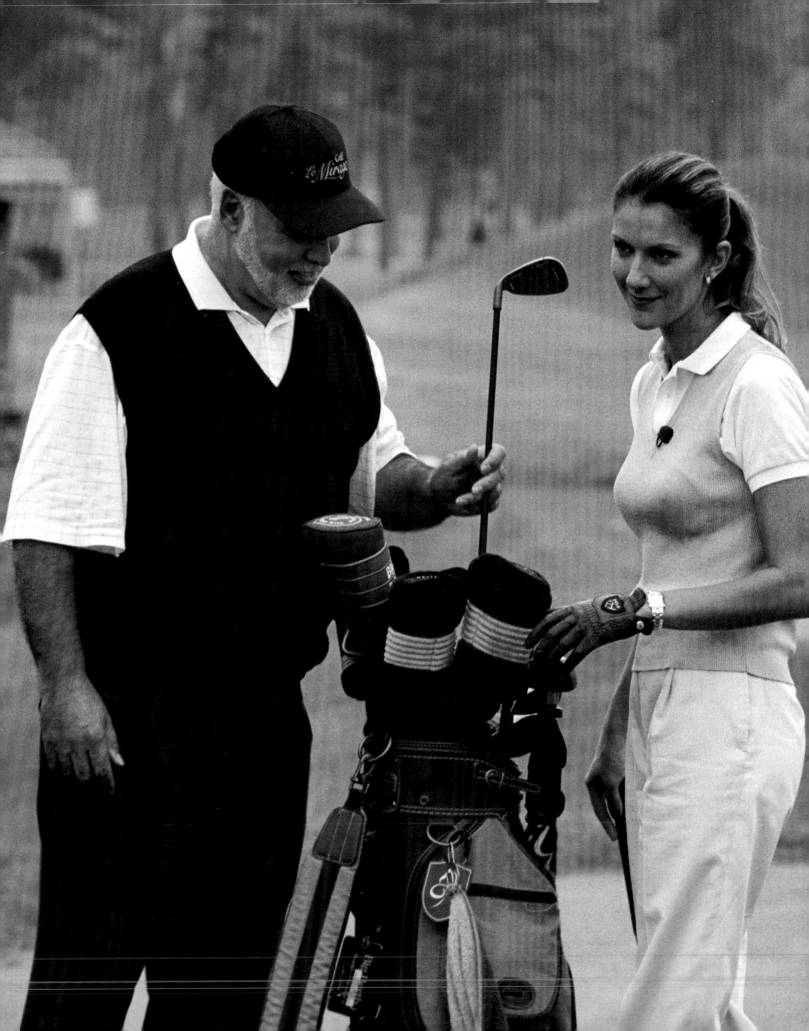

twice in one day. It must be a sign," I told myself. At halftime, I headed to the smokers' lounge for a short cigar break and saw him a third time. I couldn't resist going over to talk to him.

I asked him if he had ever played golf in Montreal, and I told him about Royal Montreal, North America's first golf club, founded in 1873. He seemed interested and asked me about it. I told him the story of the origin of the golf term "mulligan."

In the early 1920s, David Mulligan lived in Saint-Lambert, a town on Montreal's south shore. Back then, golf courses were built near railroad tracks. Cars were rare, so golfers took the train to play their favourite sport. Mulligan happened to be one of the few fortunate car owners and he would drive his three golf buddies from Montreal to the course. To get there, he had to take the Victoria Bridge, which in those days was made of wood. Navigating the bridge required exceptional driving skill, and the passengers in the car were jostled about. By the time Mulligan arrived at the course, he was a little shaken up by the precarious trip over the river and regularly missed his opening shot. So his buddies got into the habit of letting him take his first shot over again, as a way of thanking him for being nice enough to drive them to the club. The word "mulligan" was passed down over time and became a part of common golf parlance.

Jack Nicholson's eyes twinkled as he listened to the anecdote, and he thanked me warmly for sharing it. I returned to my seat to watch the end of the game, a big smile on my face.

Golf has given me the opportunity to meet some truly exceptional people. In the summer of 1998, less than two days after I first met Bruce Parker at Le Mirage, Céline and René played host to Annika Sörenstam, the world's number one female golfer. Naturally, I was very excited at the prospect of meeting her and taking photos of her and Céline.

Once again, the relationship was magical. The three players had a great time on the green. To be a good golfer, you not only have to play regularly, but you also have to be in a relaxed, almost Zen-like, state of mind and in good company. And you have to respect golf etiquette. My two benefactors understood this well, and they learned some tips from Annika.

Shortly afterwards, René asked me if I was free to go to the Perry Studio in mid-July.

"We're recording a Christmas album and Céline's family will be there."

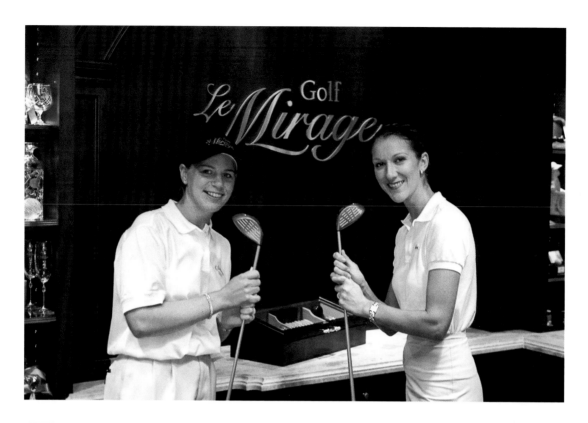

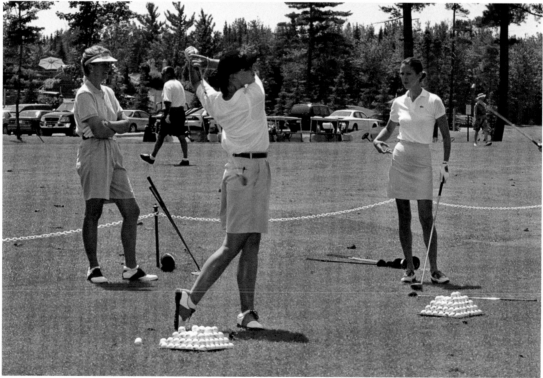

On July 11, we met in the studio of André Perry, the man who recorded John Lennon and Yoko Ono performing "Give Peace a Chance" during their bed-in at the Queen Elizabeth Hotel on May 26, 1969. Céline was recording her first English-language Christmas album, *These Are Special Times*, which would go on to sell 12 million copies worldwide.

One of the album's biggest hits was "I'm Your Angel," a duet with R. Kelly that climbed to the top of the Billboard charts and earned a Grammy nomination.

Céline also recorded "Blue Christmas," "Ave Maria," and "We Wish You a Merry Christmas," among other songs. Later that evening, the Sony team suggested that Céline replace the "we" in "We Wish You a Merry Christmas" with "I."

She agreed immediately and inserted the new word in the same tone and timbre as the original recording. I was really impressed by this technical feat. I was lucky enough to sit next to Céline in the small and intimate recording booth and listen to her sing a cappella — only she could hear the music through her headset. I watched her every gesture, her slightest movements. Her deeply expressive face showed how much she was living the song. I could feel all the emotion and vocal technique of this incredible artist. I was totally blown away!

That day, Dave Platel, René's right-hand man, gave me his business card. "It's as if you've known Céline for years," he commented.

Probably the fact that I wasn't a groupie made our relationship easier.

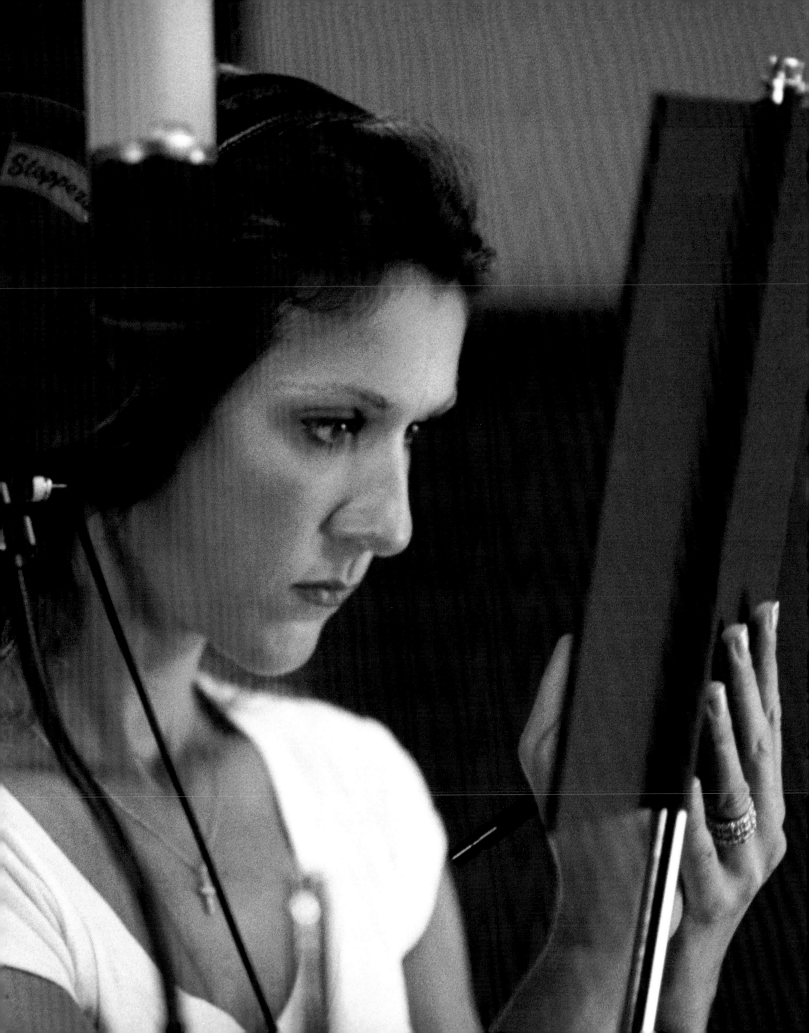

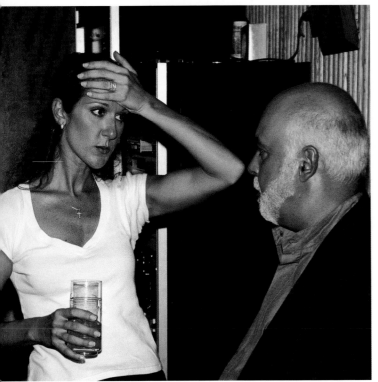

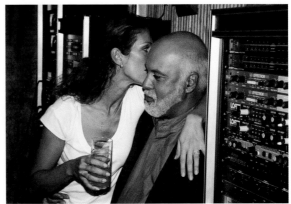

"I've never heard Céline complain. Not even that day when she was suffering from a terrible toothache."

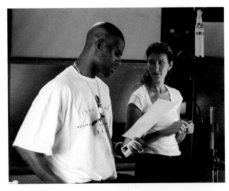
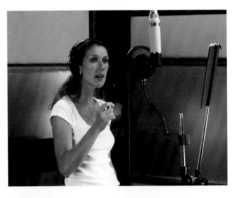

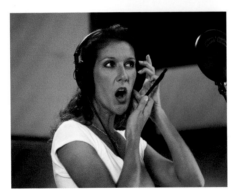
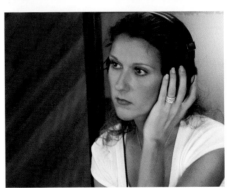

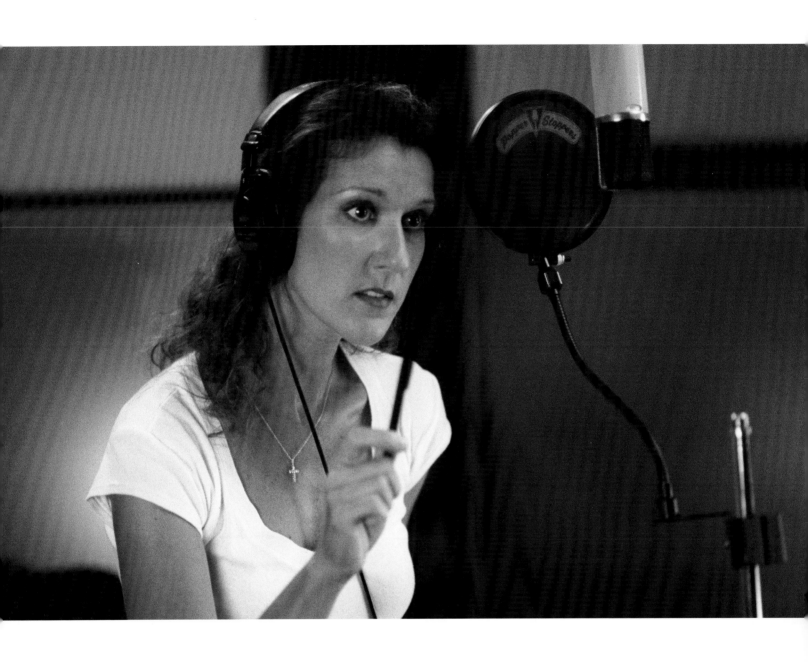

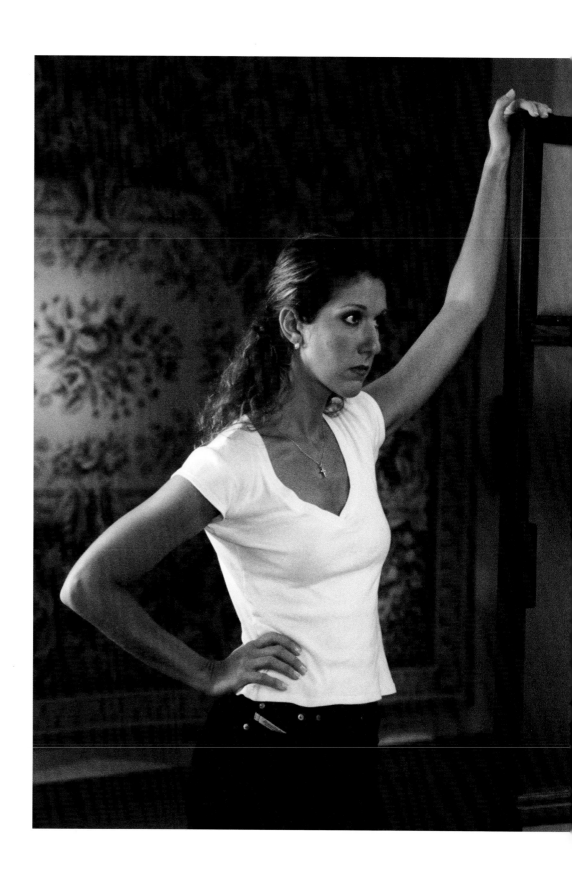

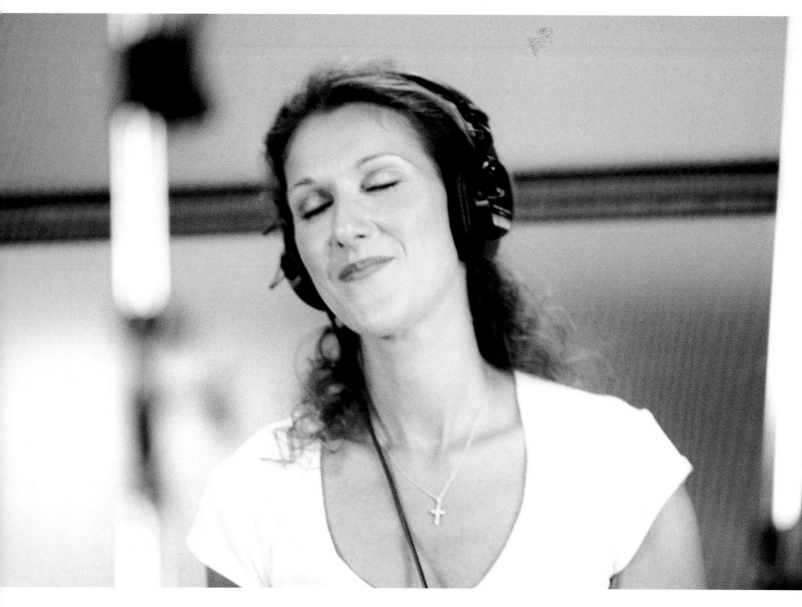

"When shooting the first photos, emotion takes precedence over technique."

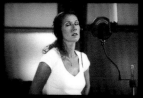
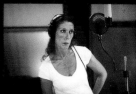

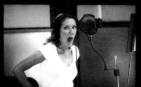
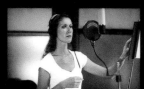
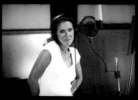
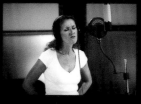
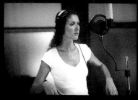

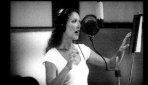
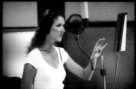
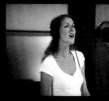
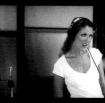

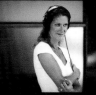

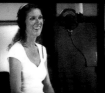
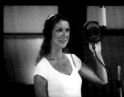
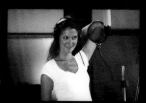

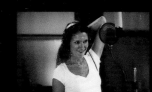
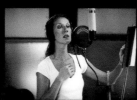

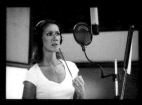
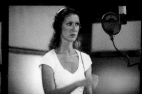
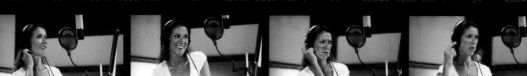

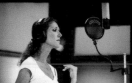
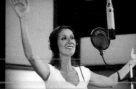

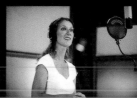
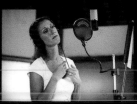

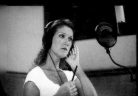

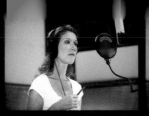

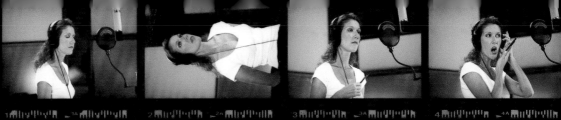
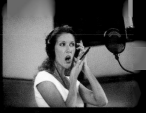

5 KODAK 5030 PJC-1 6 KODAK 5030 PJC 1 7 KODAK 5030 PJC-1 8 KODAK 5030 PJC 1 9 KODAK 5030 PJC-1

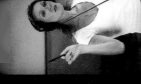
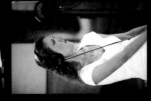
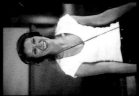
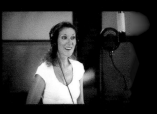

10 KODAK 5030 PJC-1 11 KODAK 5030 PJC-1 12 KODAK 5030 PJC-1 13 KODAK 5030 PJC-1 14 KODAK 5030 PJC-1

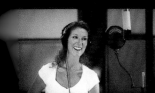
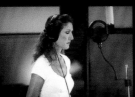
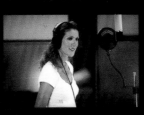

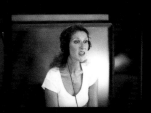

15 KODAK 5030 PJC-1 16 KODAK 5030 PJC-1 17 KODAK 5030 PJC-1 18 KODAK 5030 PJC-1 19 KODAK 5030 PJC-1

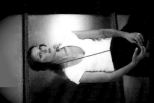
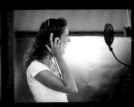
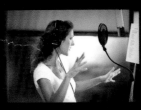
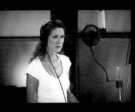
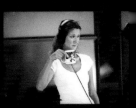

20 KODAK 5030 PJC-1 21 KODAK 5030 PJC-1 22 KODAK 5030 PJC 1 23 KODAK 5030 PJC 1 24 KODAK 5030 PJC 1

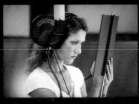
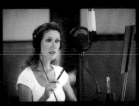
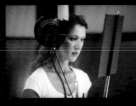
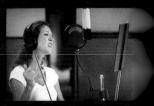

25 KODAK 5030 PJC-1 26 KODAK 5030 PJC-1 27 KODAK 5030 PJC 1 28 KODAK 5030 PJC-1 29 KODAK 5030 PJC-1

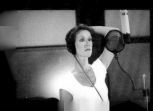
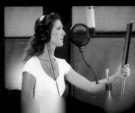
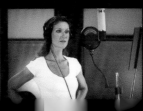
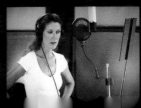
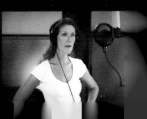

30 KODAK 5030 PJC-1 31 KODAK 5030 PJC-1 32 KODAK 5030 PJC-1 33 KODAK 5030 PJC-1 34 KODAK 5030 PJC-1

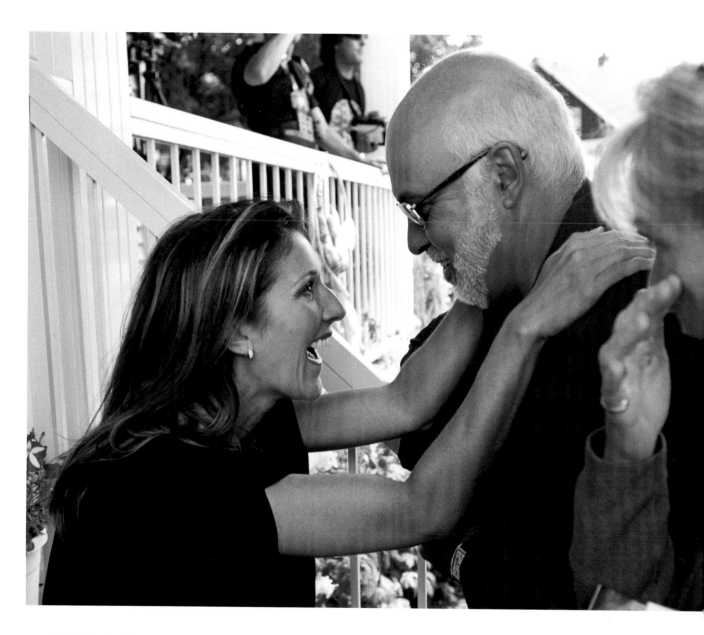

A CBS television crew was also at the studio filming a special that was set to air on November 25. In addition to the studio segment, the cameras would be following Céline to her hometown of Charlemagne. We left the recording studio only at 3 a.m., and the shoot was scheduled to start at 11 a.m.

In Charlemagne, the cameras followed Céline as she retraced her walk to school, pointed out her childhood home, and stopped at the local bakery to sample a few of her favourite doughnuts, the way she did as a child. The U.S. network was thrilled to capture this intimate side of the superstar.

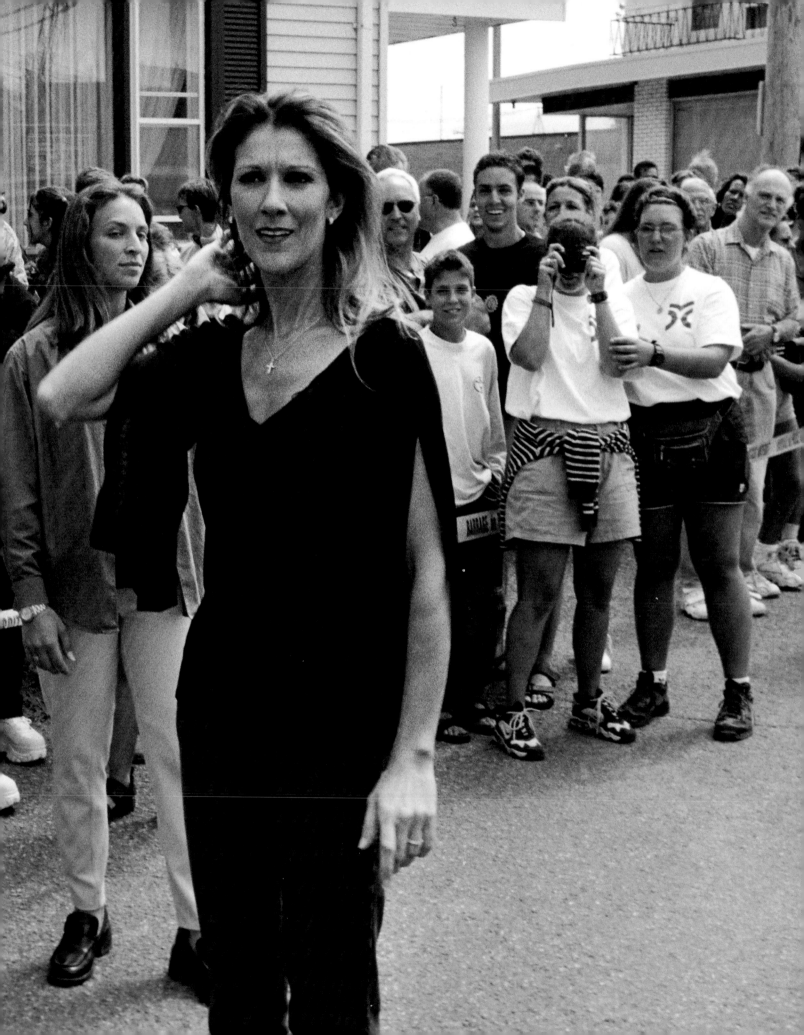

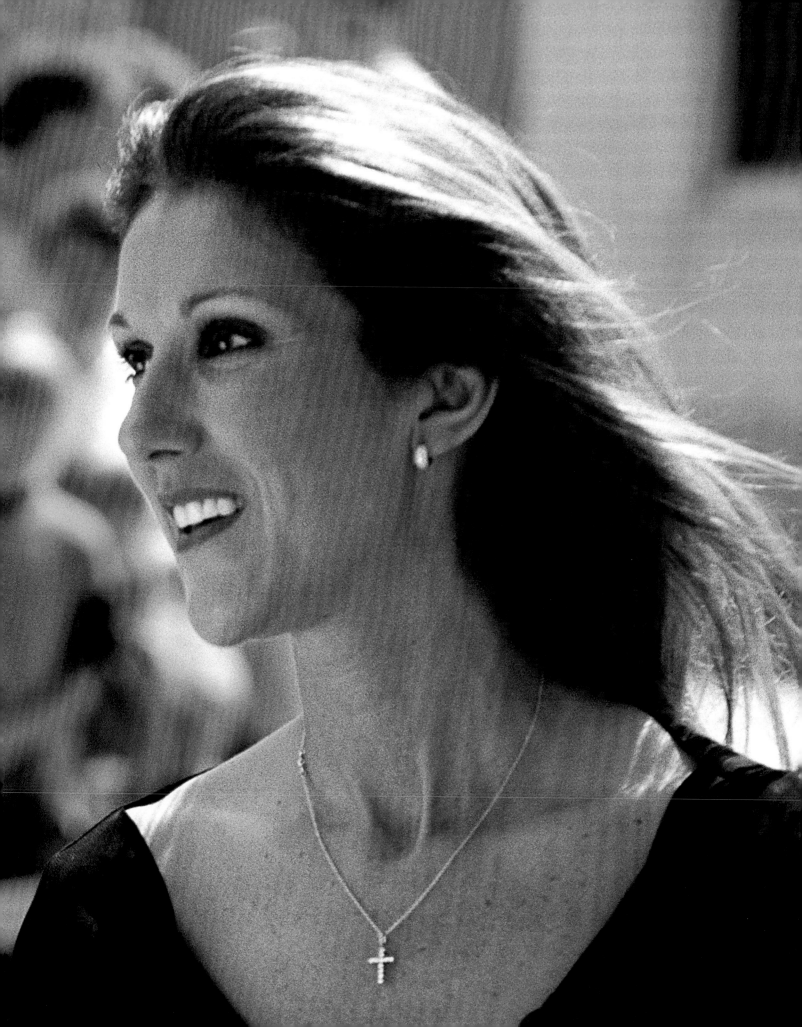

Later that evening, we went back to Perry's studio to record the entire Dion family singing "Feliz Navidad" and a traditional French air, "Les cloches du hameau." In spite of the hectic schedule, there was a party atmosphere in the studio. Whenever the Dions get together, they really have a good time. It's as if they just saw each other the day before, because they have never forgotten where they came from. Their shared memories are intact, and their joy in making music together will bind them forever.

After the recording session, Céline's day ended with a live interview at midnight for Japanese television.

At 2 a.m., I took this family photo, which was broadcast on *Oprah* six months later.

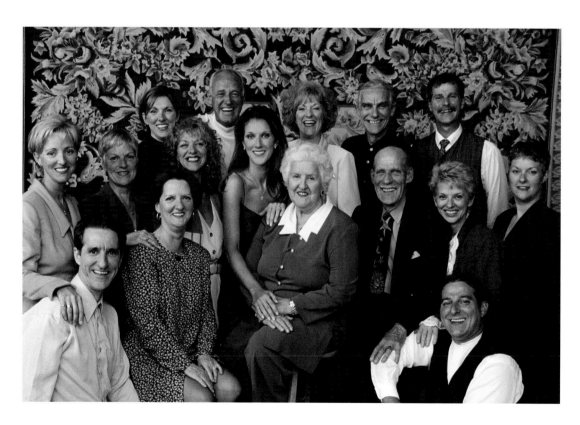

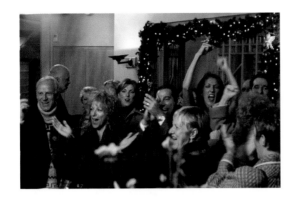
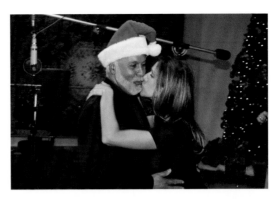

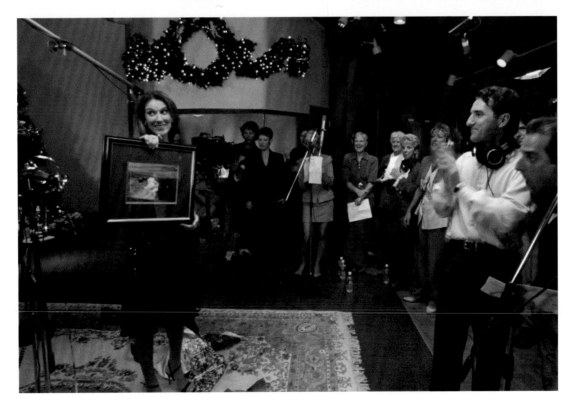

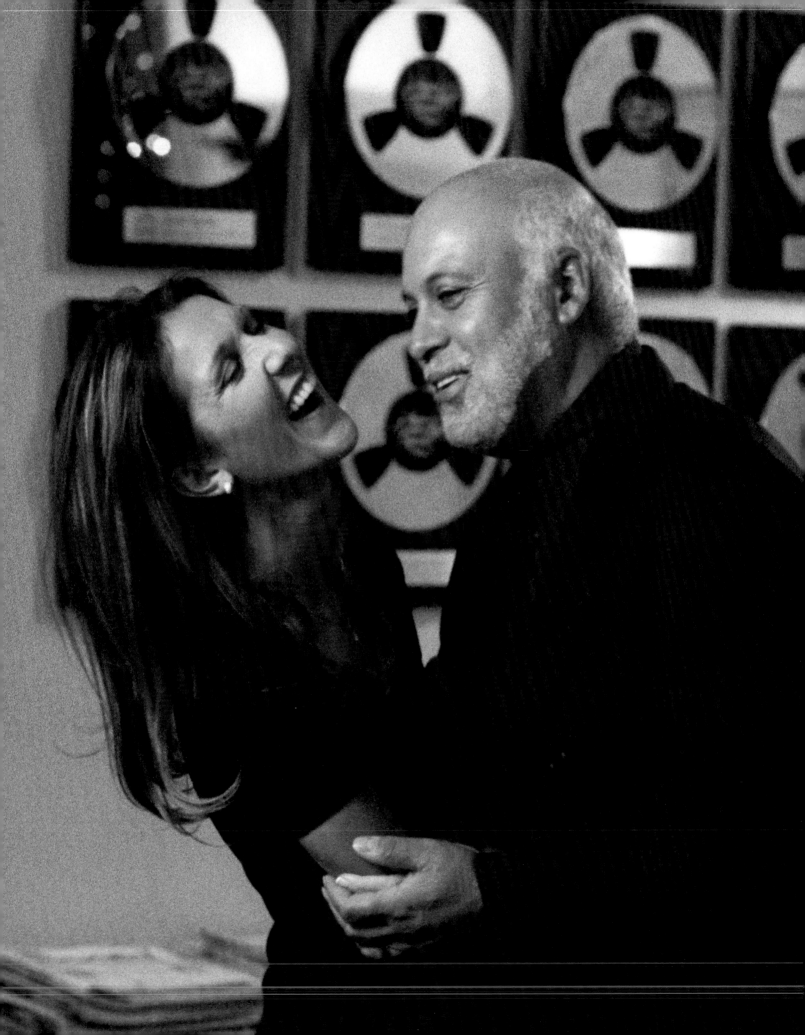

I'm Alive

I know that I'm alive
When you bless
The day
I just drift away
All my worries die
I'm glad that I'm
Alive.

— "I'm Alive"

On July 14, 1998, my wife and I were among one thousand lucky guests attending a dress rehearsal of the *Let's Talk About Love* show at the Molson Centre in Montreal. It was the first time I had seen Céline onstage. What presence! It didn't feel like a rehearsal, it felt more like a real performance. She gave it her all. That's when I discovered her drive.

Many rushed up to congratulate her after the show. I managed to say to René, "Dave Platel gave me his business card. He's looking for a photographer for the North American tour. Problem is, I haven't shot live shows since the days of the old Montreal Forum, Emerson, Lake & Palmer, and Gentle Giant."

"I know you can do it, Laurent. I've seen your golf photos, your shots of Muhammad Ali and Stallone. I chose you because I know you can do it. Everything will be fine!"

At that moment, I realized that I was going to be part of Céline and René's inner circle for a time. I was so high with excitement that the minute I got out on the street, I started singing the lyrics of David Bowie's song "Heroes."

I was amazed to learn about the special perks that came with working with the team on tour: first-class flights, the best hotels, limos, and lots of personal attention.

The tour opened in Boston, the city where Céline likes to begin her American tours. When I arrived at the airport, I was met by a limo driver holding up a sign with my name on it. He drove me to the legendary Ritz-Carlton Hotel, where I tried to get some sleep. I was really nervous, verging on anxious. I wondered if I would be able to justify Céline and René's trust in me.

The following day, I was in the hotel lobby chatting with Ben Kaye, René's good friend and former manager when he was a member of the Baronets, a pop trio. The elevator doors opened and Céline appeared. I was so nervous that the first shot I took was out of focus. Céline walked with a sure step, like an army general followed by her staff officer — yet another manifestation of her go-getter attitude. She was like a boxer on her way to a major fight. The destination: Fleet Center, the site of her opening show.

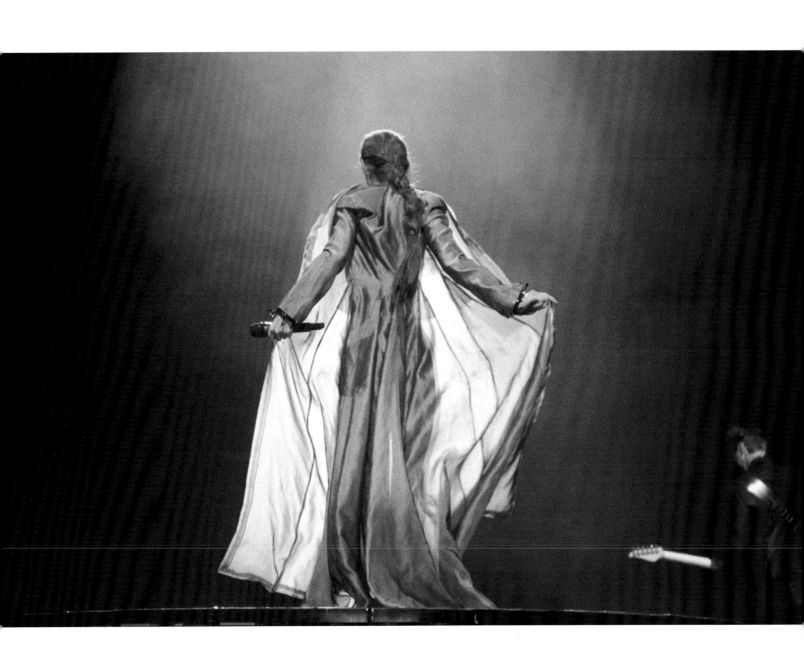

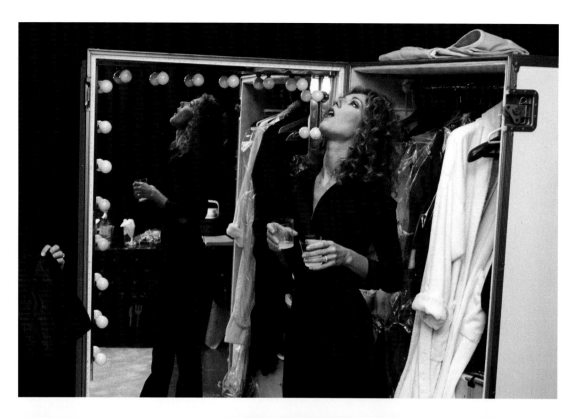

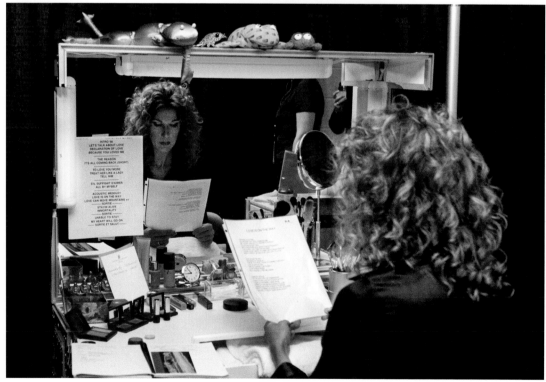

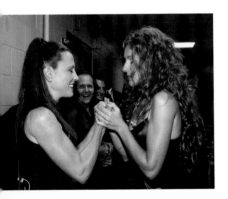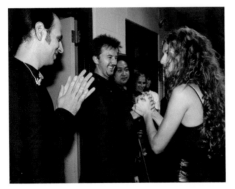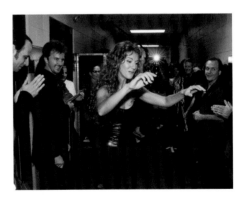

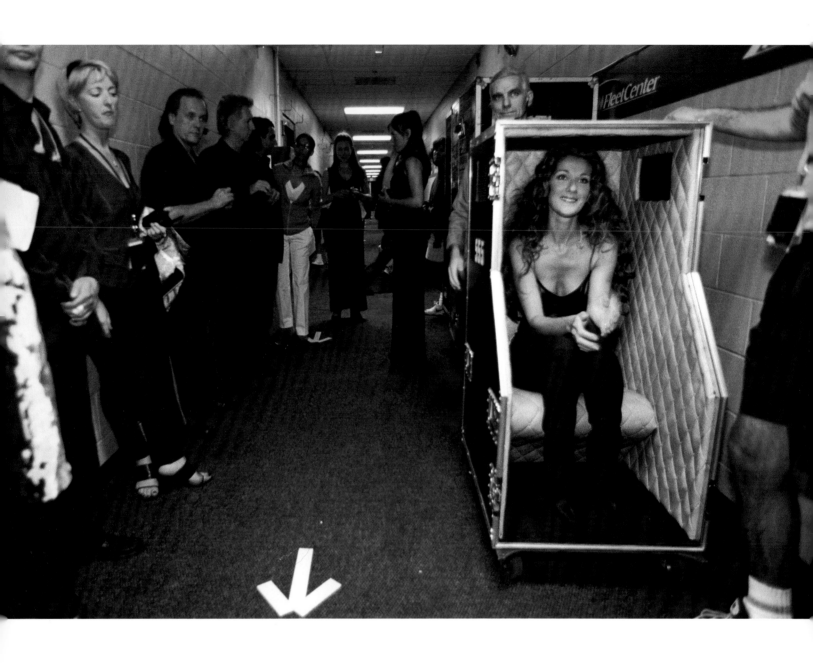

Once there, she sat down to a meal with the entire crew; she was just one of the gang. Then it was time for rehearsals. In the best team spirit, everyone did their job to improve the show and make it perfect. It was an atmosphere of mutual respect. Everyone — from the musicians, backup singers, and director to the lighting crew, costume designers, and technicians — shared a common understanding. Céline listened with an open mind, sometimes suggesting a change here or there. She sang as if the audience were there. The sound had to be perfect. And it was. That night of August 21, 1998, marked the start of her triumphant tour.

It was a first for me, too. Céline's routine before going onstage intrigued me. She went up to every member of the team backstage, touching a hand here, a thumb or an ear there, in a series of rituals or habits that would be repeated before every show. When she got to me, she touched the cross I wore around my neck as a good luck charm.

There was a second Boston performance the following evening. Everything ran as smoothly as the first, except that we had to leave quickly after the show. It was my first "runner": the encore was barely finished, the audience was still applauding, and the limos were ready to head off to the airport. It was a race against the clock. We had to make it to Montreal before midnight. Under police escort, the procession drove at lightning speed. I loved it!

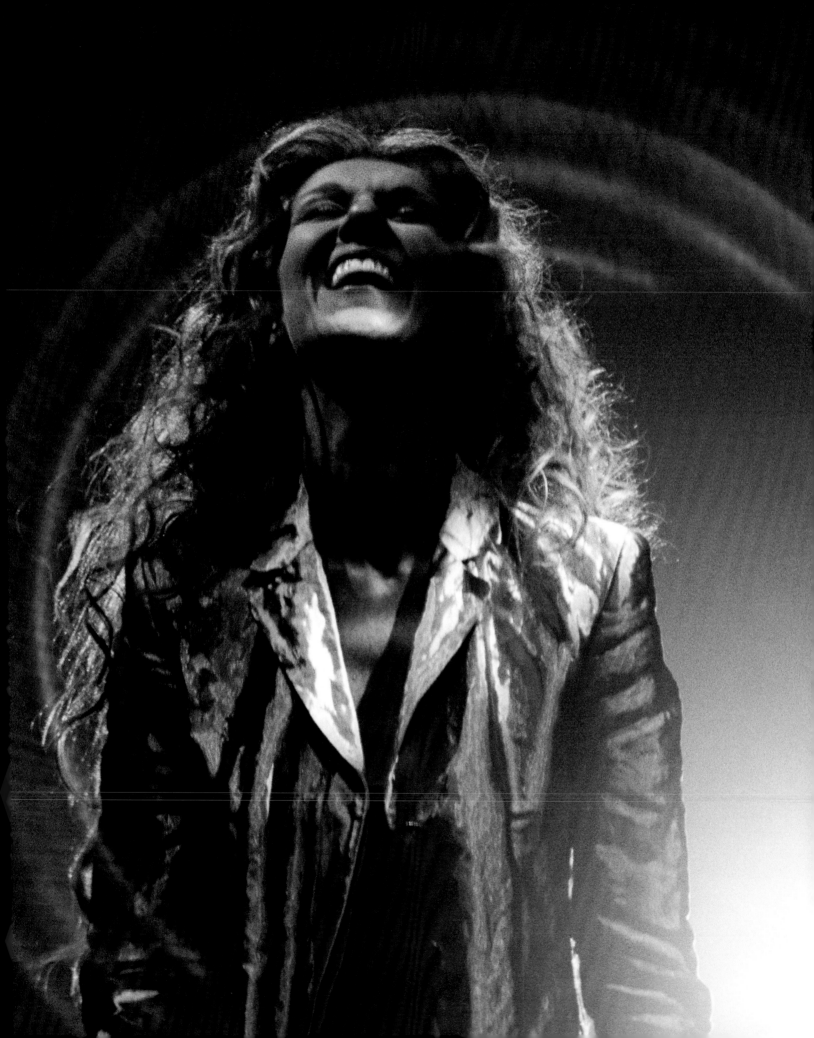

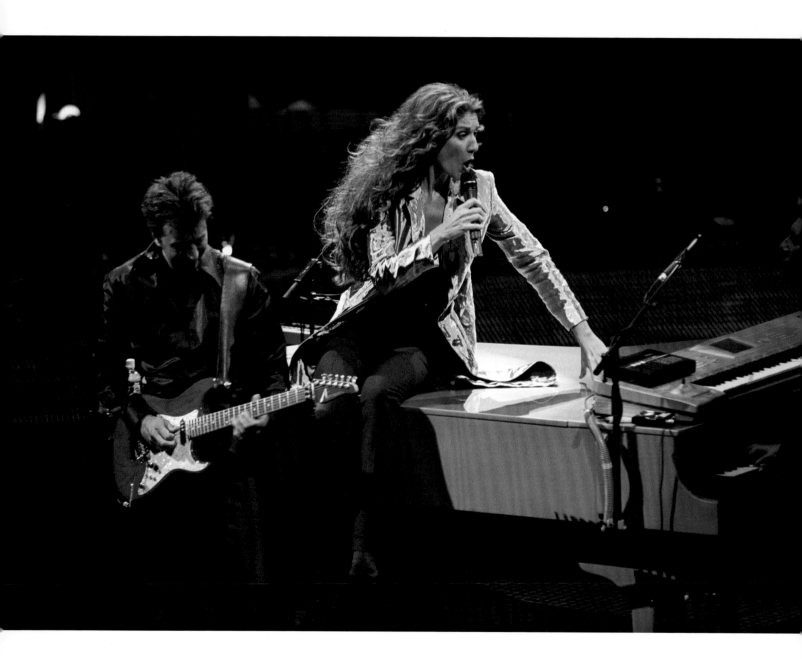

"When I showed Céline this photo and the one on the next page, I compared her to Jimi Hendrix and Janis Joplin. She was proud of it. But René replied that you should never compare one artist to another."

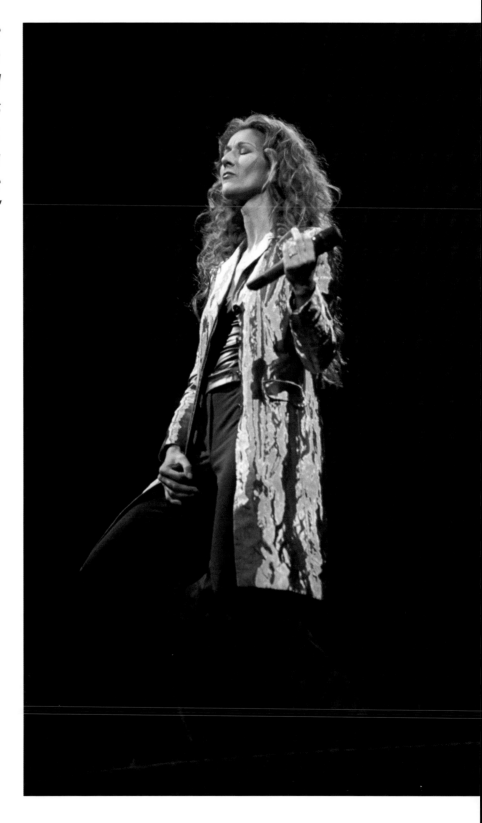

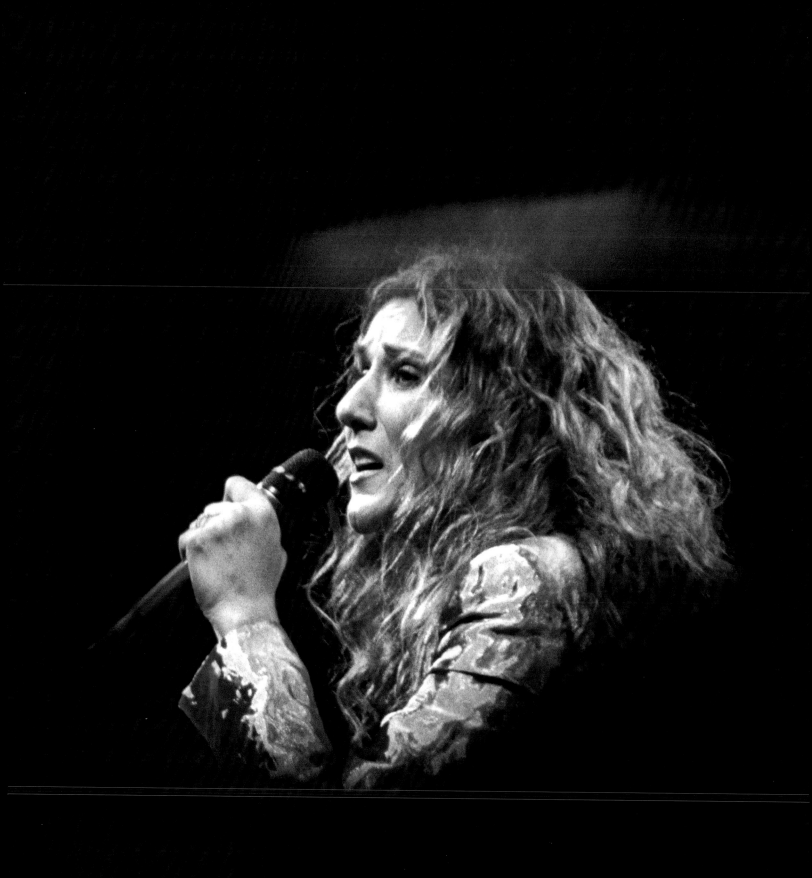

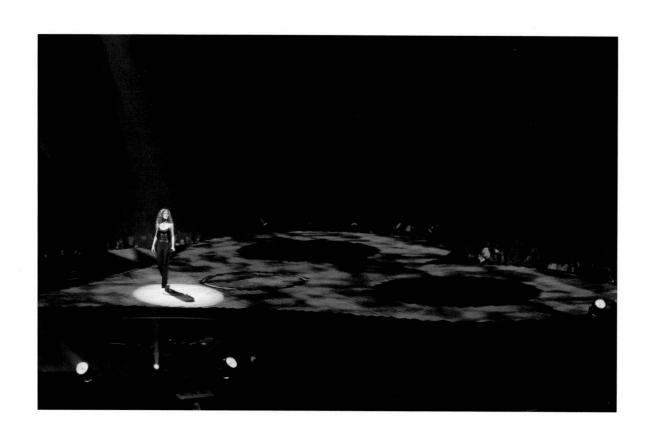

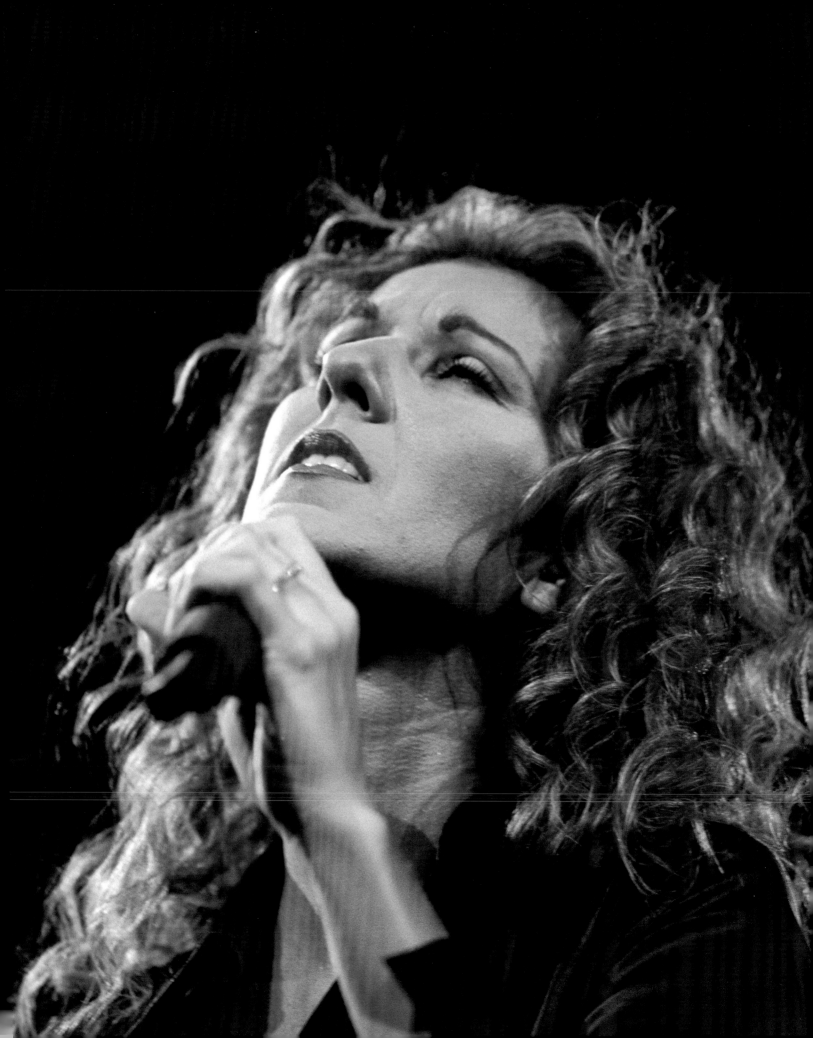

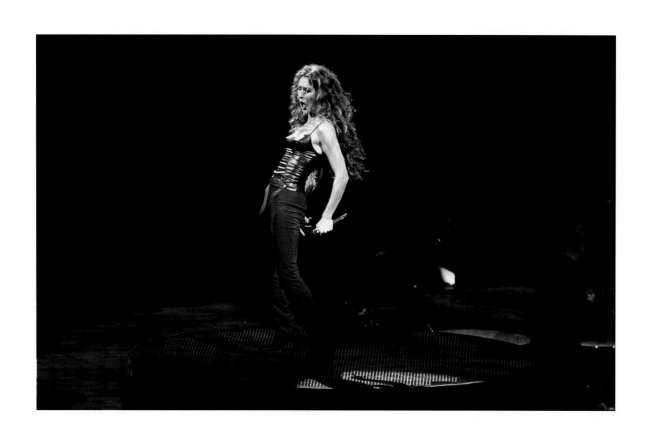

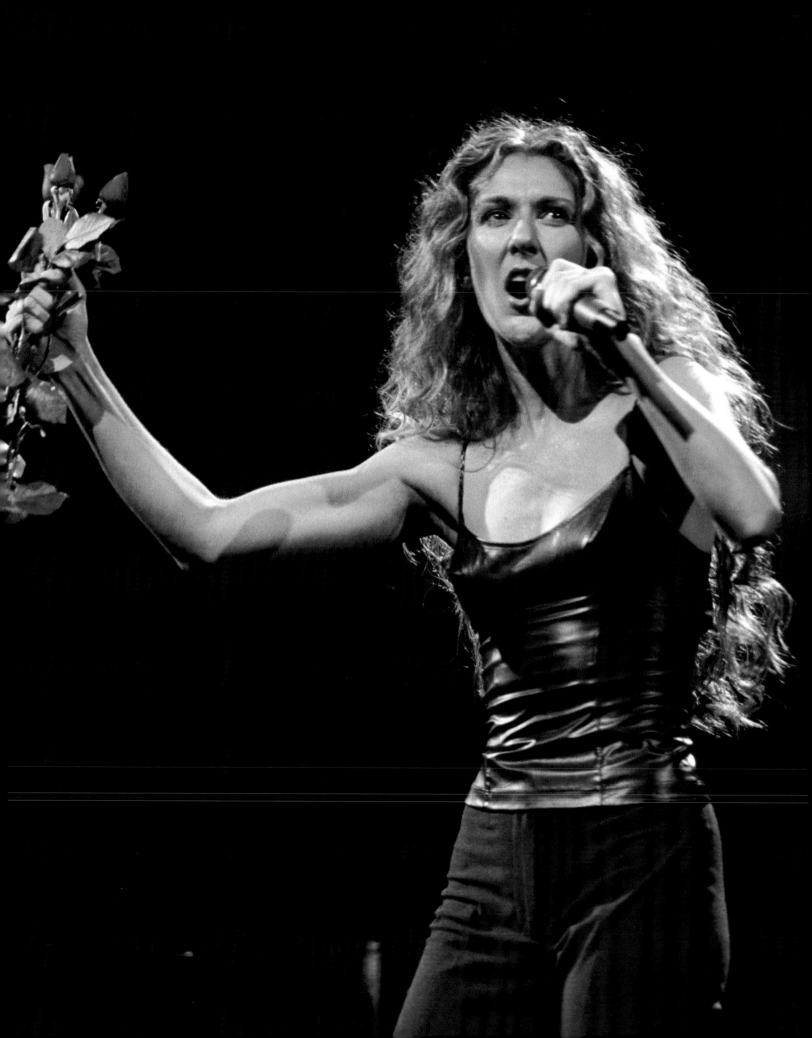

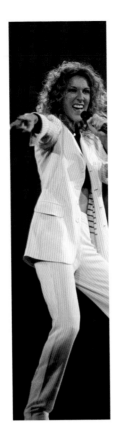
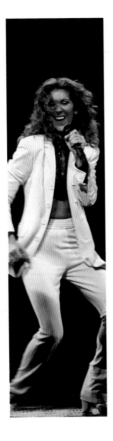
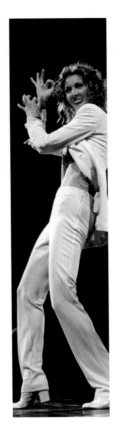
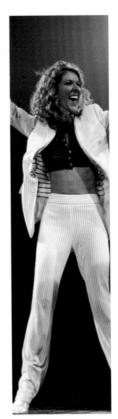
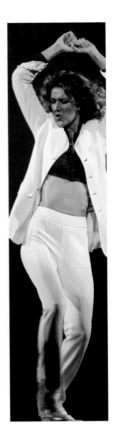

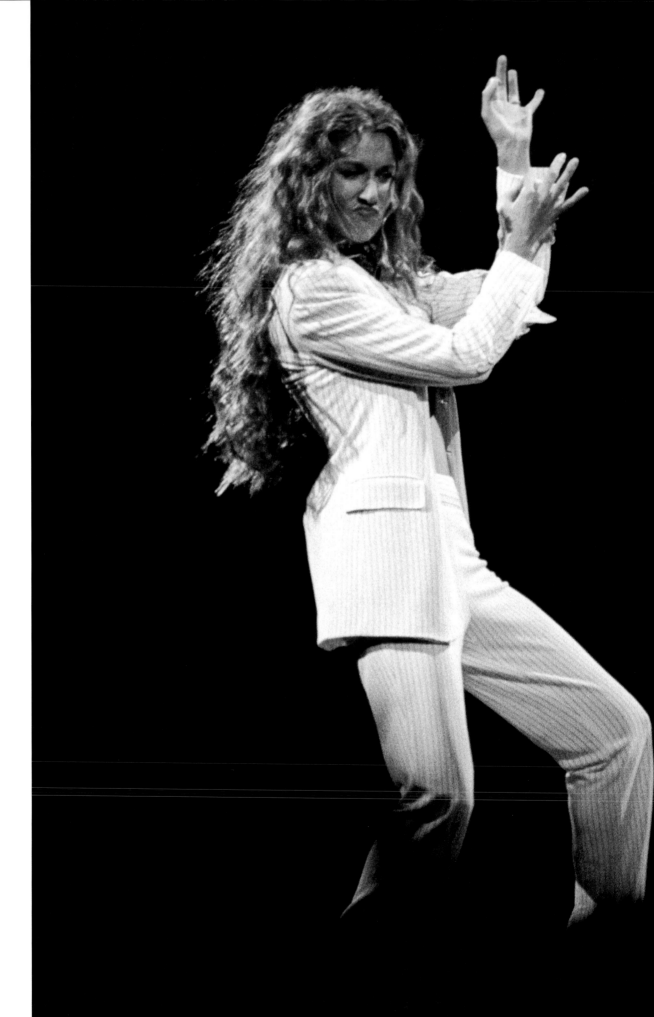

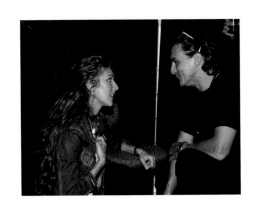

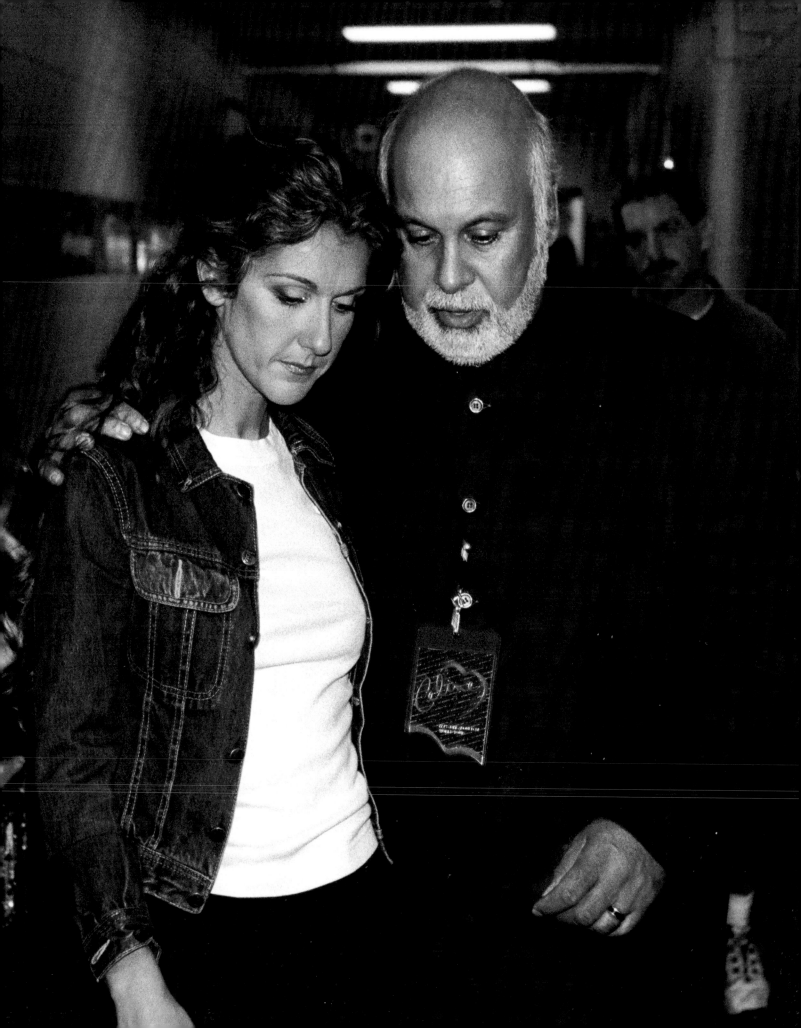

 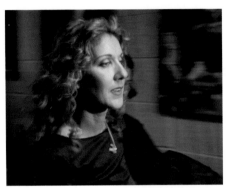

"When René hit his head and fell while getting off the plane, there was more fear than harm done. Everyone breathed a sigh of relief and I was glad to have been able to capture that moment."

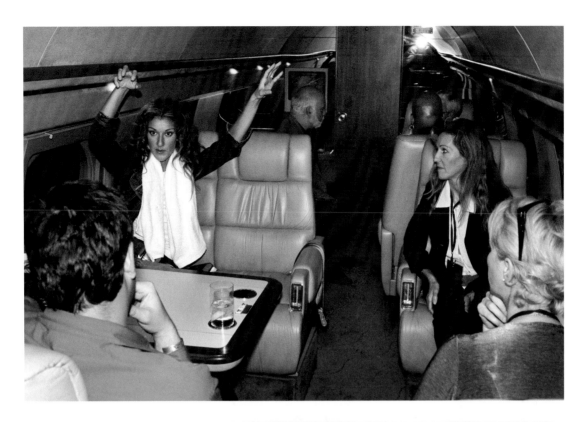

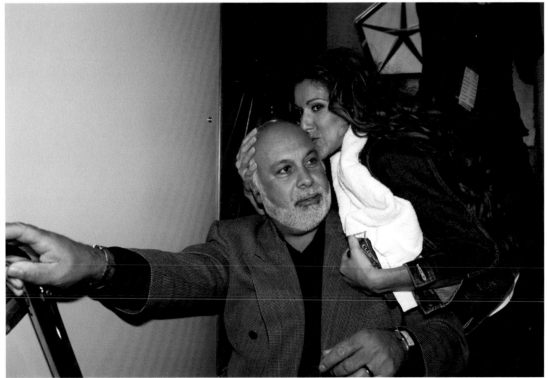

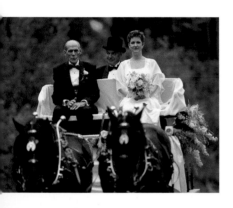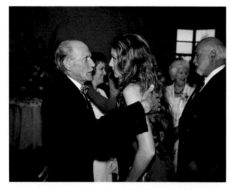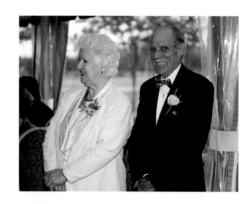

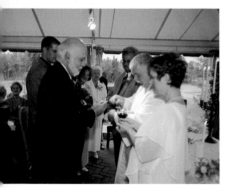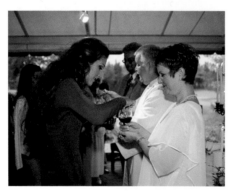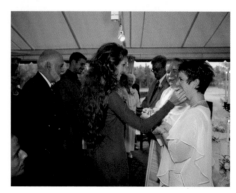

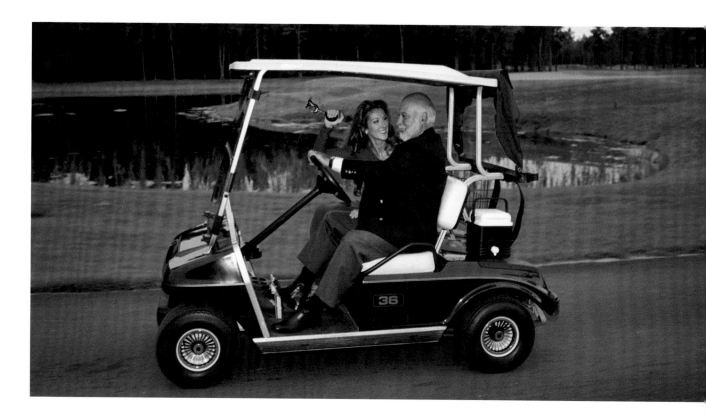

Less than 24 hours later, we were at Le Mirage for the wedding of Céline's sister Linda and Alain. Linda arrived with her father, Adhémar, in a horse-drawn carriage. The gentle rhythm of the horses' hooves plunged us into a totally different atmosphere than the previous night's hectic jet flight. I love shooting happy occasions, and there were many in the Dion family. Céline enjoys fooling around and acting the clown. She is a live wire, always full of energy. She also has eyes in the back of her head, which makes it hard to take a spontaneous photo of her. When she's with friends and family, it's as if she is reliving good times in the family kitchen in Charlemagne. She becomes the youngest of 14 children again.

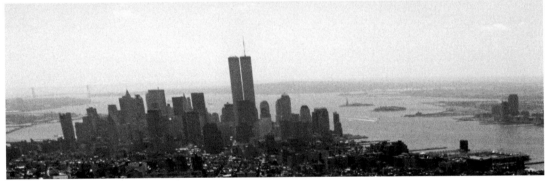

"*Over time, some photos take on a whole other dimension. Today, the shape of this skyline makes me think of two tragedies: the* Titanic *that Céline sang about and the World Trade Center.*"

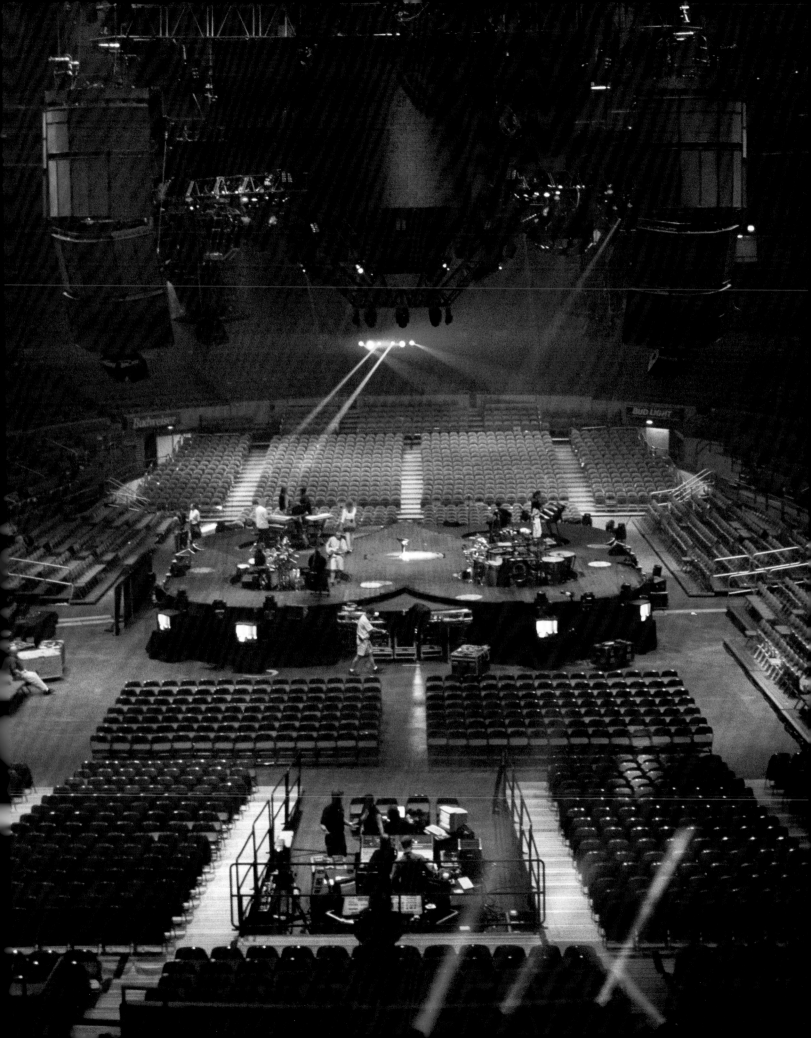

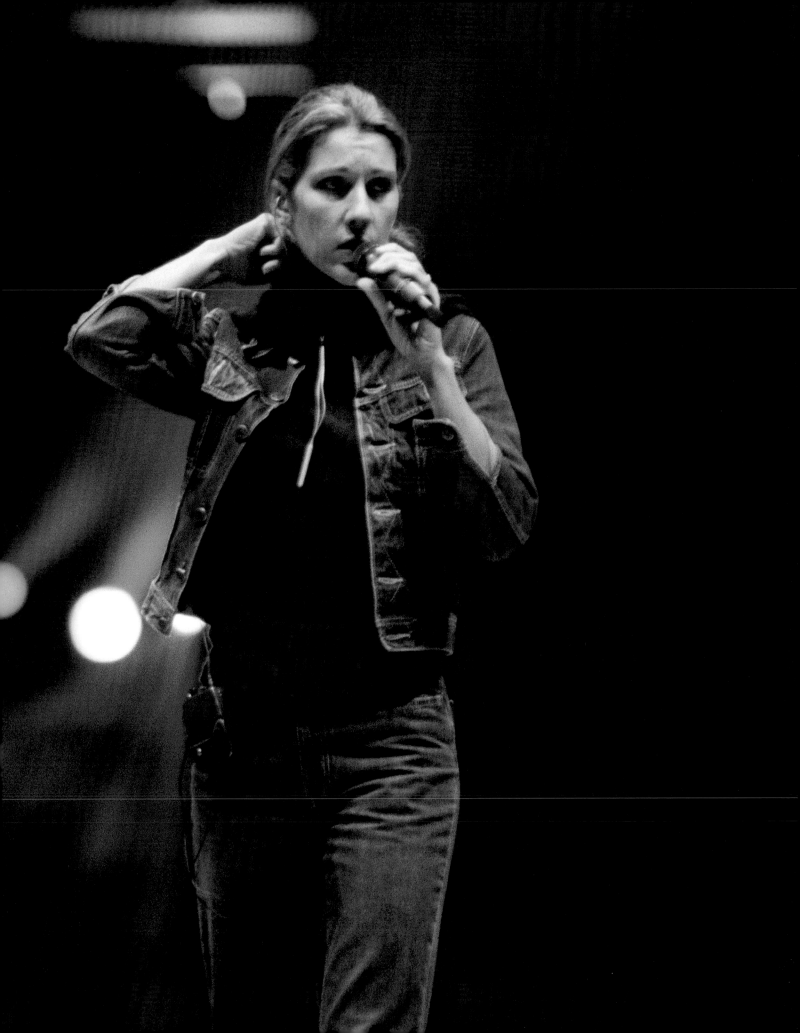

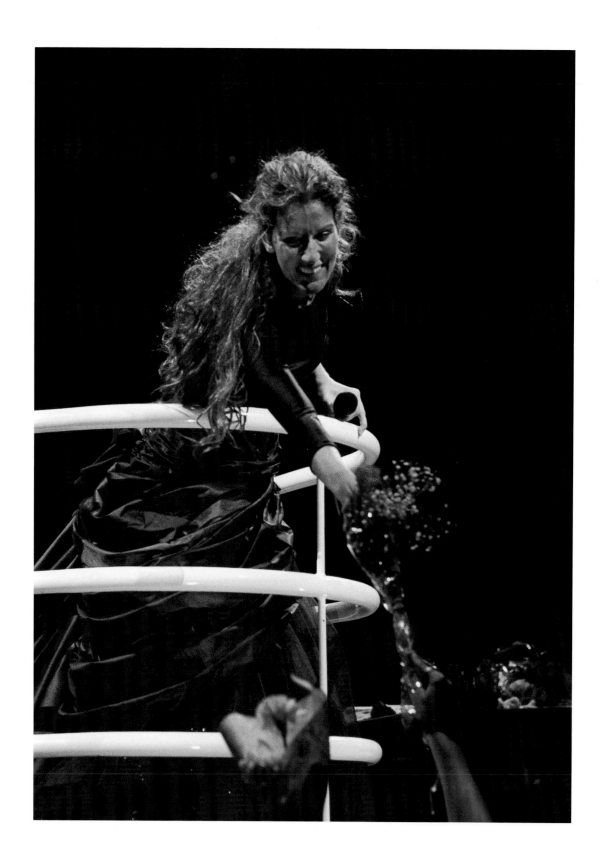

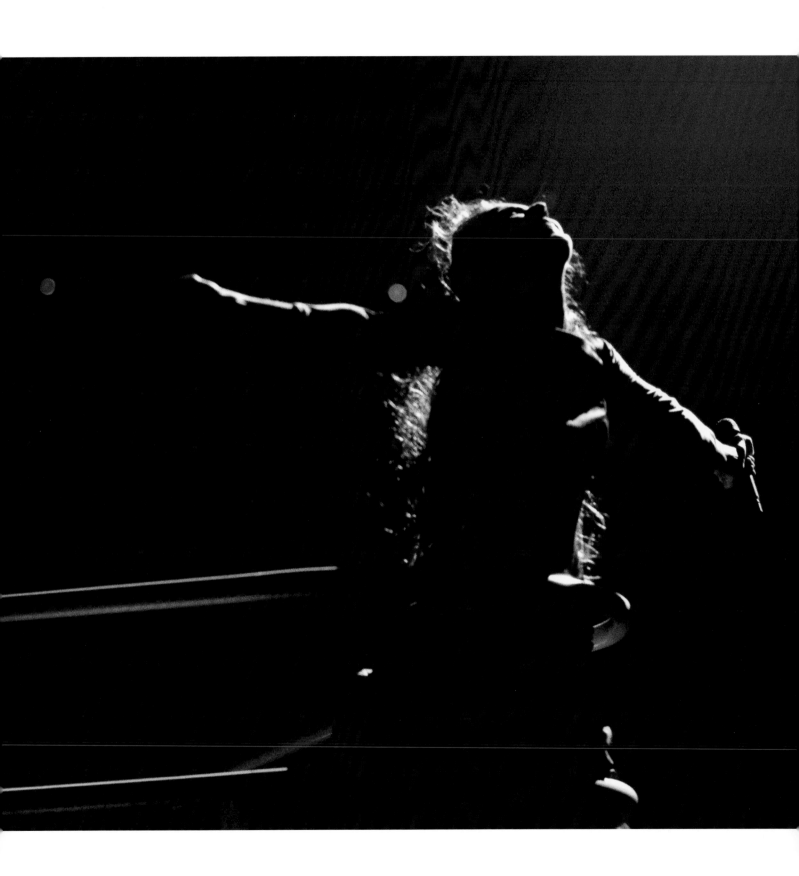

Upon arriving in New York, where Céline was giving an evening performance of *Let's Talk About Love*, I asked the limo driver to make a quick stop at the hotel before heading to Madison Square Garden. Some of my equipment, including my heavier lenses, had travelled to the Big Apple with the show's technical crew. Considering the heavy traffic, the driver was none too pleased and gave me a sour look. He barely had time to double-park in front of the hotel where Céline was staying, when I saw Pierre Lacroix waiting at the entrance with my kit. The general manager of the Colorado Avalanche is a good friend of René and the father of Martin Lacroix, the tour's director. They both knew that I didn't have a minute to lose and, thanks to them, I was on time for the show — one more example of the efficiency of Céline and René's team. Nothing is ever left to chance. The timing of the show had sped up since Boston and I got there just in time. The evening ended with a performance of "My Heart Will Go On," the theme song from the movie *Titanic*. I like the song, which requires great vocal control, rising from a whisper, almost a murmur on a breath of air, to a crescendo. Céline was triumphant.

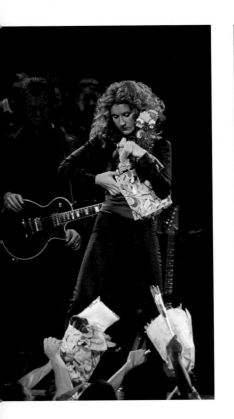

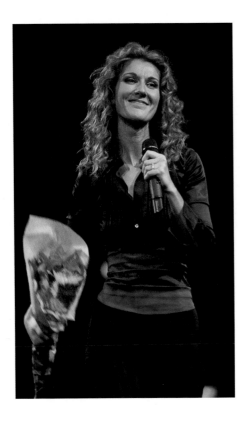

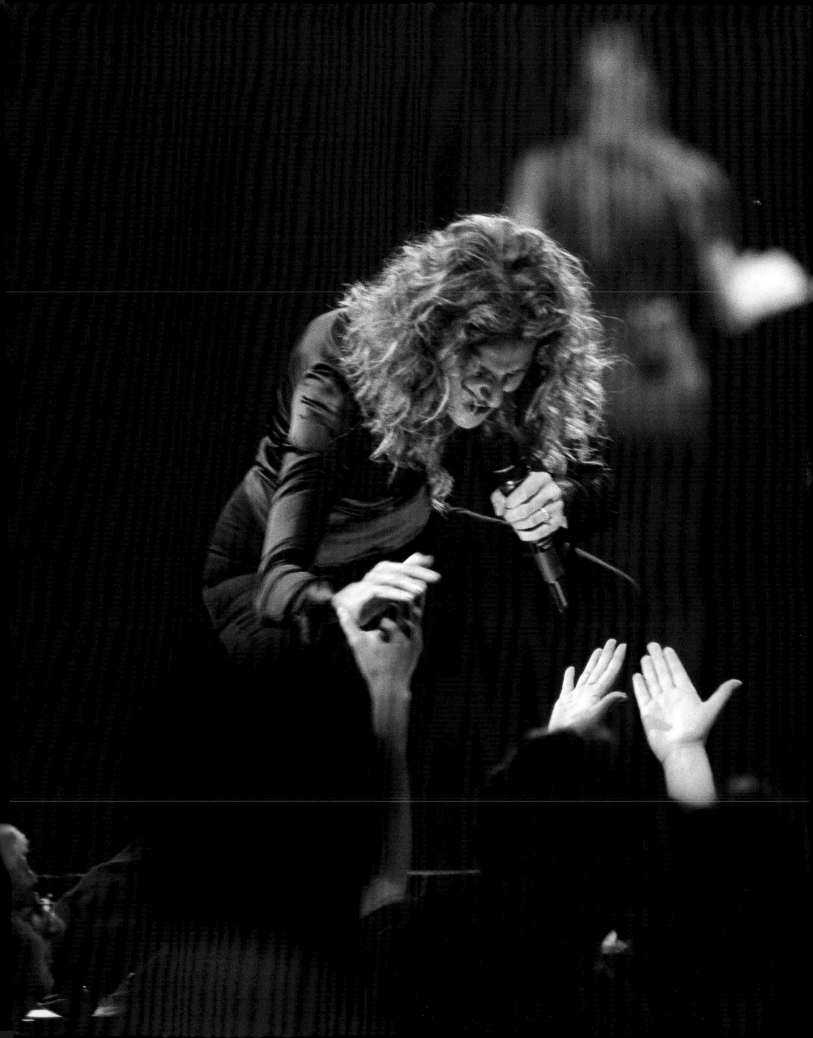

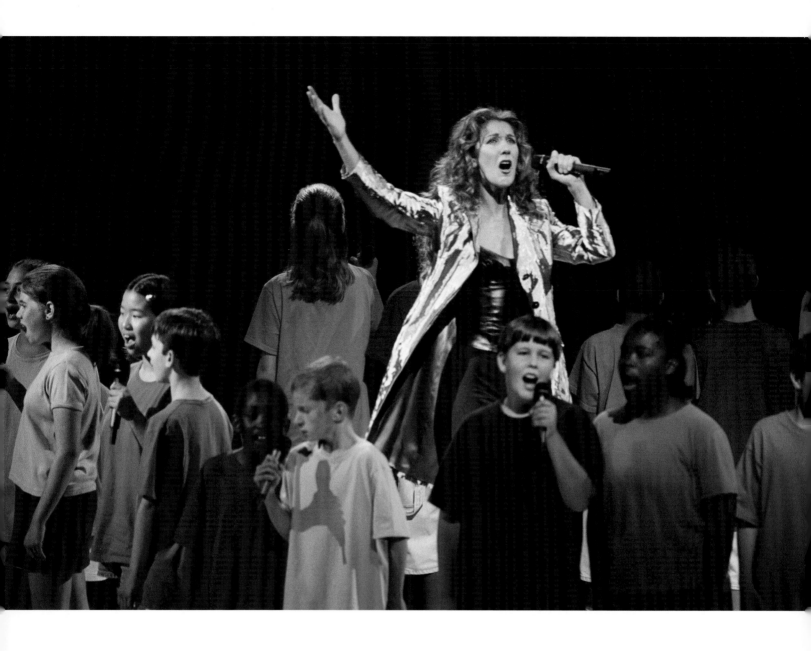

"I love photographing Céline a fraction of a second before a song ends."

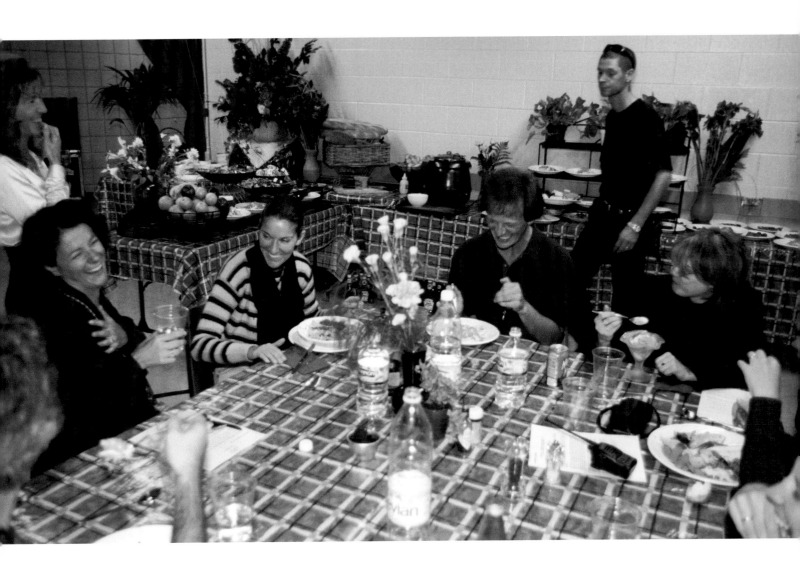

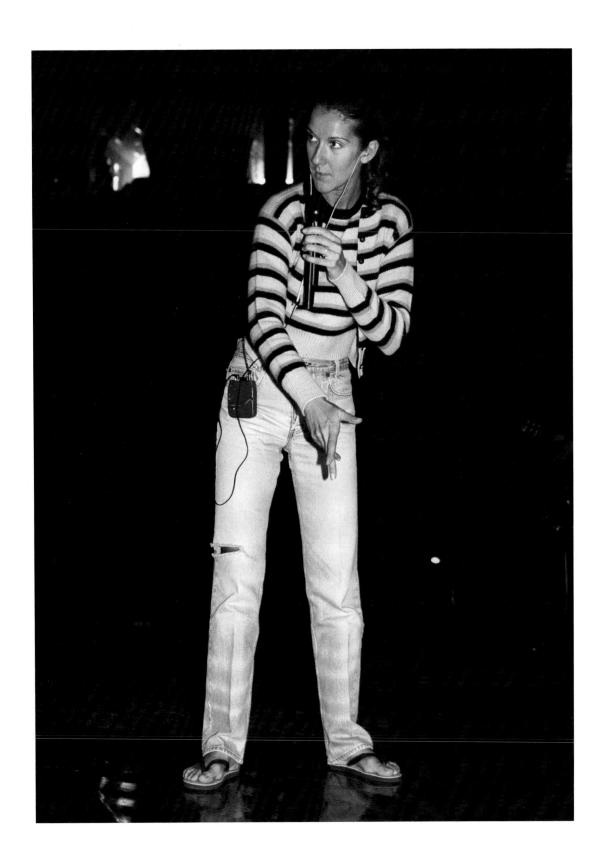

On that September 3rd, with success shining down on me, I recalled the last time I had been in New York, when I was 20 and just back from Barbados with only $3 to my name. I had to ask my father to buy me a bus ticket to Montreal. He had sent an extra $20 for food. I spent it on beer instead.

Now I had been sober for nine years and was working for the woman whose photo was on posters all around this show-business town. I had found my dignity thanks to Céline and René. The fact that they were both clean and had never done drugs meant a lot to me and gave me hope. I knew how lucky I was.

LET'S TALK ABOUT LOVE TOUR, 1998 **117**

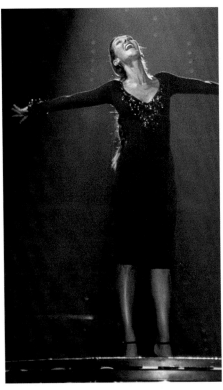

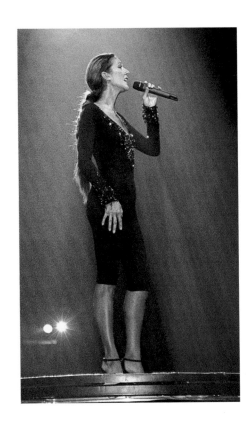

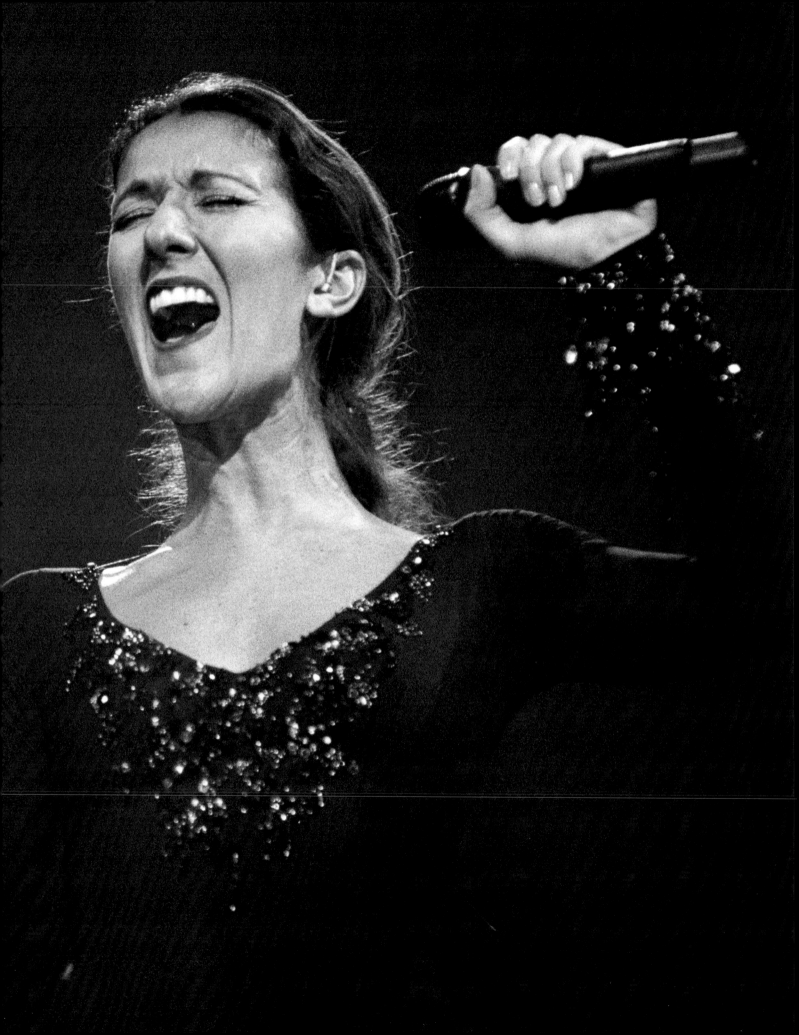

"I want a photo of Céline taken from behind, so you can see Maurice Richard's name and his number 9."

René, the boss, had just given me my instructions. The *Let's Talk About Love* tour was at the Molson Centre for a five-show run in Montreal, the birthplace of Céline's career. It was in this city that her first fans had believed in her. The whole team felt as if they had come home.

On that December night in 1998, a living legend was in the audience: Montreal Canadiens' Maurice Richard, considered by some to be the best hockey player of all time. This was *the* player who had excelled at the sport and made Quebecers proud of being francophone in an English-speaking world. He was not only universally liked; he was loved by everyone.

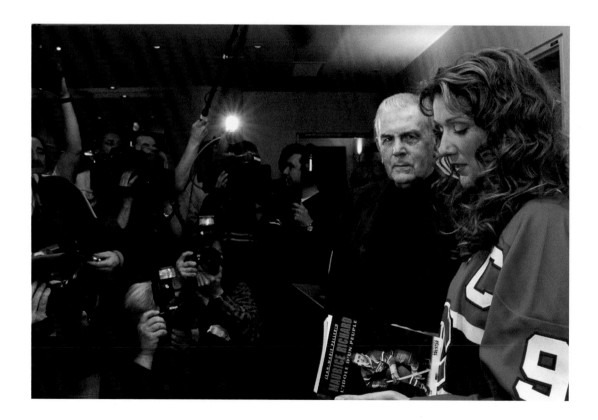

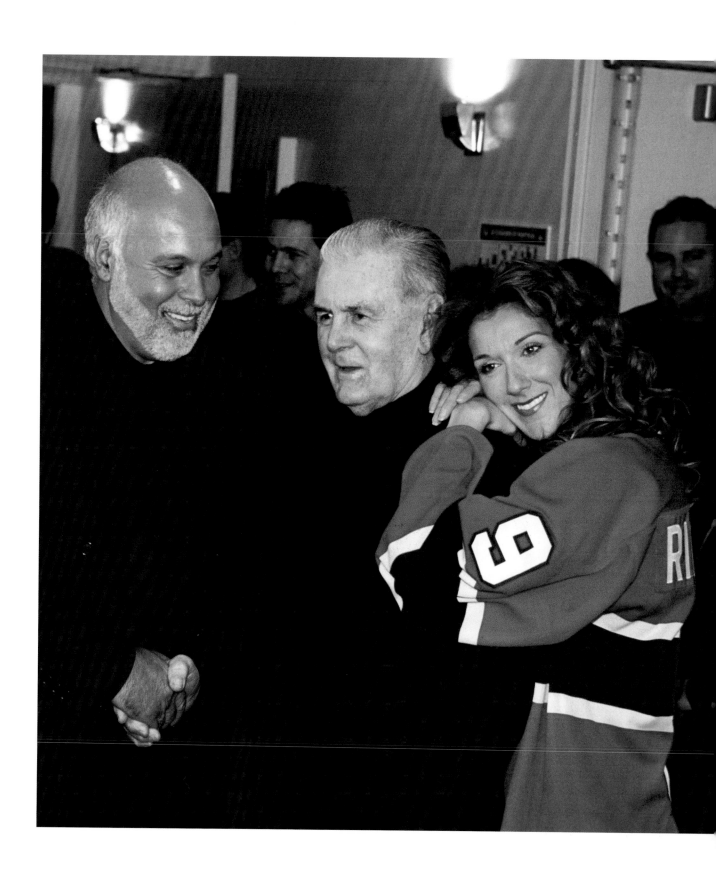

Céline walked onstage wearing a Maurice Richard jersey, a gesture rich in meaning. Like Céline, Maurice had grown up in very modest circumstances and achieved fame and success through discipline and determination. They were cut from the same cloth.

When Céline appeared onstage, the audience went wild. They gave her a standing ovation reminiscent of the ones Maurice used to get when he scored a goal.

I was positioned behind Céline, with my two Nikon cameras. The atmosphere was highly charged. My eye was glued to the viewfinder and I was surprised at what I was seeing. Céline lifted her arms and the audience went into ecstasy. The whole scene seemed surreal. Suddenly a spotlight illuminated a box seat above the stage and there was Maurice. The two mythical stars waved at each other . . . and the distance between them disappeared. Click! I got the dream shot. It was an unforgettably magical moment. That photo was carried on all the newswires, with the boss's approval.

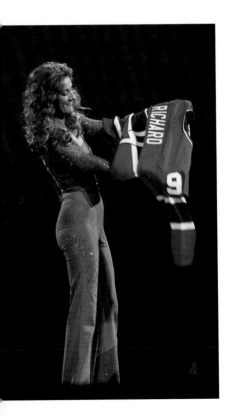
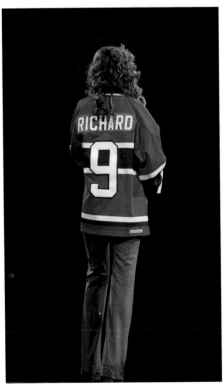
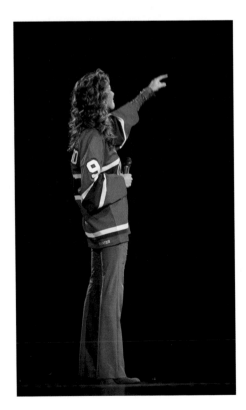

212

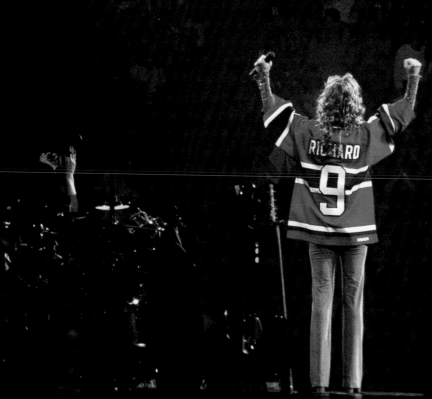

"When I showed the photo on the previous page to Céline, she signed it and wrote, 'Thank you, Laurent, for having captured that magical moment.'"

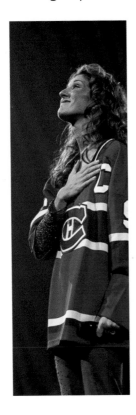 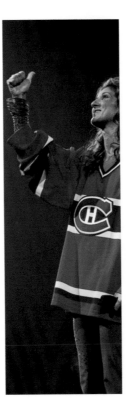 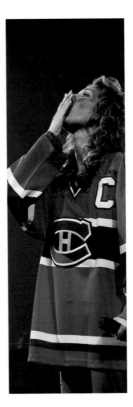 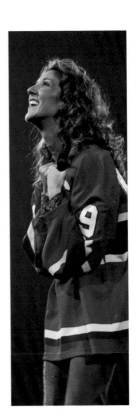

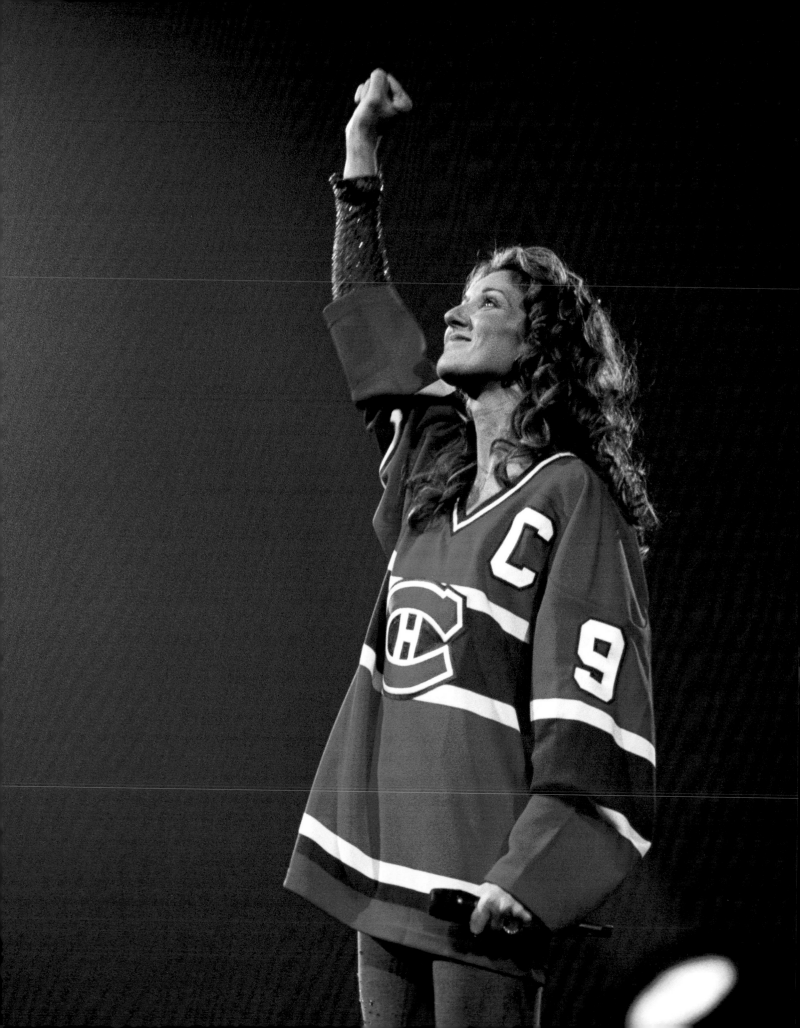

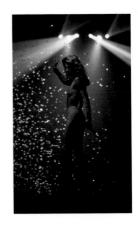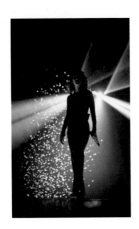

That same night, I took an uncharacteristic shot of Céline. In it, she was standing under falling snowflakes, striking a proud pose, her silhouette impeccable. The play of light and shadows melded perfectly, capturing the emotion that filled her just before she went onstage. A ray of light on her forehead revealed an expression that betrayed her strength, in a dreamlike halo. Mia Dumont, who has shared Céline and René's professional and personal life since the start of Céline's career and was the tour program planner, chose that photo for the poster. Mia has a keen eye for artistic detail and has always supported my work on the many events that she organizes for them.

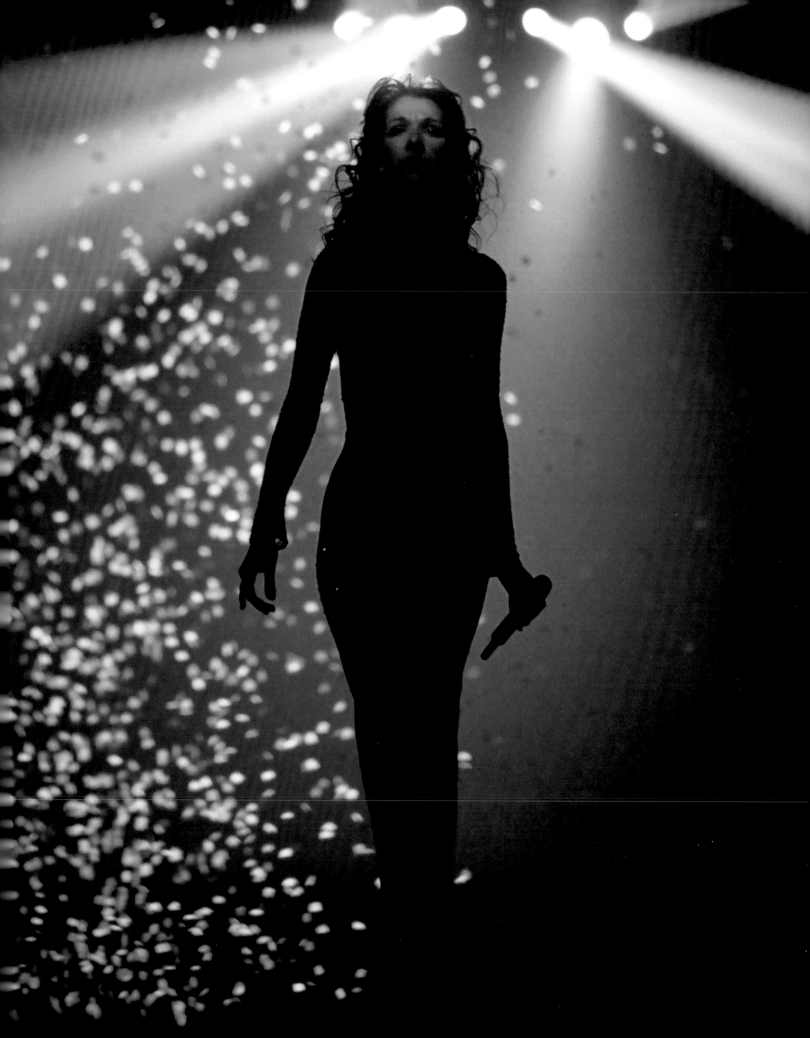

There were many perks to being part of Céline and René's team; we were always treated royally. They never passed up an opportunity to tell us how grateful they were for our work. A few days before Christmas, they rented the Molson Centre rink. That afternoon, we played a hockey game, each of us wearing a jersey with our name on it. René was captain of the blue team and Céline's brother Michel was captain of the white team. Céline joined in the fun with the cheerleaders. The puck was dropped by none other than . . . Maurice Richard! Later in the evening, they held a casino night, with prizes that took our breath away.

That is just one example of how Céline and René treat their 100 or so employees, all of whom feel as if they are truly friends of the couple.

My first Christmas at Le Mirage was a dazzling affair. The entire extended Dion family — cousins, uncles, aunts — was there. More than 200 people!

The decor on the walls and tables was amazing.

There were lots of games and even a nine-hole golf course set up in the snow, which Céline couldn't resist. Inside, the lights sparkled and the tree evoked images of Christmas trees in children's tales. For the little ones, there were pyramids of candy and gifts, Santa and the Sugar Plum Fairy. It was a beautiful month of December and a great year for me.

The greatest gift of all was that I would be spending many more Christmases with them, until December 17, 2006 . . . Each time, Céline went out of her way to greet me and make me feel welcome and part of the family.

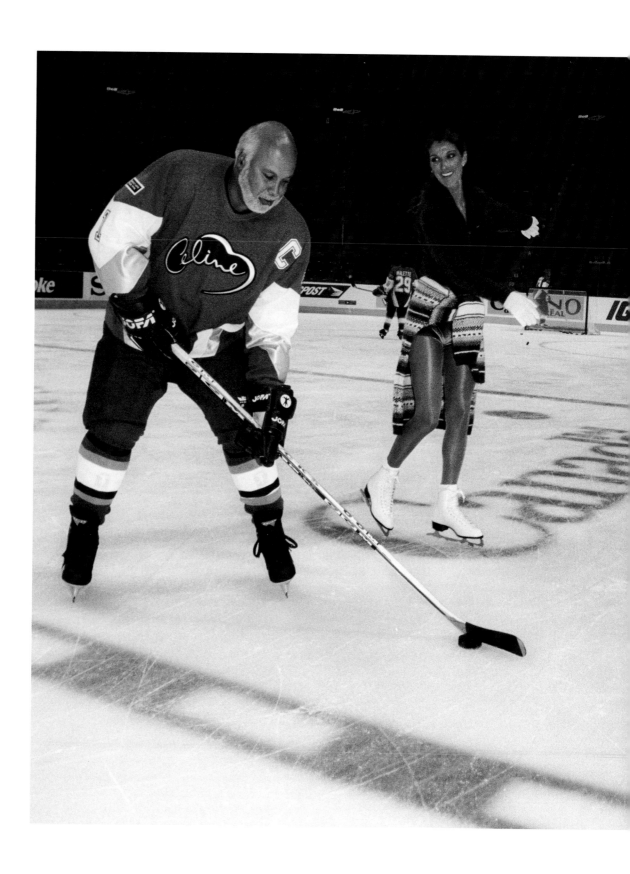

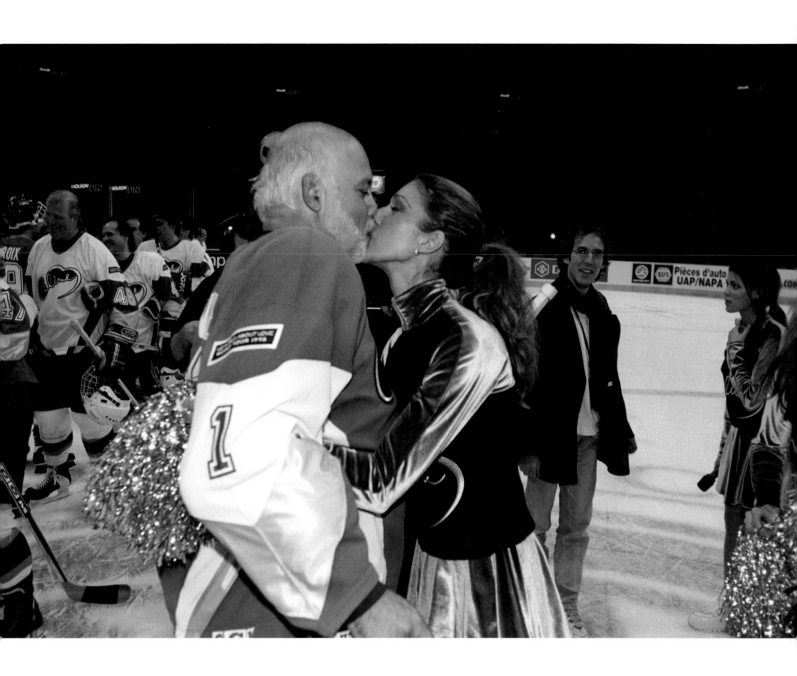

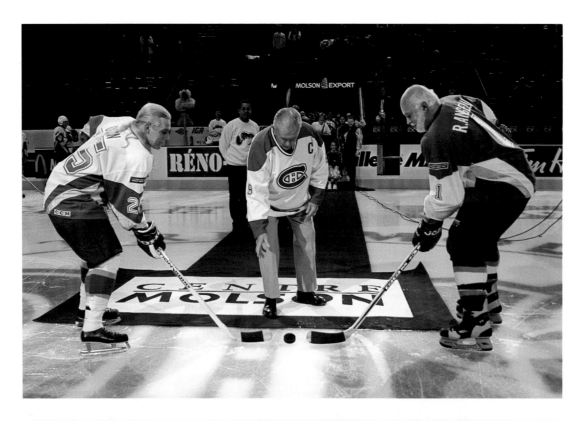

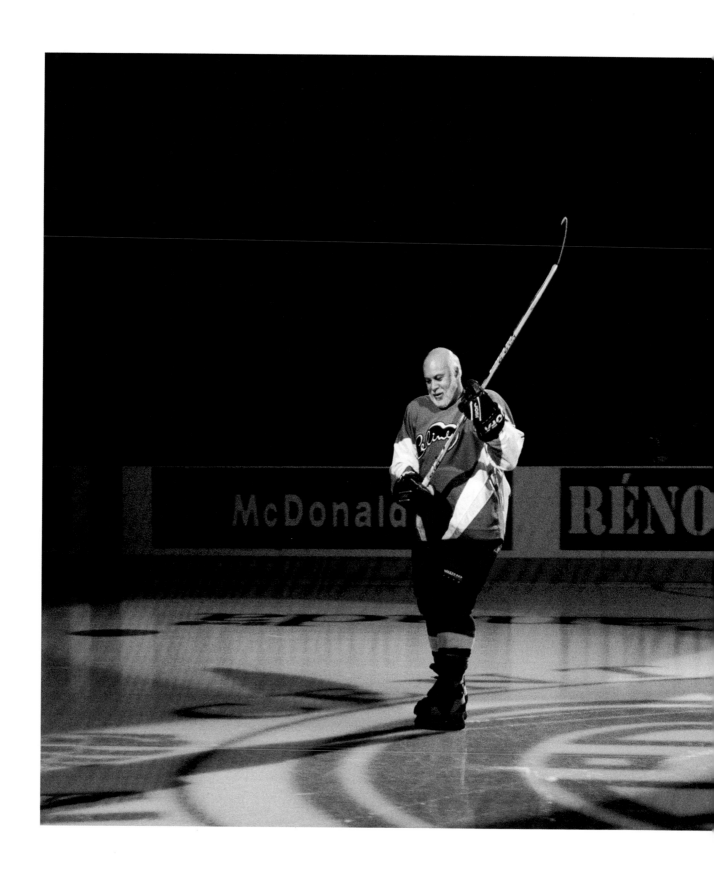

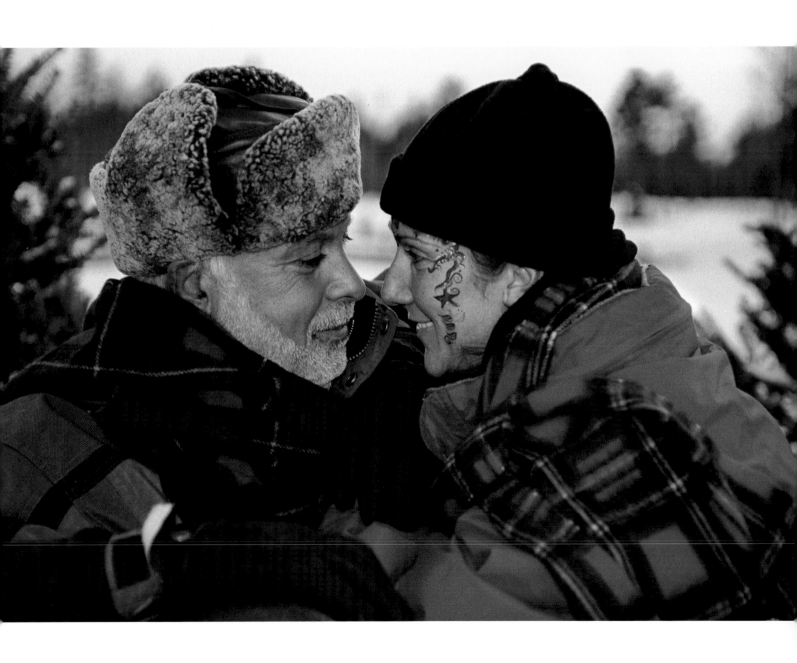

If 1998 was an exceptional year, 1999 brought a stroke of bad luck. The news came in the middle of the *Let's Talk About Love* tour, which was travelling through the U.S. before heading to Europe. On March 30, Céline's 31st birthday, René was hospitalized in Dallas. The diagnosis: throat cancer. My services had not been required for that part of the tour. I felt bad that I was so far away at that terrible time. I tried to find out as much as I could. I learned that some shows had been postponed. At René's insistence, Céline continued the tour, performing at the Stade de France in Paris as scheduled. There on June 19 and 20, in front of more than 180,000 fans, Céline sang for the man she loved as he watched via satellite. Watching from home, I was moved to tears by so much love.

I was pleased to see René again when the tour returned to Montreal in September. We were backstage and one of the VIP guests that night was Guy Laliberté, the founder of Cirque du Soleil and a childhood friend of mine from Saint-Bruno. It was great to see him after more than 20 years, so many memories bubbled to the surface. Here he was, a successful businessman, and it made me think about how beautiful life is.

As I watched René and Guy talk, I felt the energy between them. Both men exuded a certain magnetism. Upon learning that René and Céline were planning to renew their vows in Las Vegas on January 5, Guy spontaneously offered each of the guests attending the anniversary celebrations tickets to Cirque du Soleil's *O*. More than 300 special guests joined the audience at the Bellagio theatre on January 4, 2000.

I couldn't help noticing the similarities of character that René and Guy shared, generosity foremost among them.

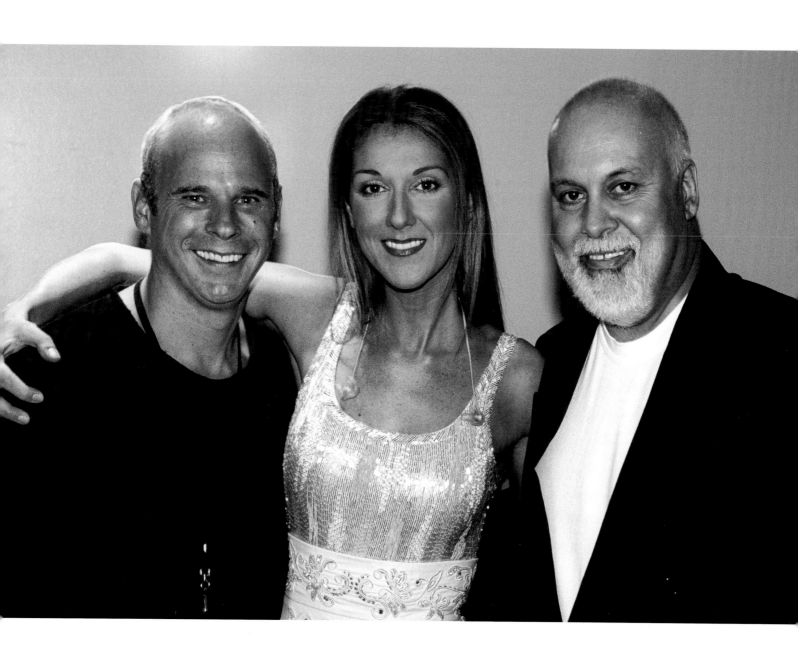

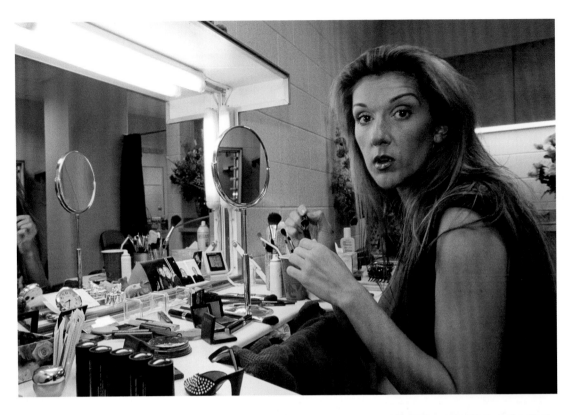

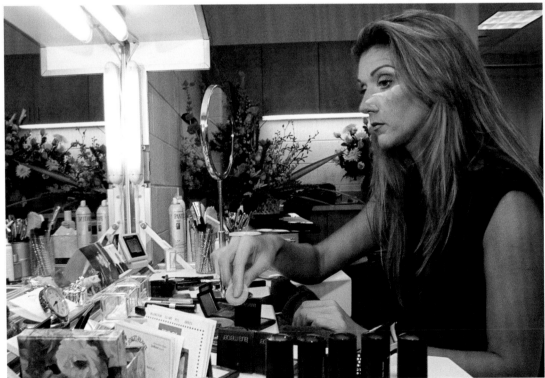

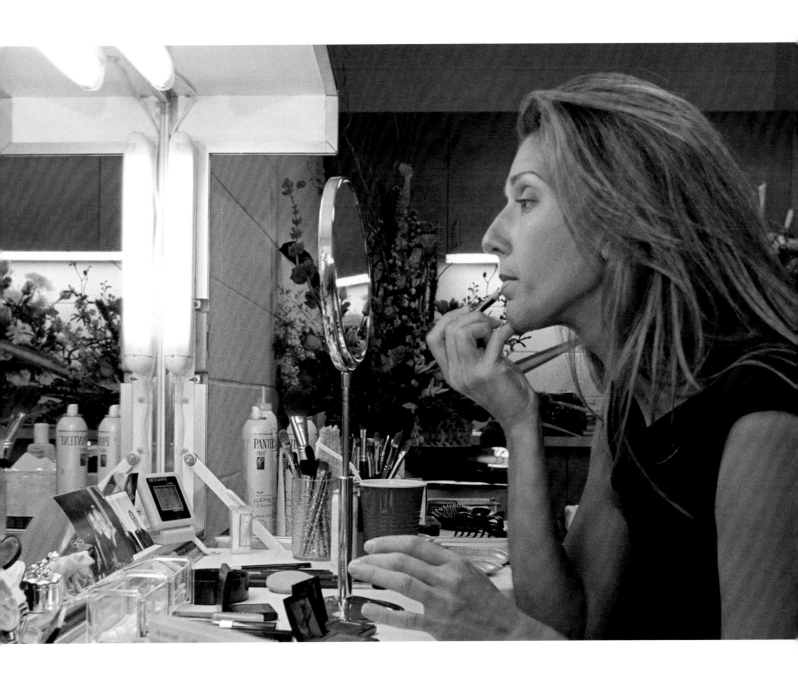

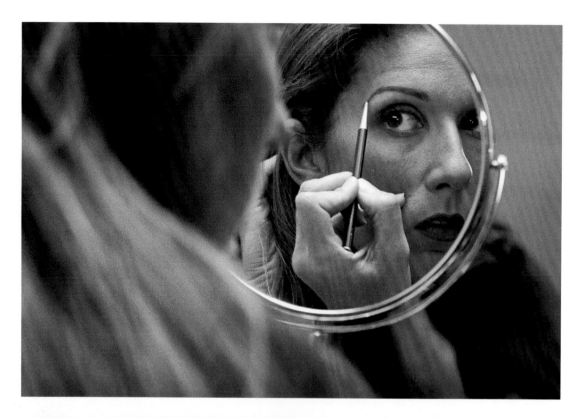

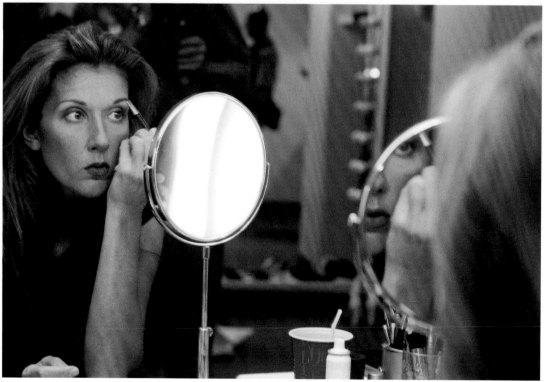

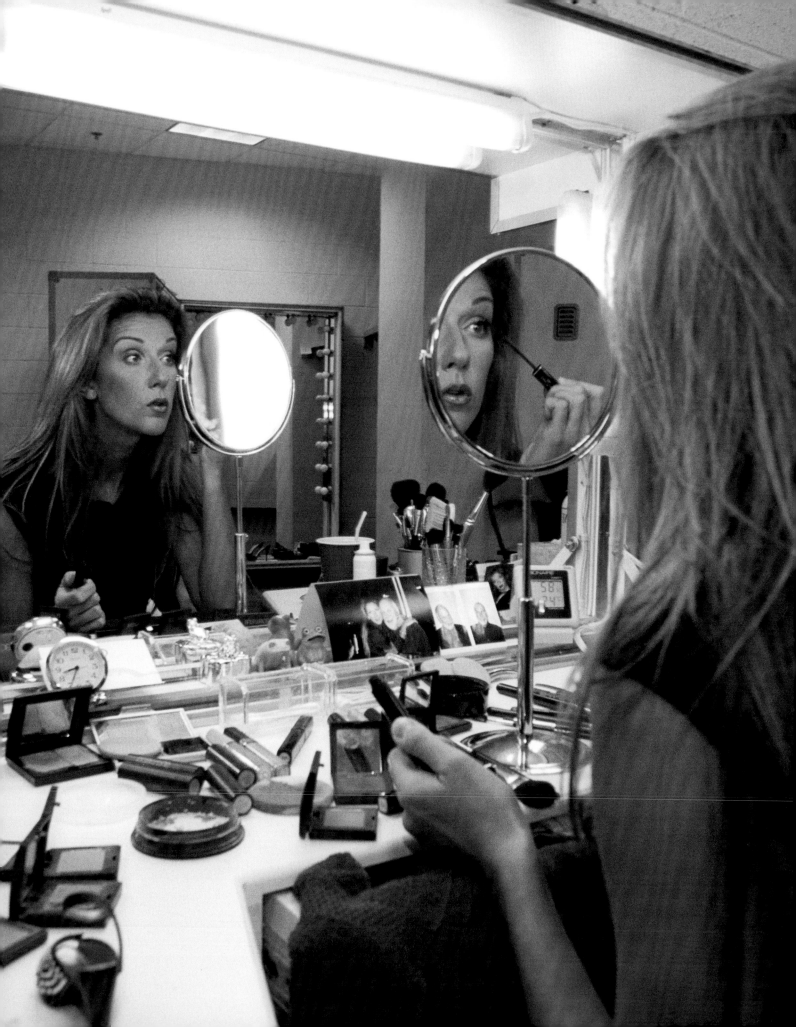

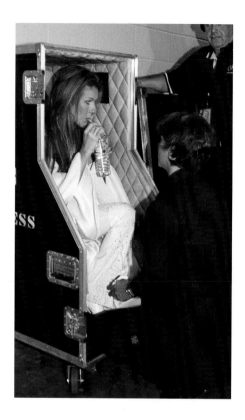

On November 5, I boarded a plane for Fort Lauderdale, the site of the last performance of the *Let's Talk About Love* tour. There was sadness in the air. A chapter was ending for all of us. For more than a year, the members of the team had shared often exhilarating, and sometimes difficult, moments. Bonds had been forged. Now no one knew when the next tour would be. Each person had to return to their private life, deprived of the adrenalin that had become second nature.

Céline was in her dressing room, applying her own makeup as usual. She appeared calm. Her good luck charms were spread out on the makeup table in front of her: photos, keepsakes from fans, a thermometer, a hygrometer, a clock, and an assortment of beauty products. A list of about 20 songs — a new set that she had to memorize — was taped to the mirror. During a tour, the order of the songs changes, and some are removed and replaced by others. That night was no exception.

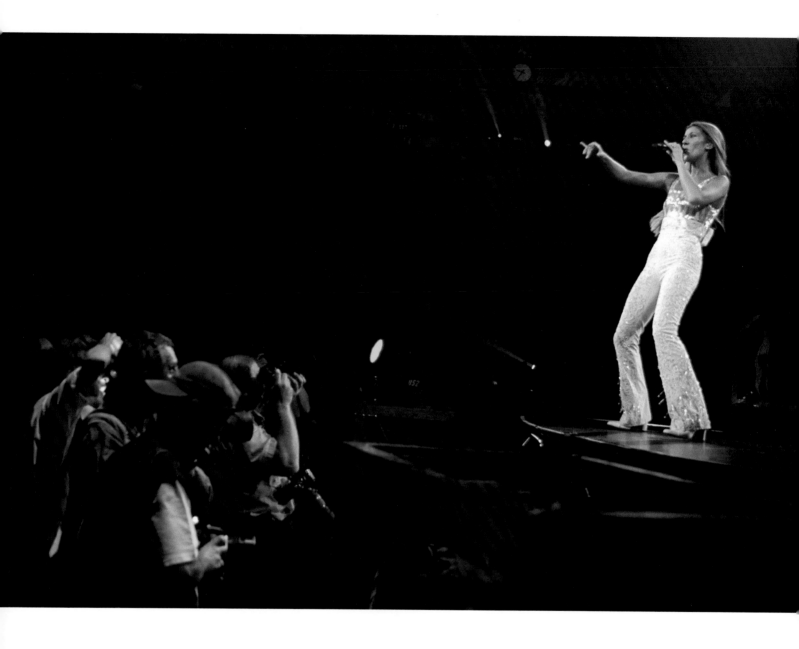

144

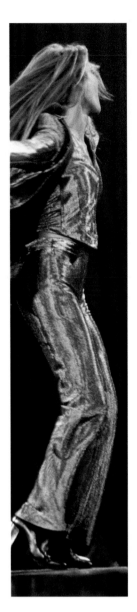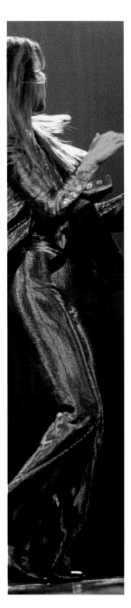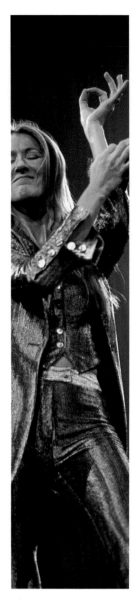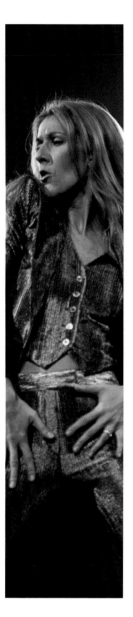

Céline prepared for this last show as if it were the first. There was a rehearsal in the afternoon and a few final adjustments. This was *the* show that would bring to a beautiful end the tour of 100 sold-out performances in North America, Europe, and Asia. More than 28 million albums were sold around the world. It was a success from start to finish!

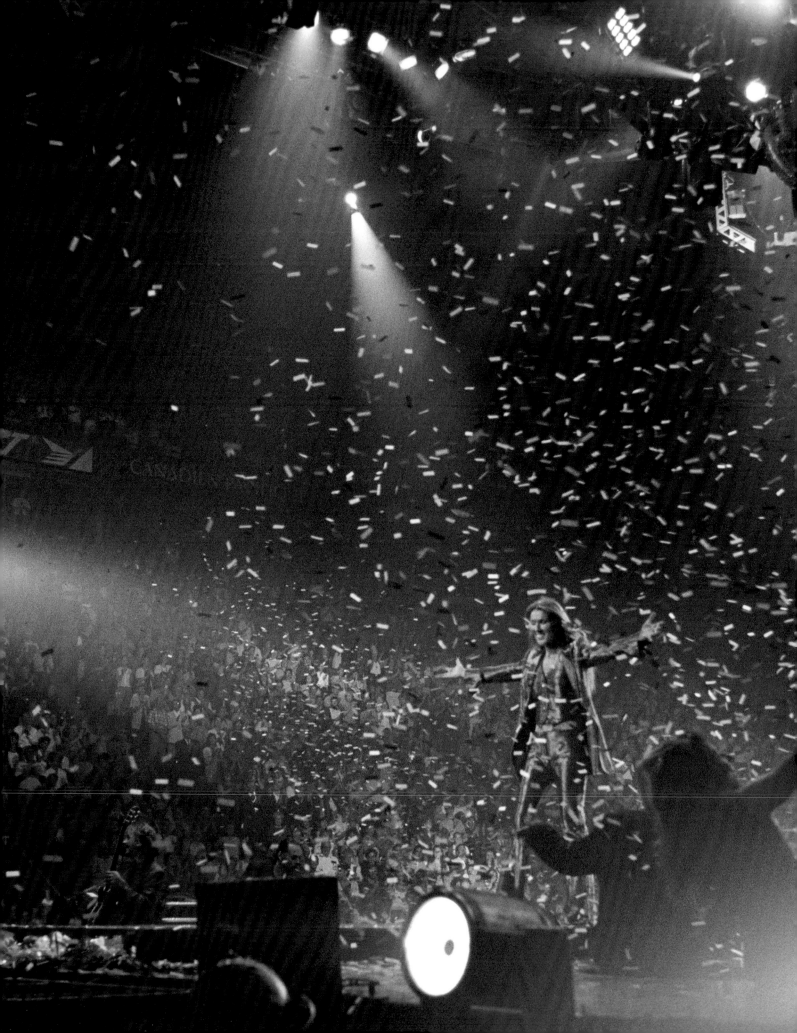

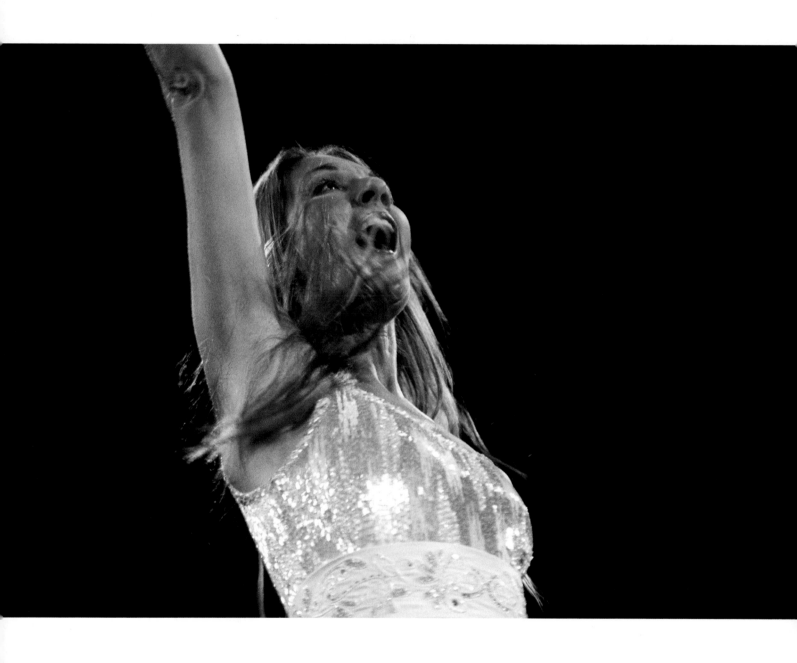

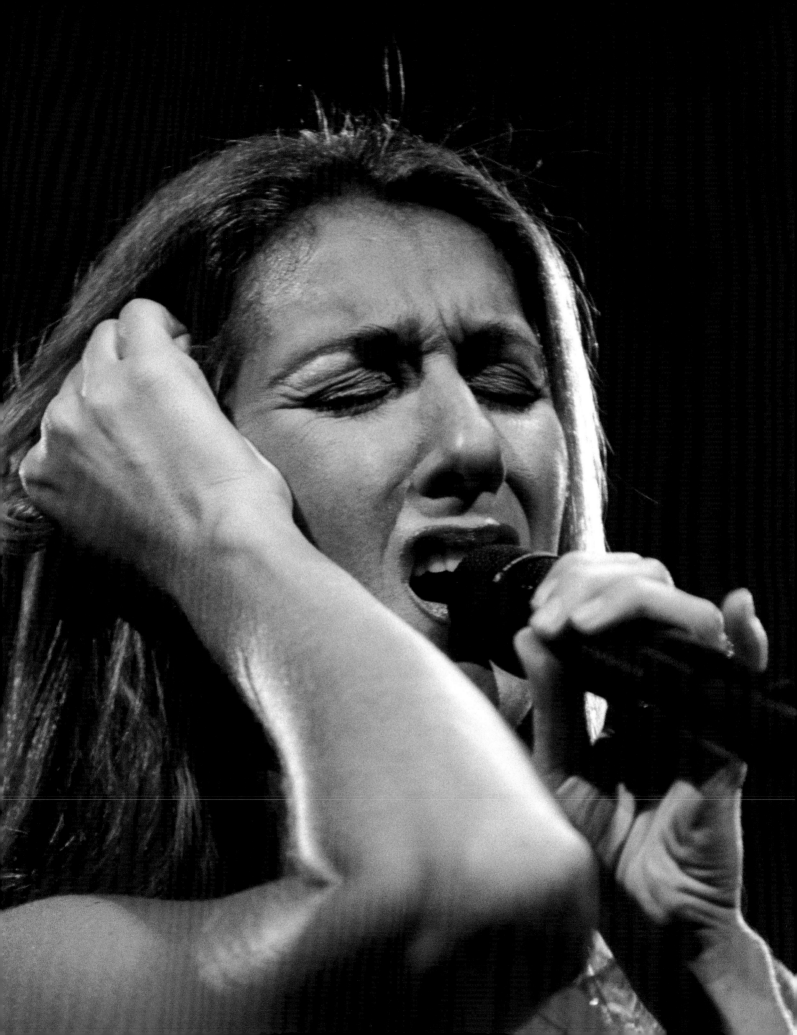

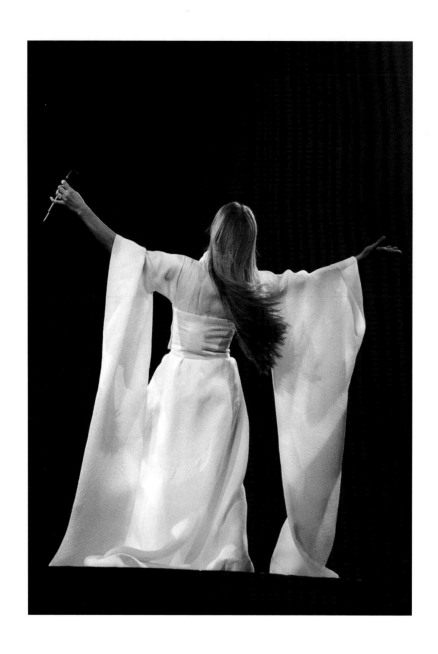

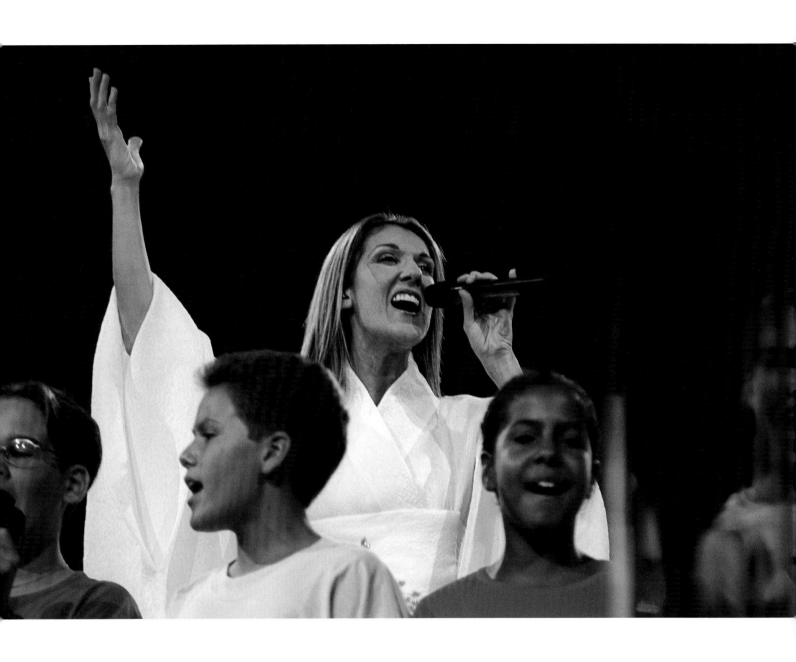

"I didn't like this shot 12 years ago. Now, I love feeling its energy, its passion."

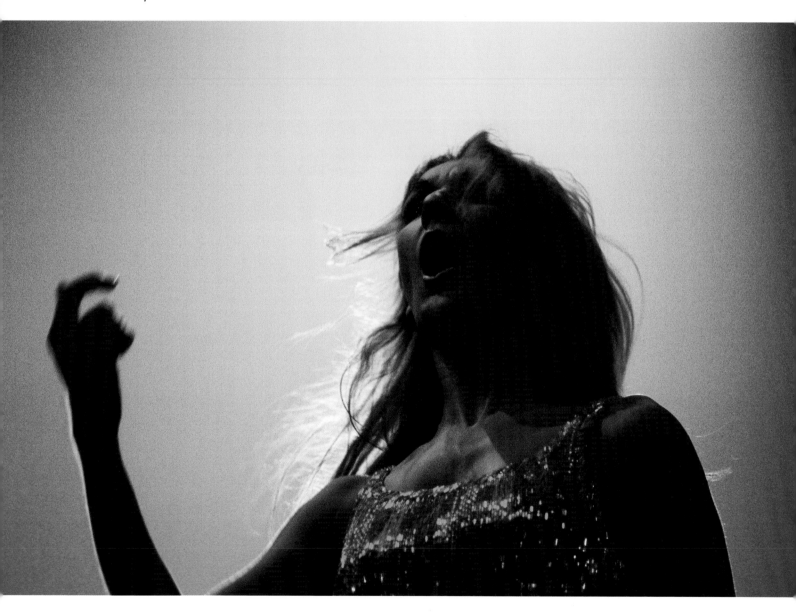

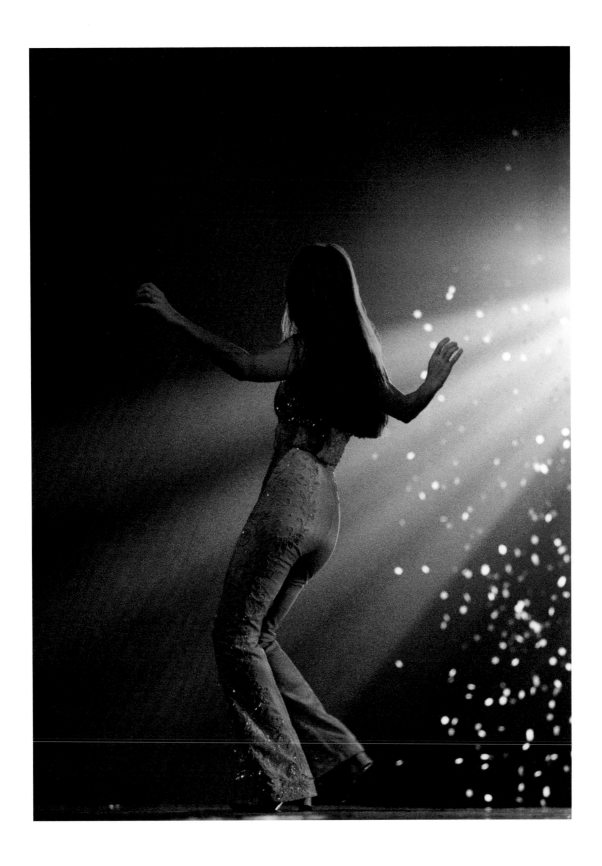

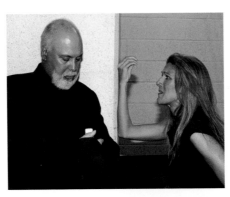
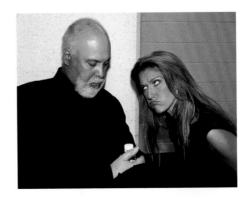

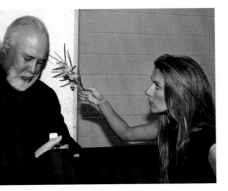
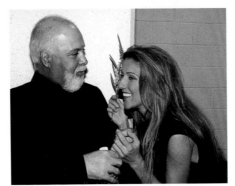
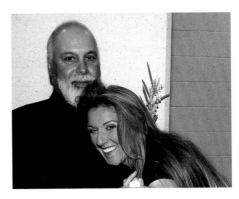

"Céline has fun showing off while René sleeps."

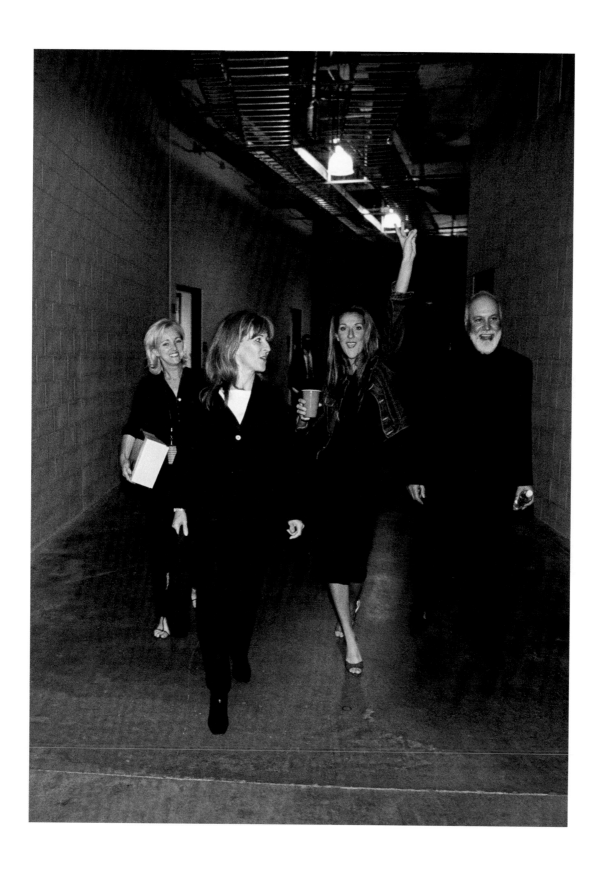

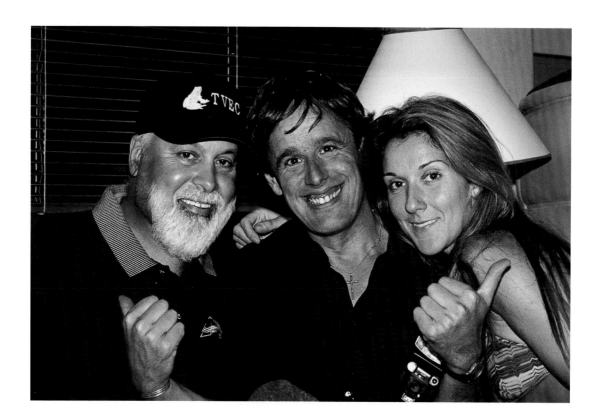

Two days later, we were all invited to Céline and René's Florida home to celebrate the end of a legendary tour. The reception was a great success, with a gigantic buffet and stunning decor. Everyone had fun. Team members shared anecdotes and exchanged memories of the tour. Céline and René managed to talk to every one of the 100 or so guests in the room. They slow danced. Céline clowned around, René laughed heartily. I even managed to get a shot of Céline with a cigar in her mouth. It was starting to feel like holidays. I came up with the idea of photographing each member of the tour with Céline and René aboard their yacht, named TVEC after one of René's favourite expressions, "*Tout va être correct*" (everything will be all right). The guests took their turns on the boat and I photographed them flanked by Céline and René. I got my picture taken, too. Finally, I had a souvenir photo of the three of us together.

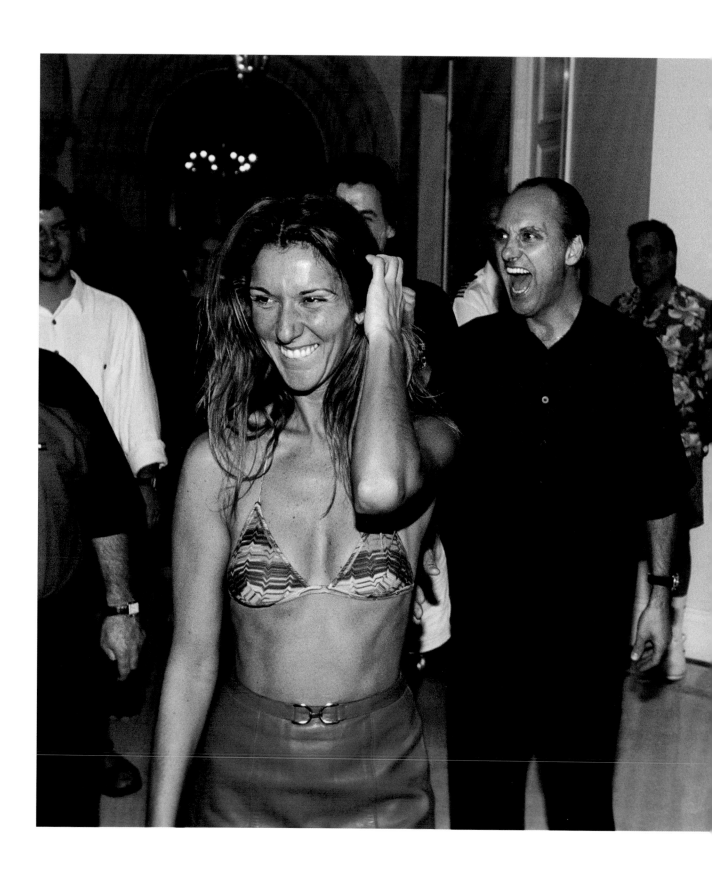

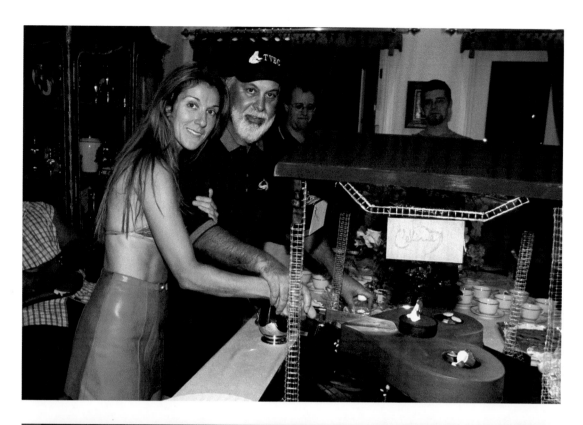

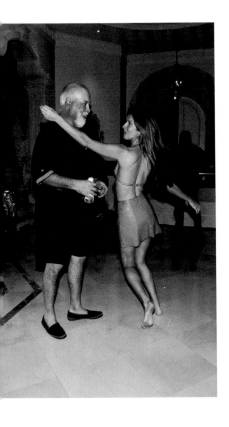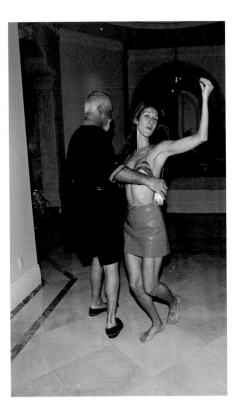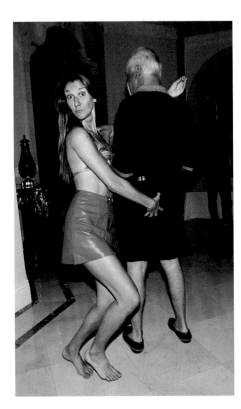

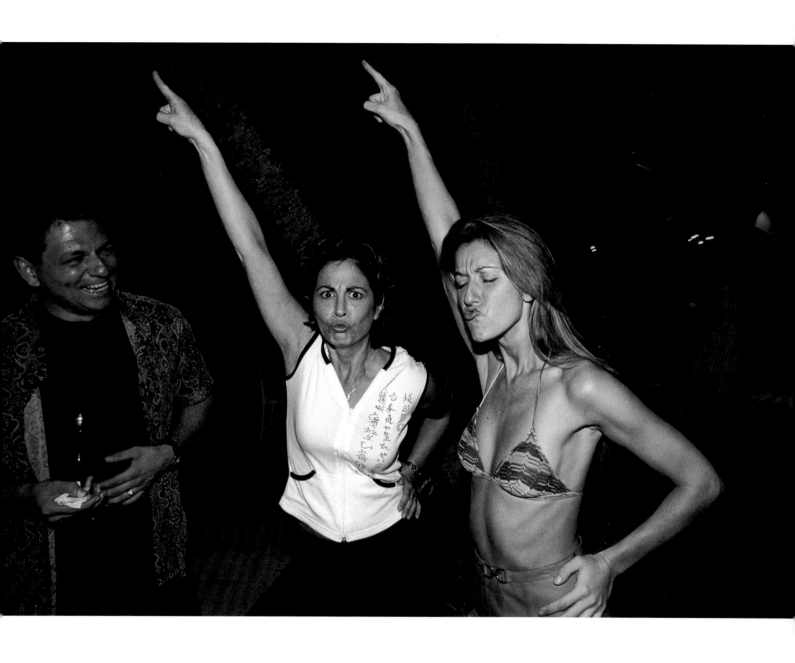

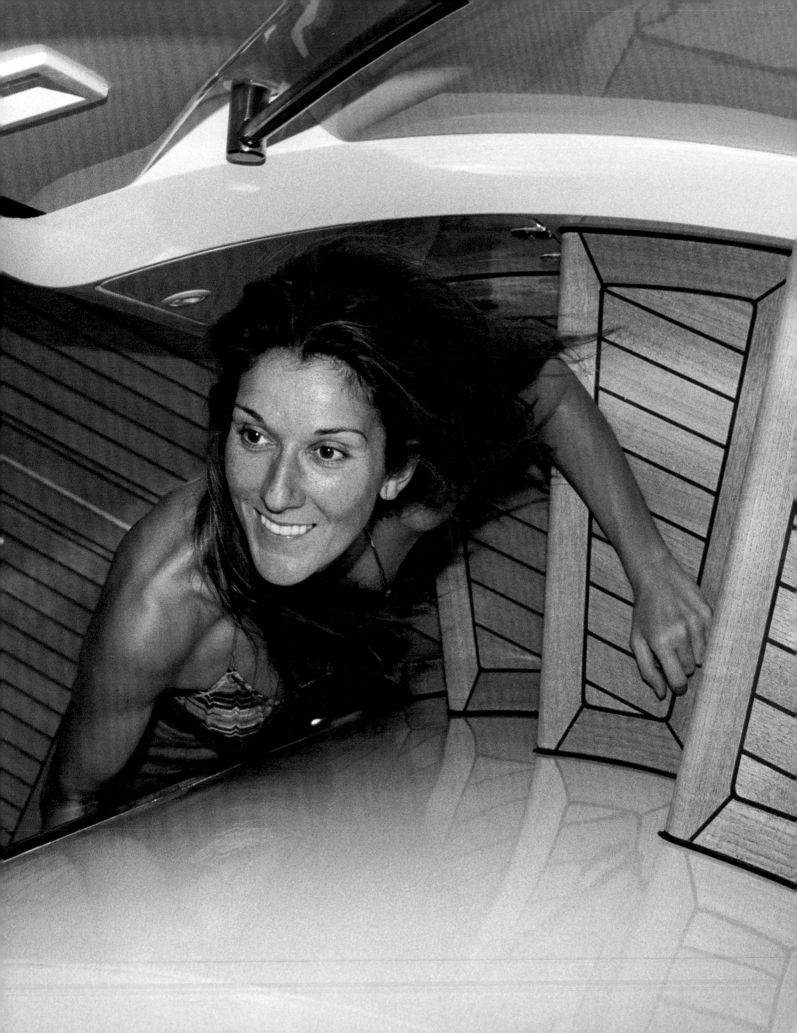

The year ended with a fabulous concert organized to celebrate the new millennium. The once-in-a-lifetime show took place at the Molson Centre in Montreal, which was filled to capacity. On the night of December 31, 1999, all Céline and René's family, friends, and thousands of fans shared this unique moment. The concert was also broadcast live on TVA, a private television network. It's fair to say that all of Quebec was there too.

The concert was special for several reasons. All kinds of rumours were swirling around the arrival of the new millennium. If no one seriously thought the world was ending, there was a feeling of unease nevertheless. We all knew, of course, that we were coming to the close of a century, and everyone was in a bit of a panic about time slipping away, never to return. To top it off, Céline announced that she was going on sabbatical for an unspecified period of time. The world's top singer was taking a well-deserved break. To close this chapter, she and René decided to put on a show with a party atmosphere, filled with surprises.

The show started off with a bang and lasted well past midnight. It was a gift from Céline not only to all her fans, but also to her employees, who were paid triple time on this first day of the new millennium. A unique happening for an unforgettable show!

Céline sang some 25 songs, many of them duets. The show opened with "All the Way," sung in perfect unison with Frank Sinatra on the big screen, followed by three songs with Bryan Adams: "It's Only Love," "When You're Gone," and the perennial favourite "(Everything I Do) I Do It For You." She also sang "When I Fall in Love" with Daniel Lavoie, "Le blues du businessman" with Bruno Pelletier, and "J'irai où tu iras" with Luck Mervil. These singers had all starred in Luc Plamondon's musical *Notre-Dame de Paris*, which Céline and René had seen in Paris and loved. Humorist and comedian Stéphane Rousseau was also there that night. Garou performed a traditional Québécois song with Céline, with a rigadoon air that had the audience on its feet. Then and there, René committed to helping Garou with his career. And René's cancer was in remission.

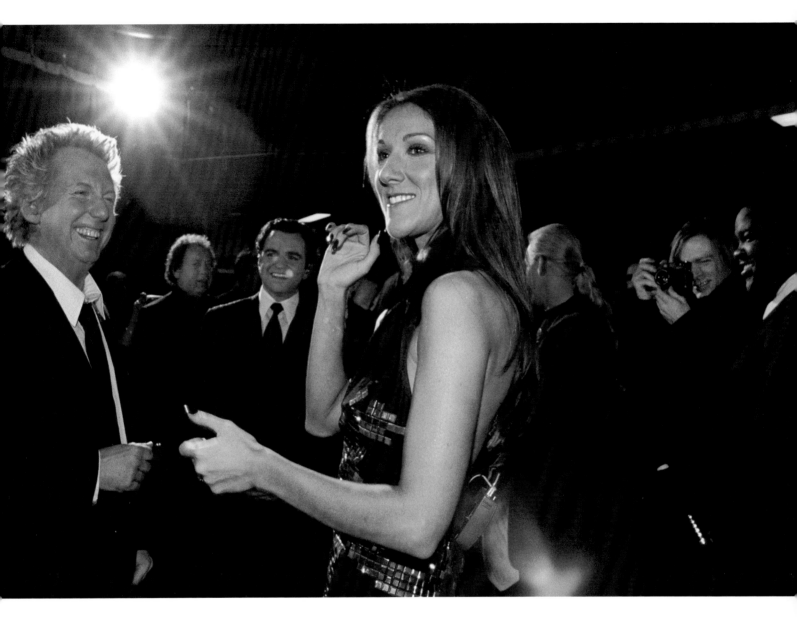

"There's Bryan Adams on the right, competing with me for Céline's attention. He's a photo enthusiast too!"

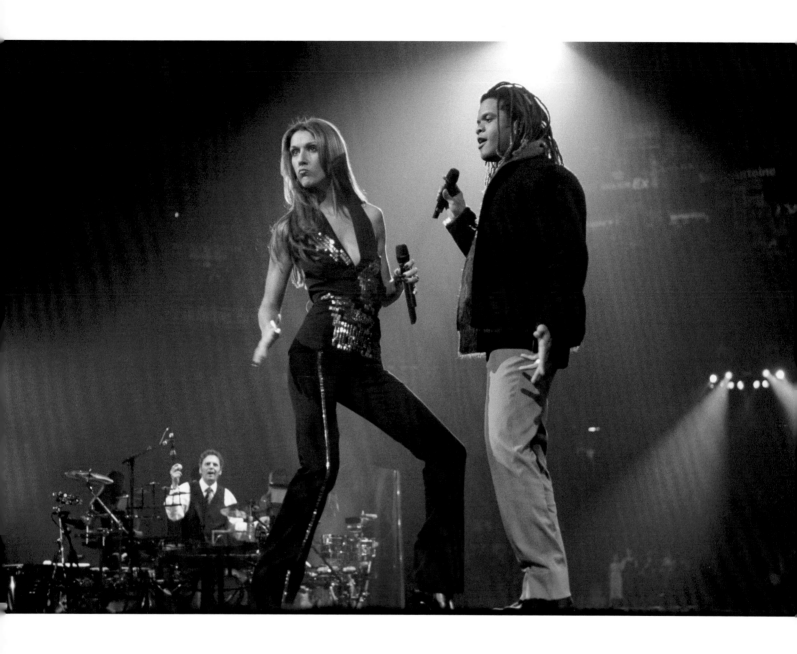

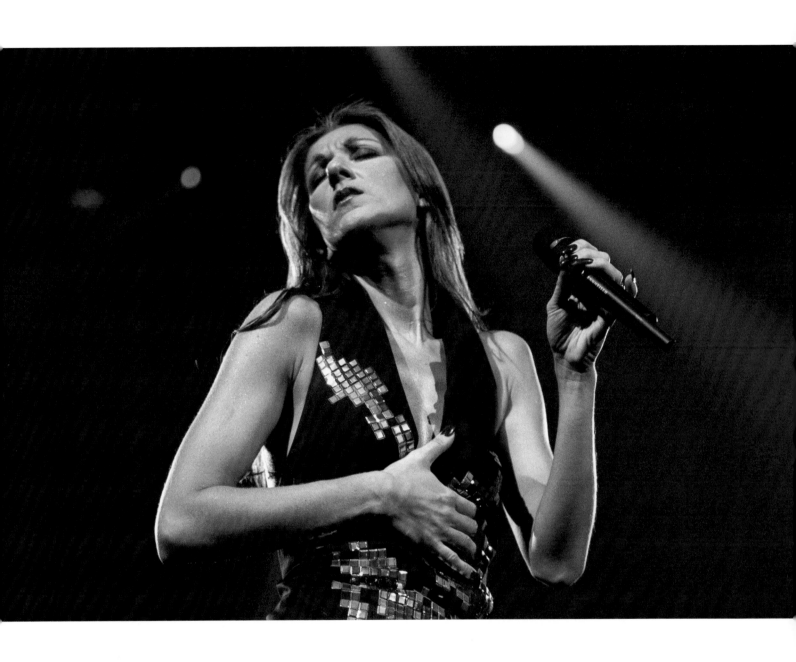

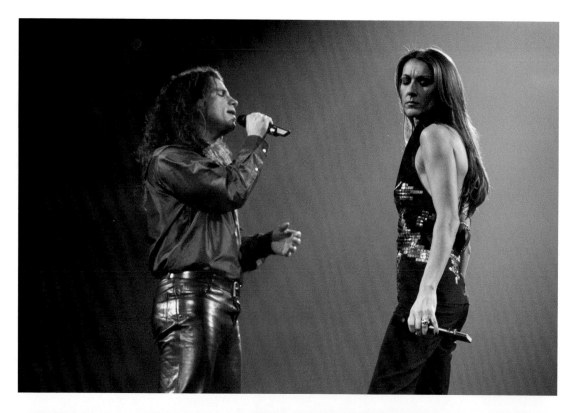

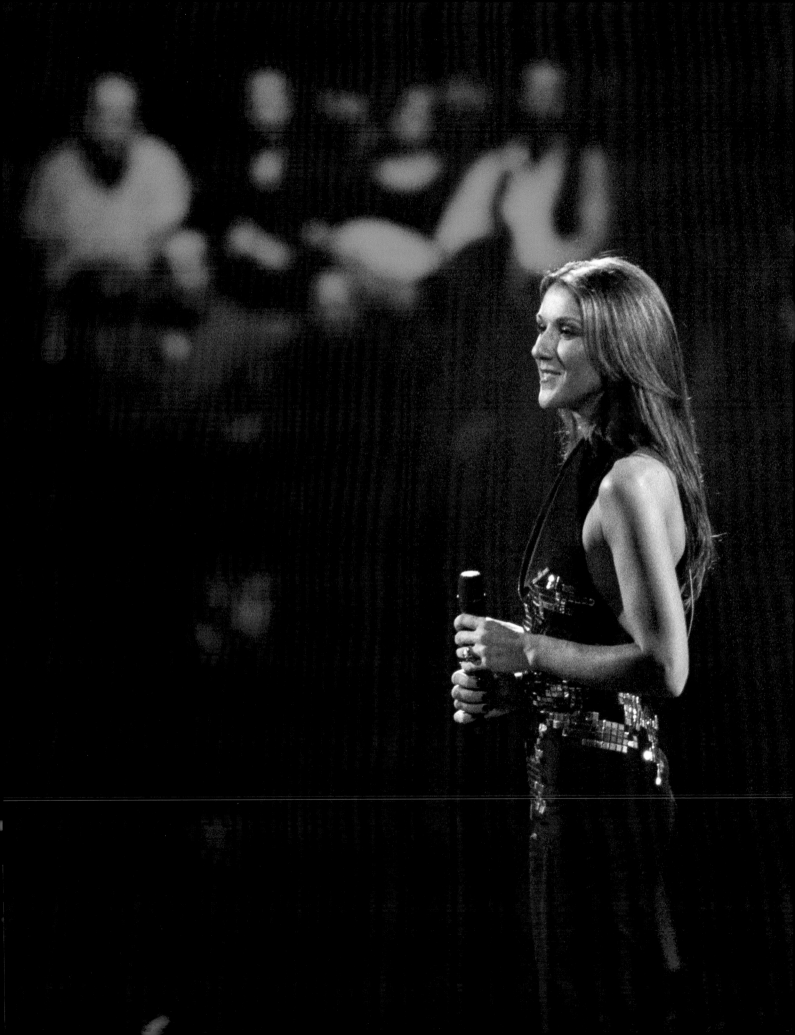

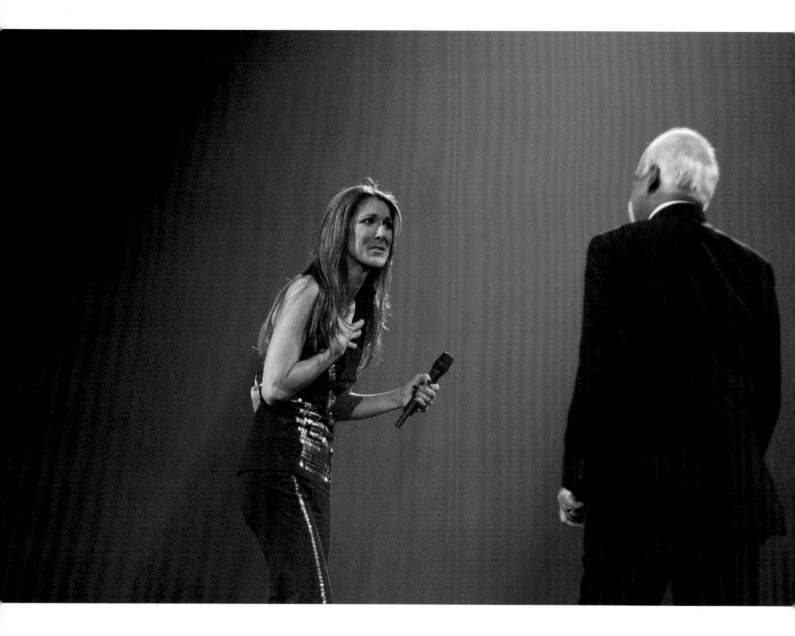

My memories of Céline and René that night will always be surrounded by a certain aura, and not just because of the show's artistic qualities. When René walked out onstage at the stroke of midnight and took the woman he loved in his arms, I realized that love really can conquer all.

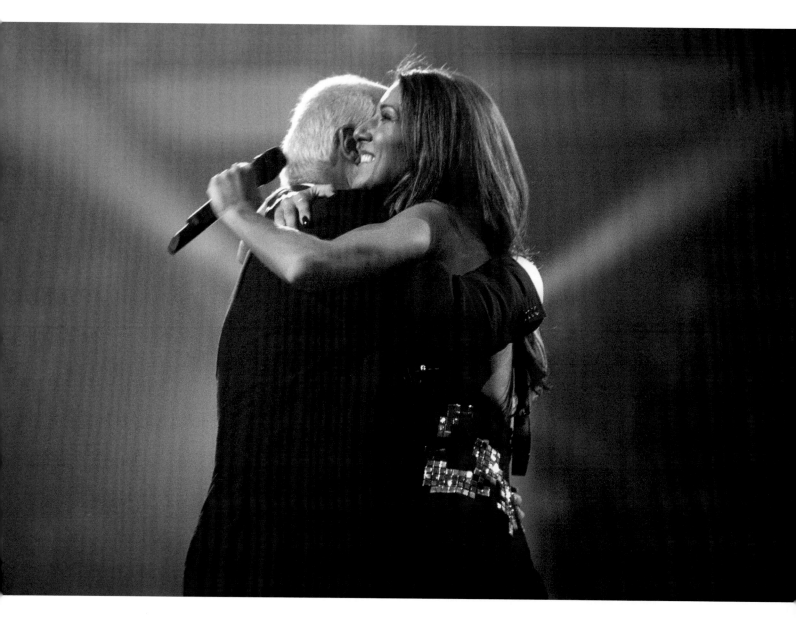

René had beaten cancer. Now there he was onstage that night, ready for his next challenge. It's his fighting spirit that I admire so much. This photo of Céline and René, one of the more than 400 that I took that night, remains for me a symbol of hope and resilience. Amid all the frenzy at the Molson Centre, this was the most significant moment for me.

And I did not forget that December 1999 marked my 10th anniversary of sobriety.

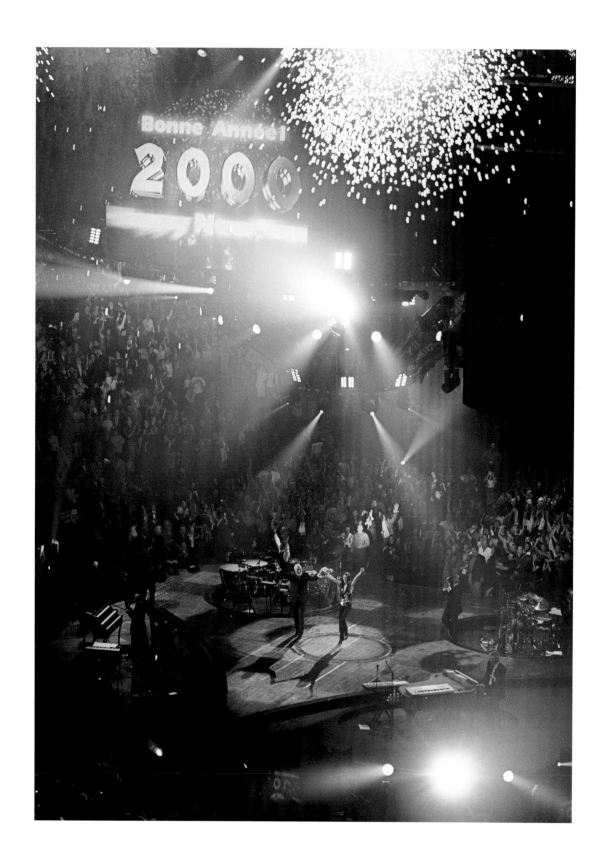

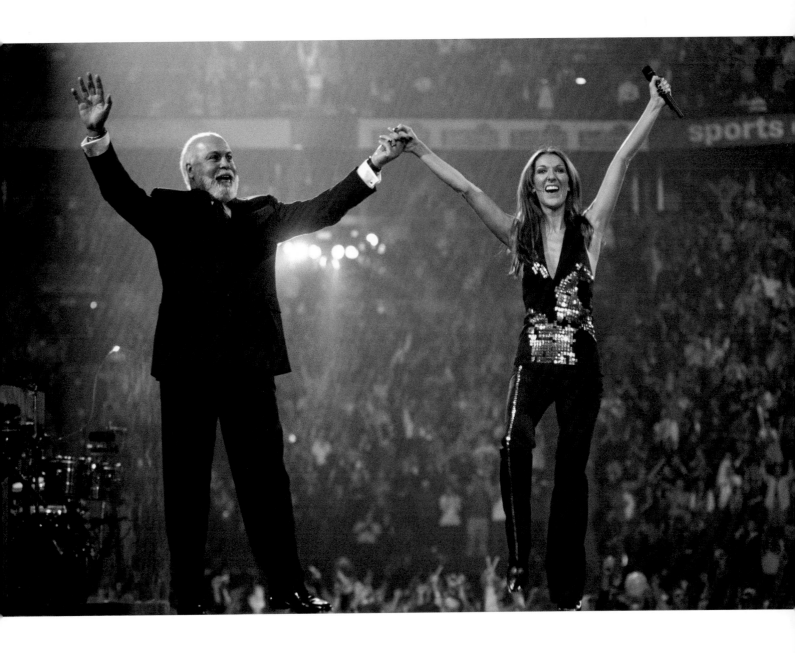

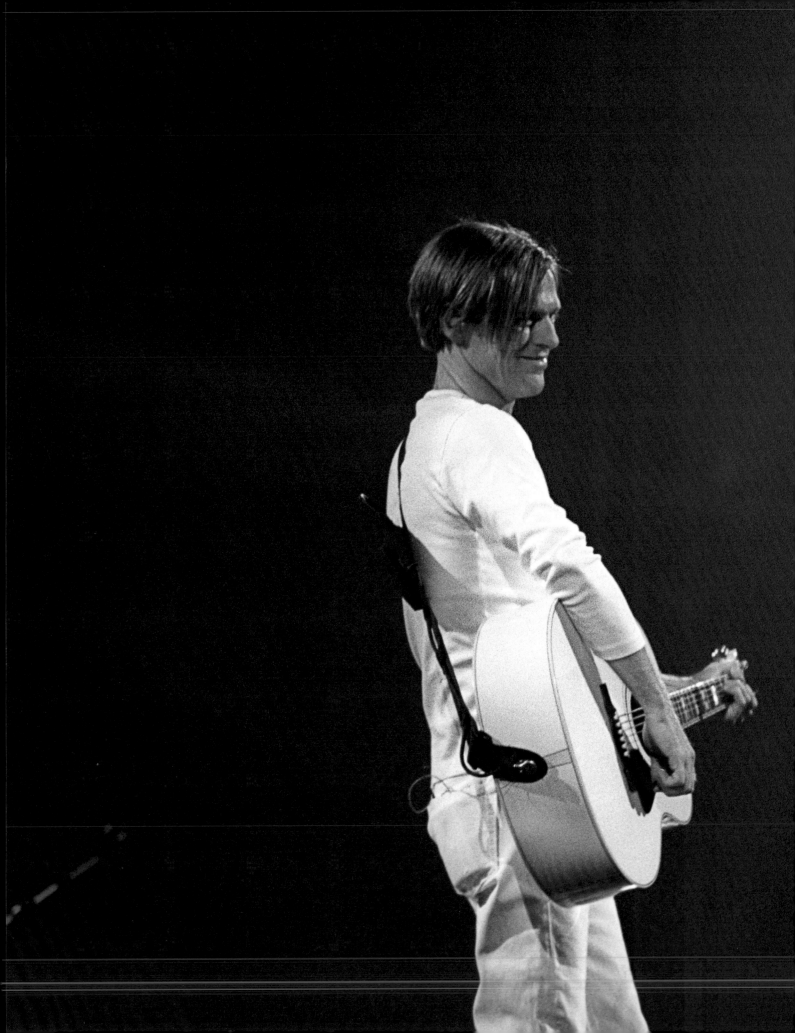

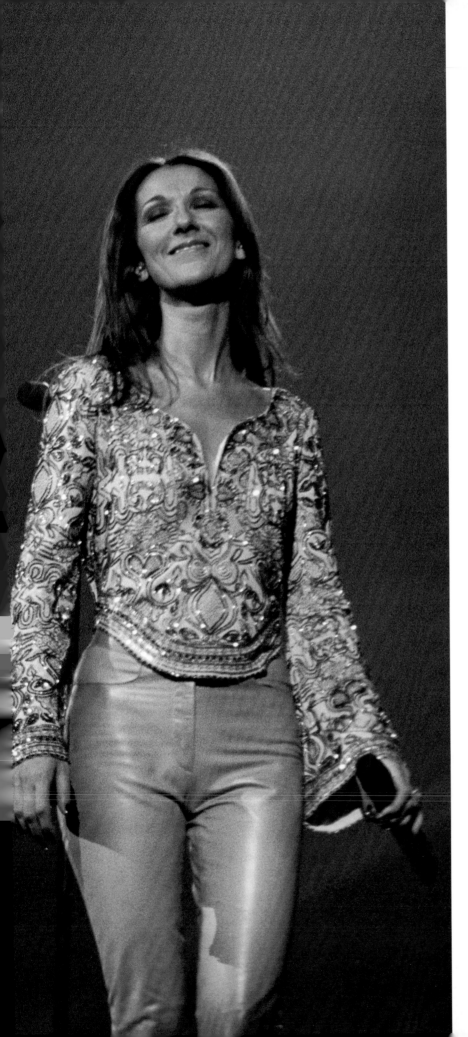

"Another technically flawed photo that I love for the feeling it conveys."

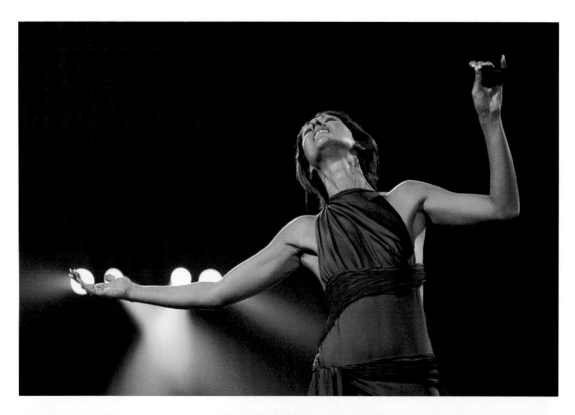

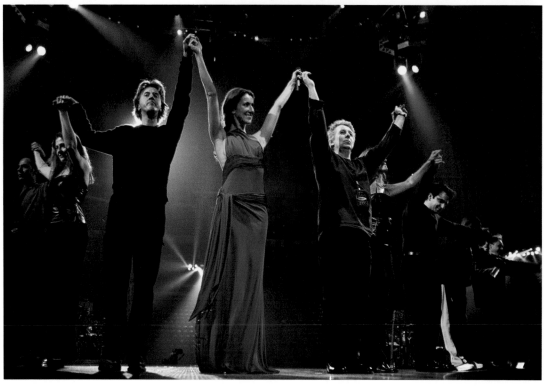

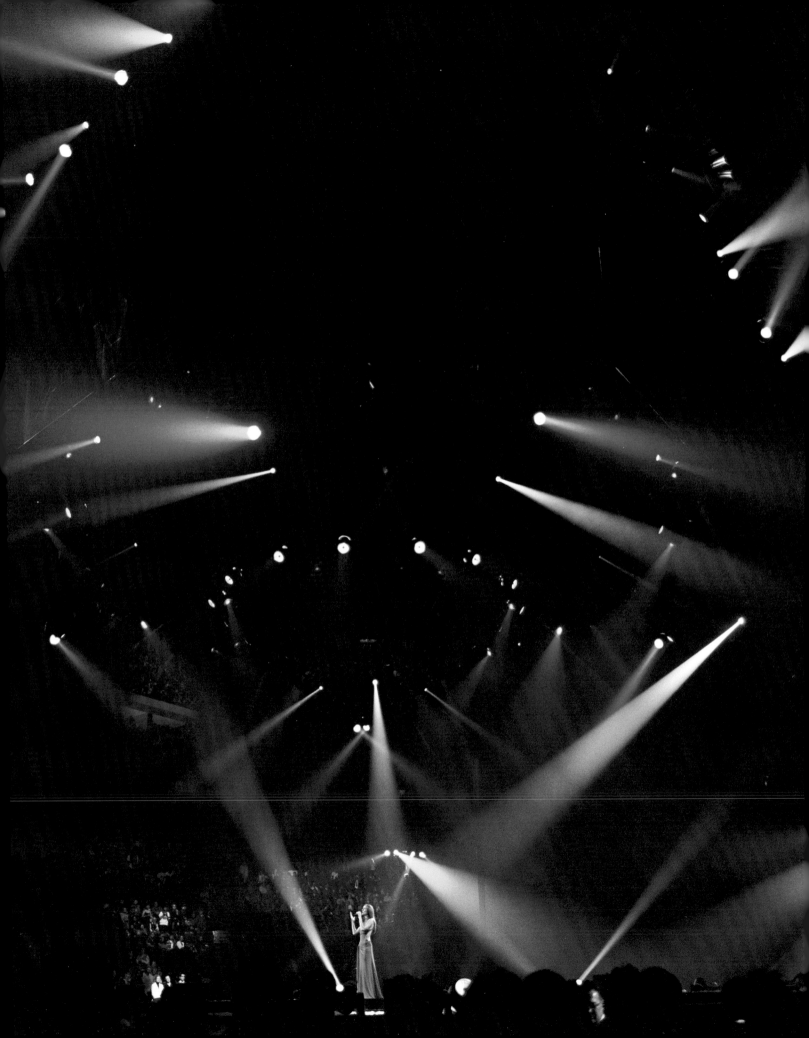

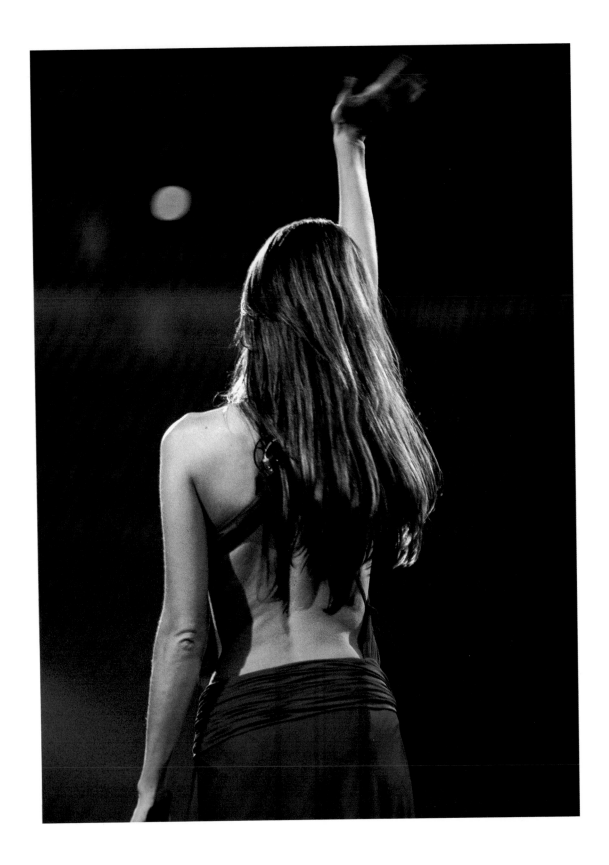

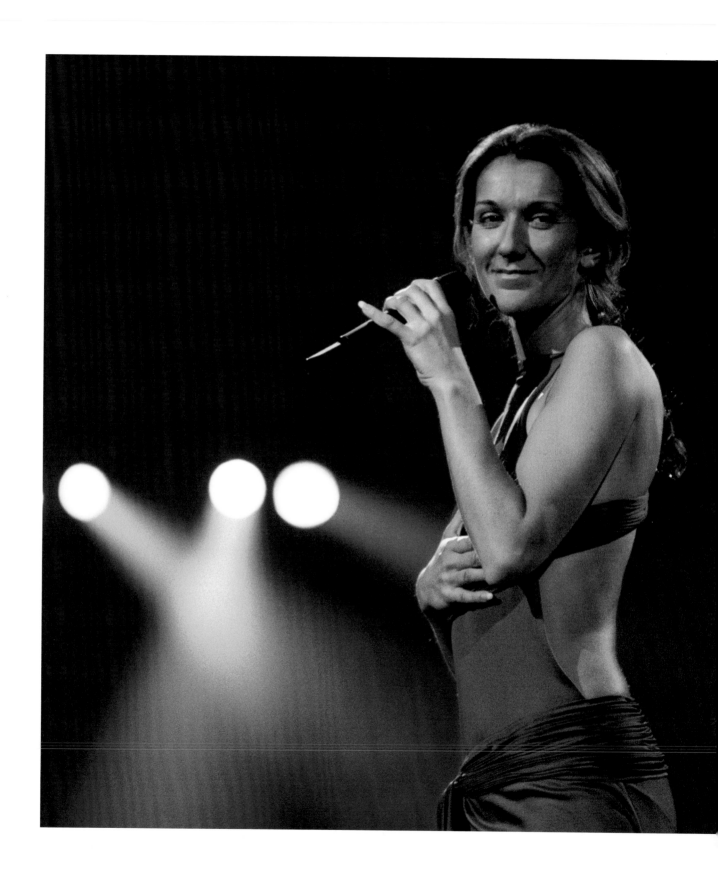

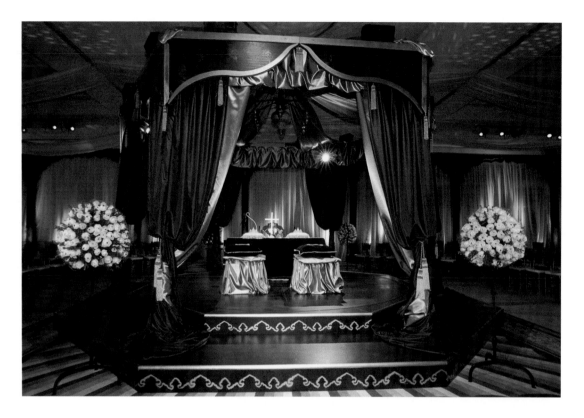

The night after that memorable concert, Céline and René left for Las Vegas. A charter flight took off from Montreal with 300 of their closest friends and family en route to celebrate the couple's fifth wedding anniversary. Like everyone else on board, I did not need to do anything. Everything had been arranged. Our hotel rooms were reserved and paid for, and our luggage arrived almost before we did.

As planned, on the evening of January 4, the day after the Christmas party, we all attended *O* as guests of Guy Laliberté, president and founder of Cirque du Soleil. Several seconds after the show had begun, Céline and René slipped in quietly, unobserved in the shadows. *O* was such a revelation to Céline that she wanted to work with the show's creator, Franco Dragone. This collaboration gave birth to *A New Day...* five years later. And the rest is history.

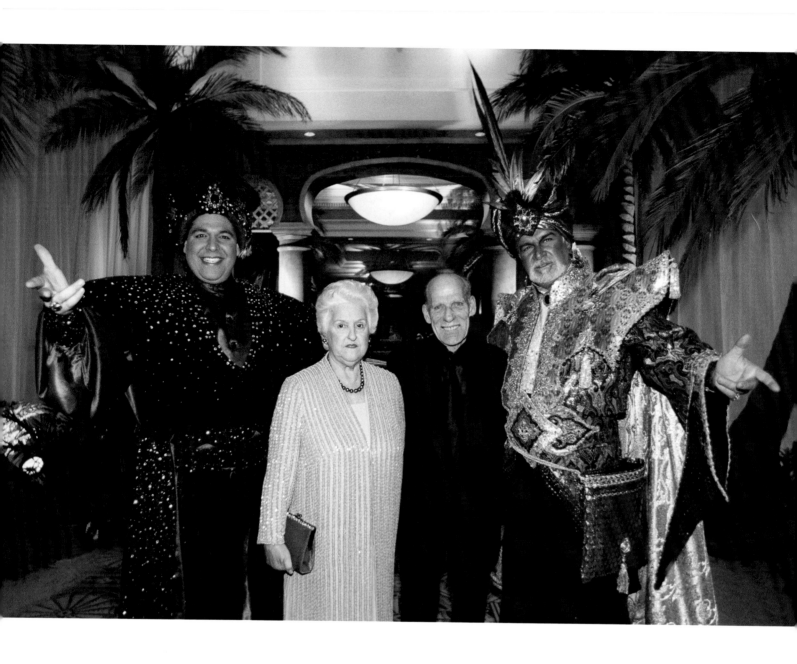

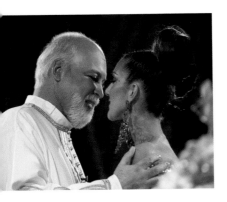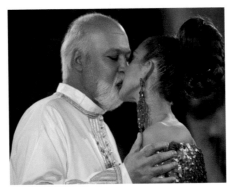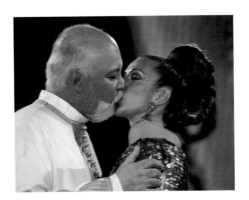

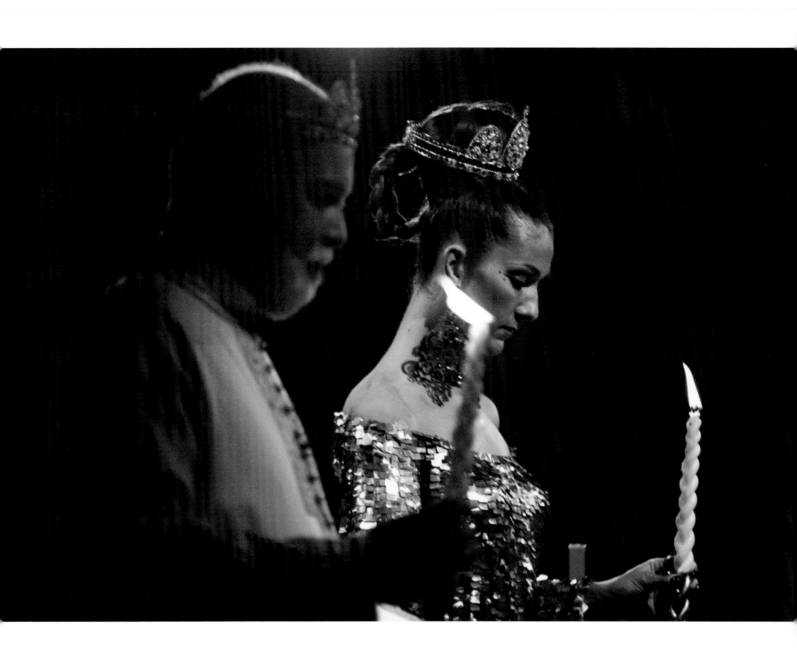

For the ceremony on January 5, the ballroom at Caesars Palace was decked out in Middle Eastern style, reminiscent of René's Syrian and Lebanese heritage. Although the decor was elaborate, the exchanging of the vows was an intimate and sacred affair, as the couple had wished. The five-course meal that followed consisted of Arab dishes served to guests who were seated on cushions on the floor. The overall effect was unforgettable. The night marked not only their fifth wedding anniversary but also the beginning of Céline's sabbatical. The number five, pronounced *hamsa* in Arabic, is Céline's lucky number. Every guest in attendance, whether from Montreal, New York, Paris, or Los Angeles, knew that Céline and René fervently wished to have a child.

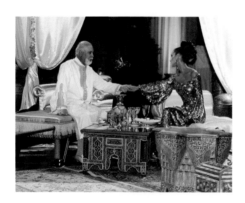

 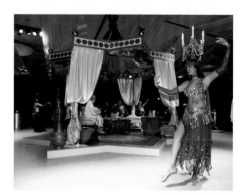

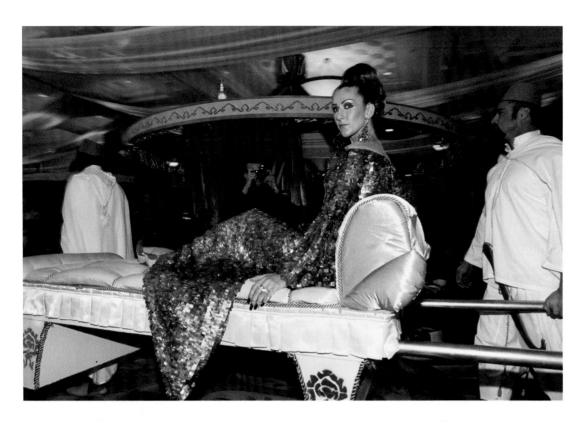

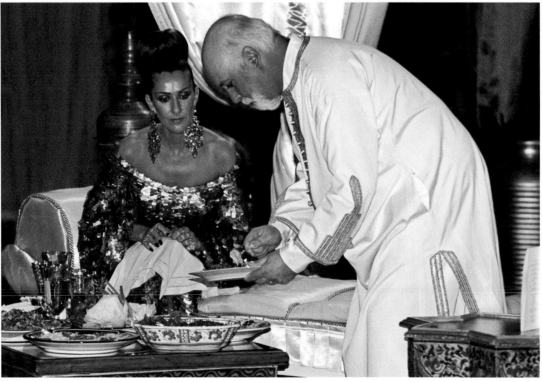

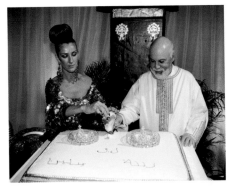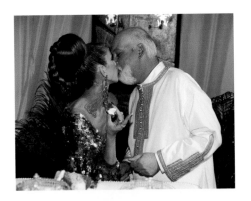

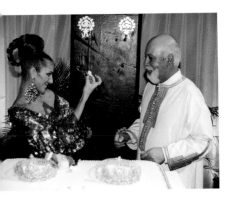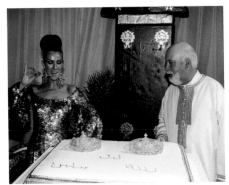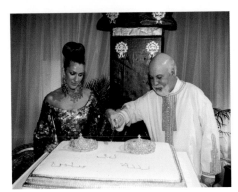

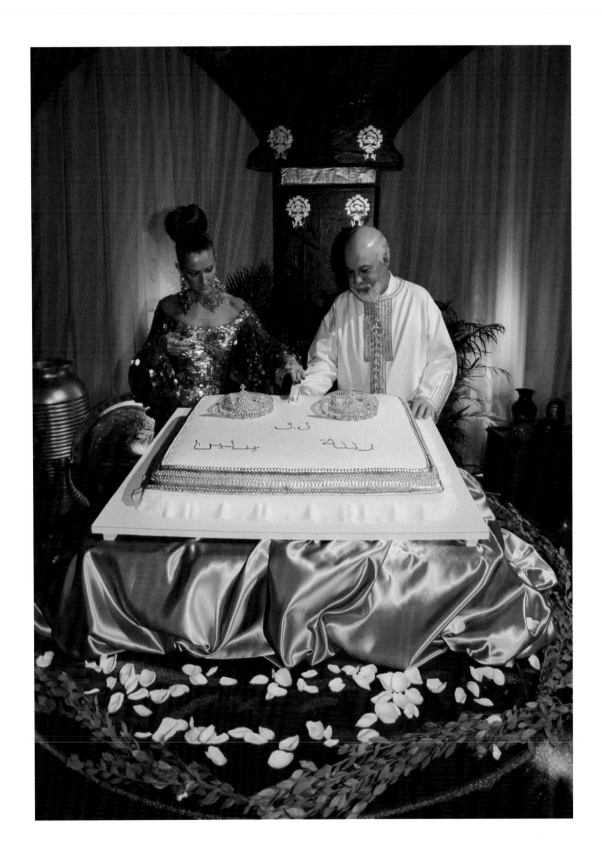

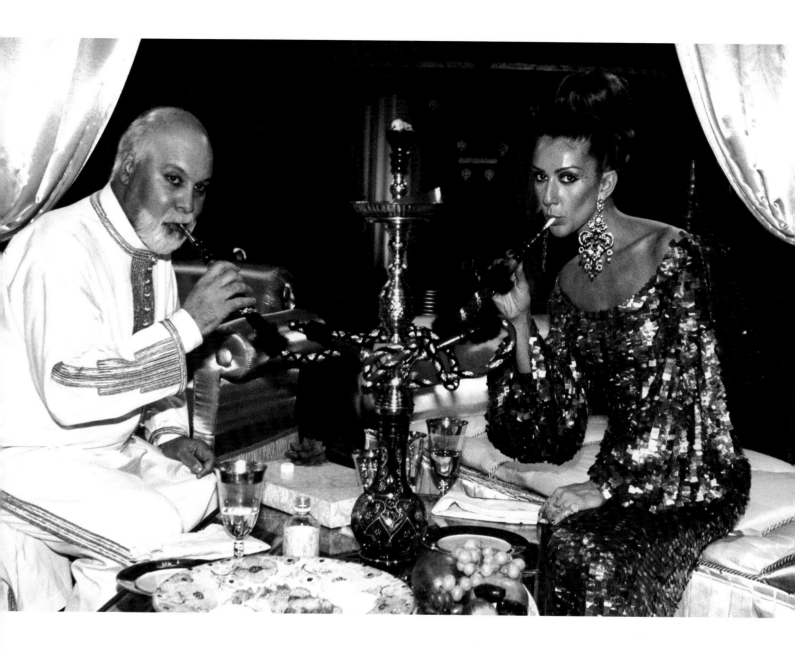

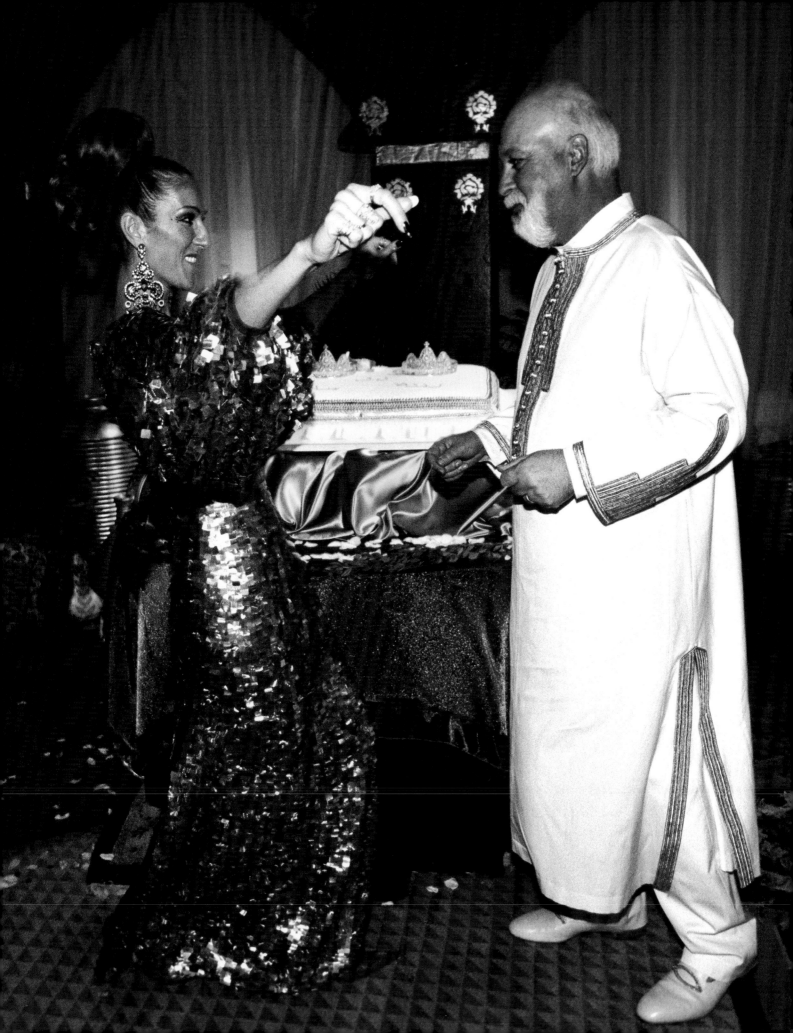

 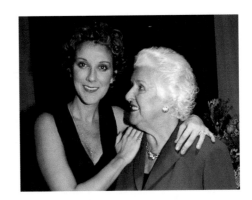

The following September, during *Maman* Dion's golf tournament at Le Mirage, I noticed an expectant Céline! She was beaming. I was the first person to photograph the soon-to-be-mother, glowing among her family and the tournament participants. She was radiant. A light shone within her that had nothing to do with her talent and fame. I had always been aware of that light, even without a zoom lens.

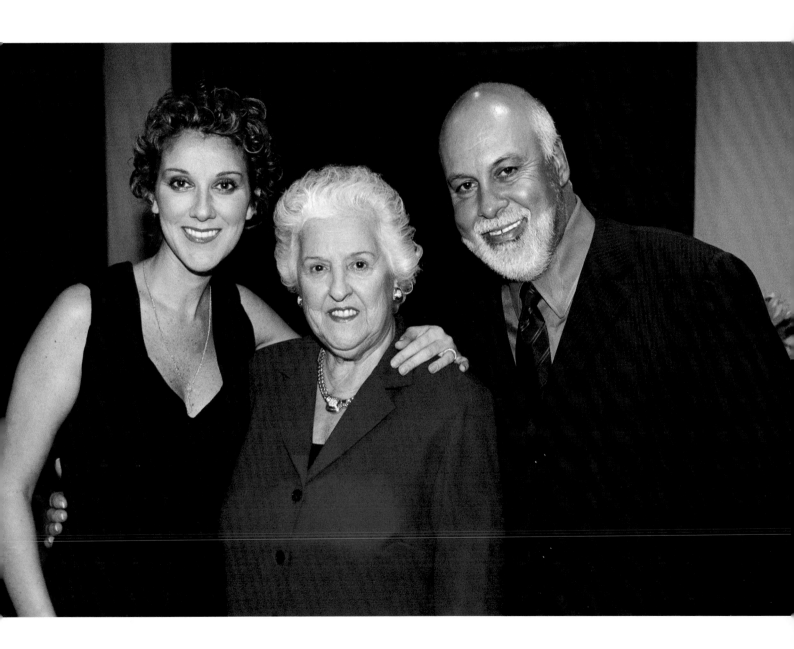

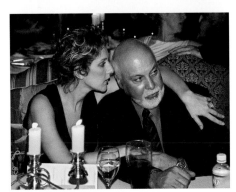
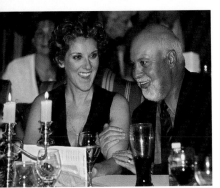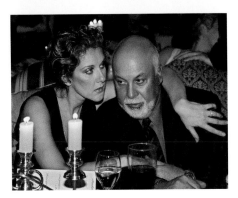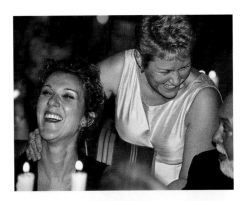

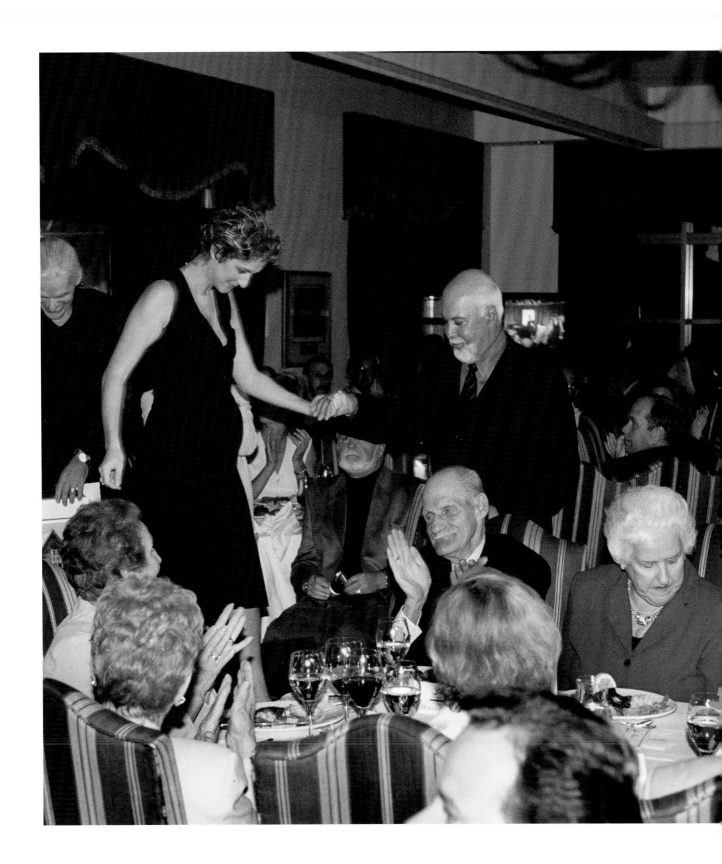

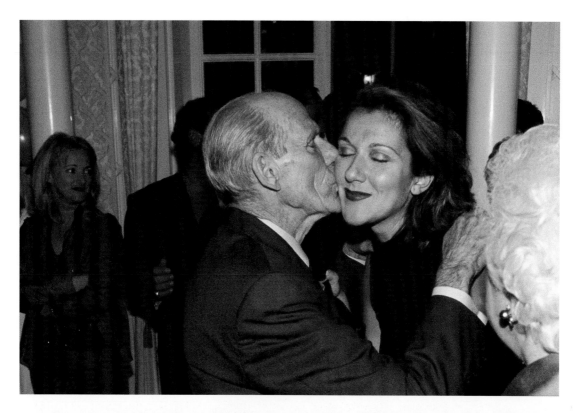

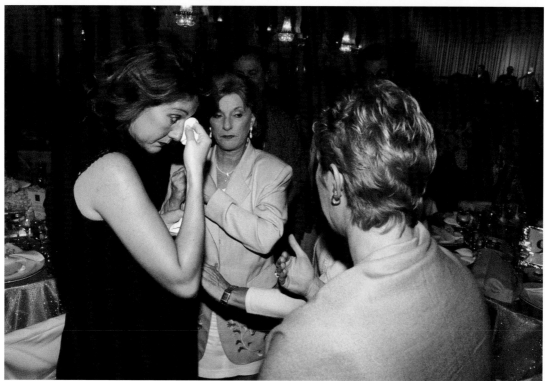

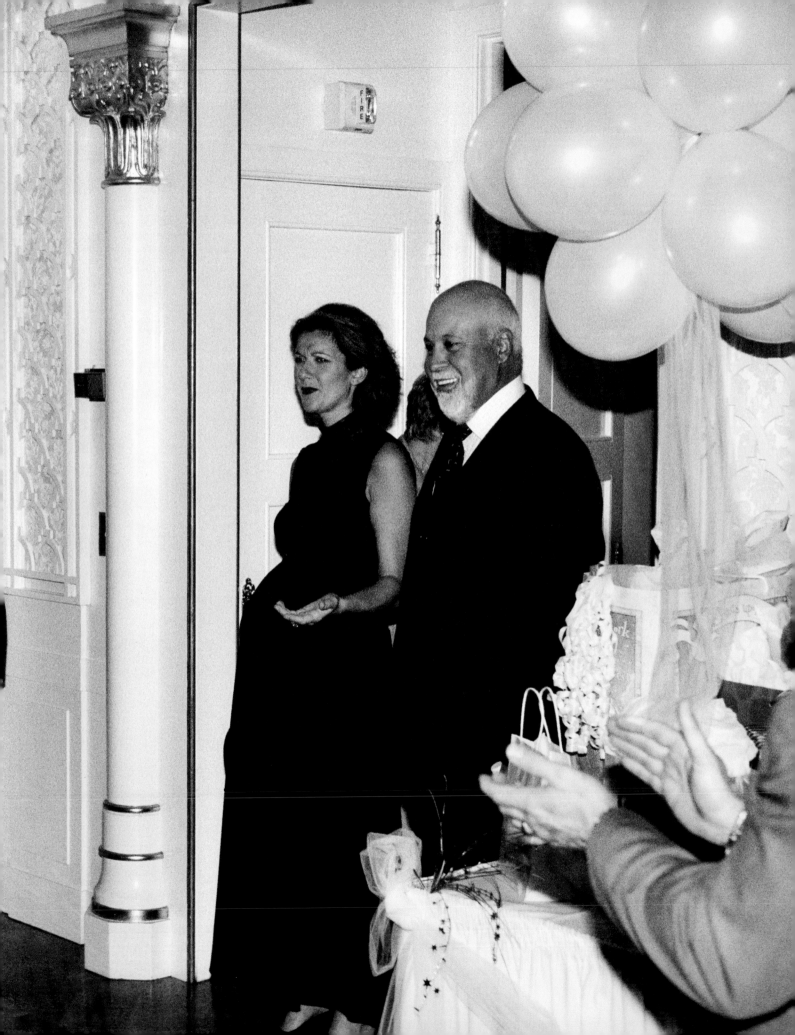

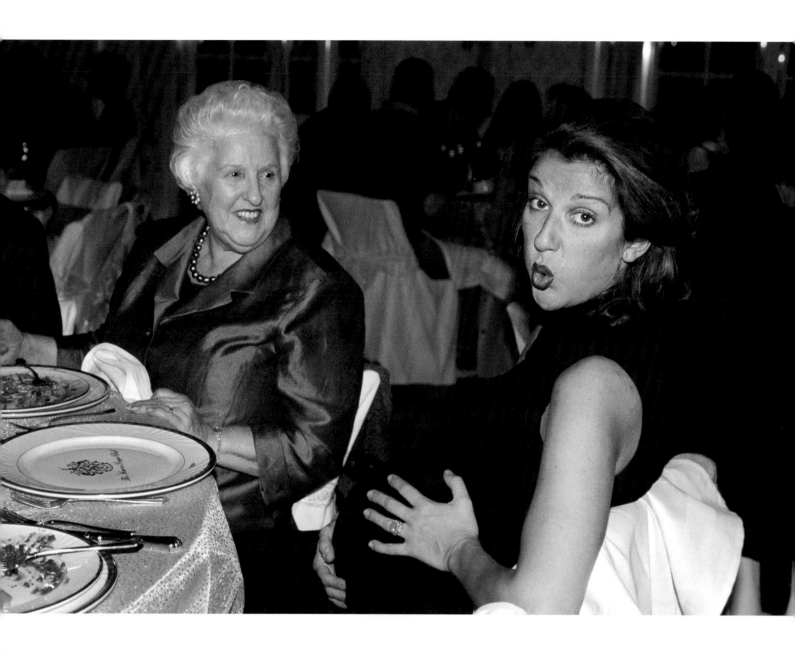

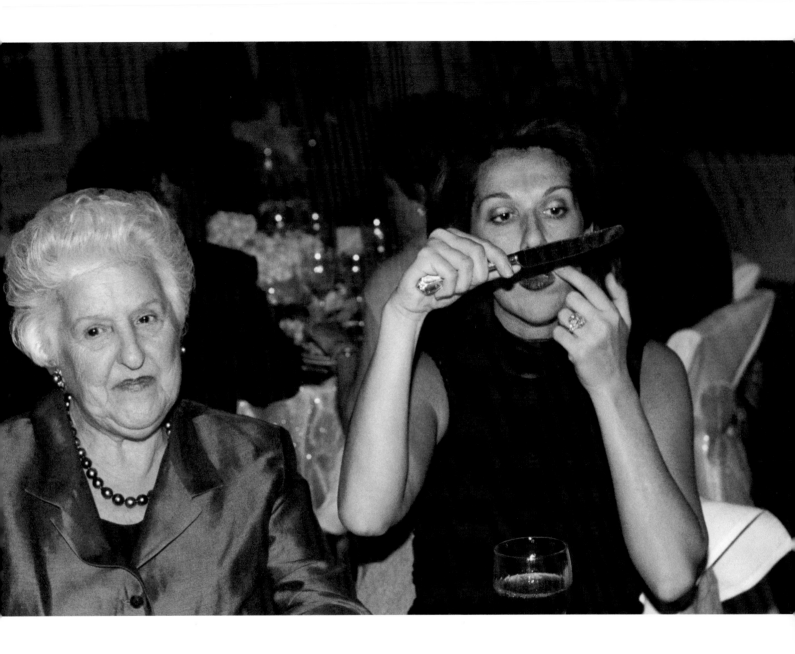

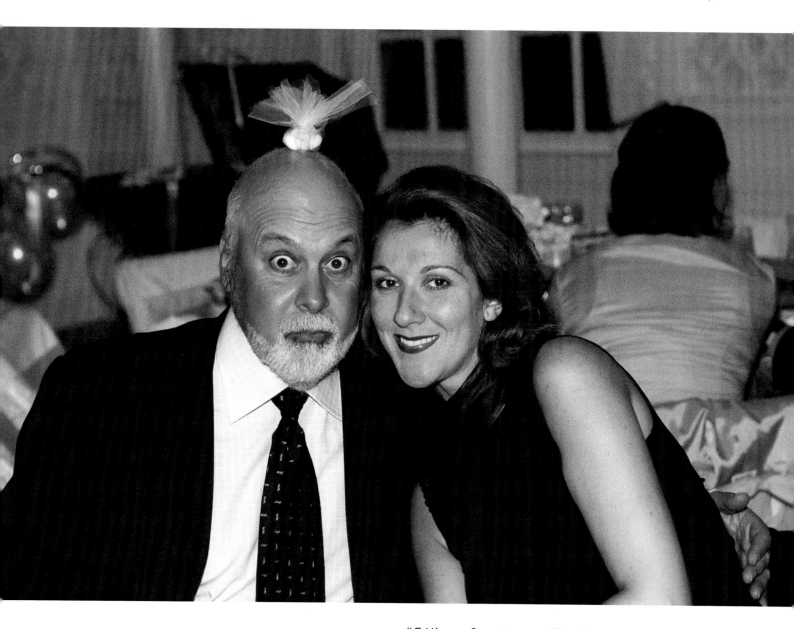

"*Céline often teases René.
He adores it and is always
game to join in the antics.*"

I saw Céline again at the baby shower that René secretly organized for her at West Palm Beach. All her closest friends and family were invited. The shower was held at Donald Trump's private club, Mar-a-Lago, once the home of Marjorie Merriweather Post of Post cereals fame. Céline was completely surprised and overwhelmed, bursting into tears in front of all her guests. She was just days from her due date and displayed her expectant motherhood with unbridled pride. She looked beautiful in a long, black dress that hugged her figure. I took a lot of photos. Céline seemed a little tired but, before leaving the reception, she managed to sing a song as a gift to her family and guests, René's hand on her belly her only accompaniment.

 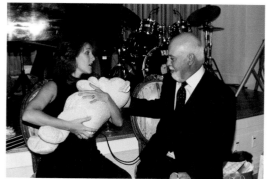

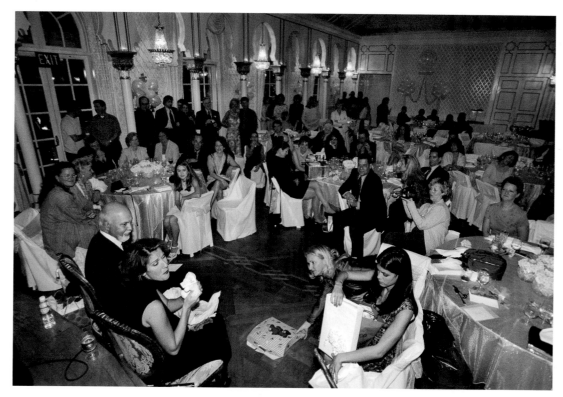

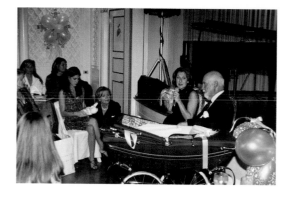 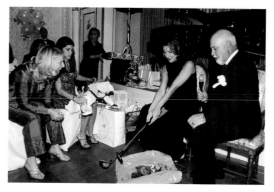

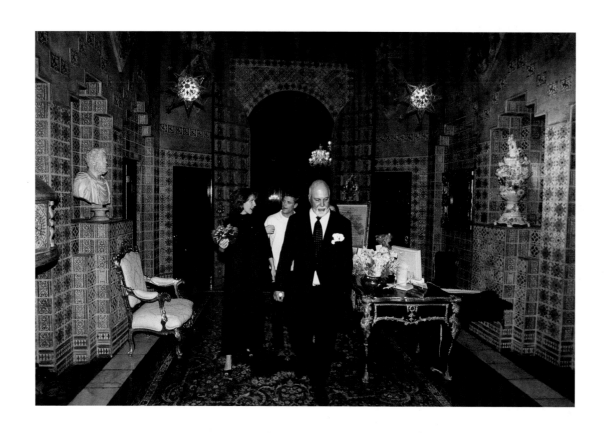

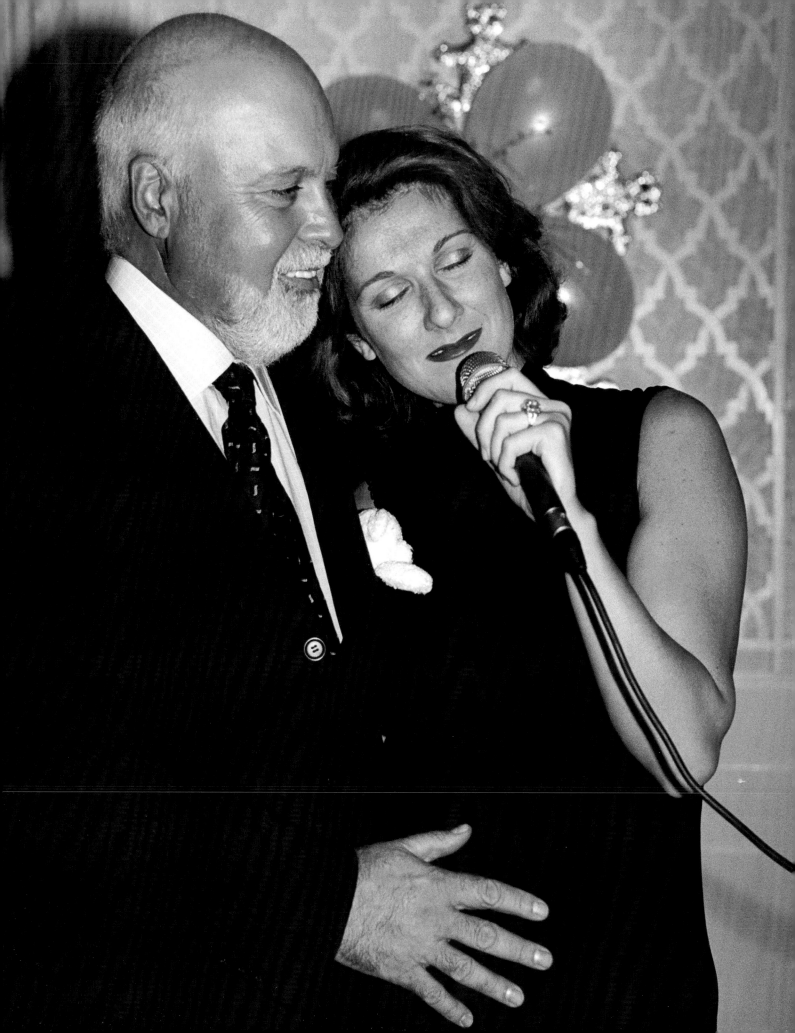

 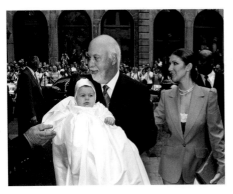 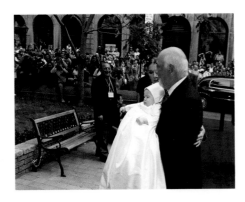

René-Charles was born at 1 a.m. on January 25, 2001, weighing in at 6 pounds 7 ounces. Six months later, I found myself in a crowd of media photographers in front of Notre-Dame Basilica, where René-Charles' christening would take place. I was the only Quebec photographer allowed in the church. Only one other photographer, a European, was allowed in.

"I hope she doesn't show off the baby to everyone. I won't be able to sell my photos," he said.

I smiled because, at that very moment, Céline had climbed out of the limo and, from the church steps, was proudly showing off her baby to the adoring crowd and to every photographer present. I wasn't surprised, having witnessed many times how much Céline likes pleasing her fans.

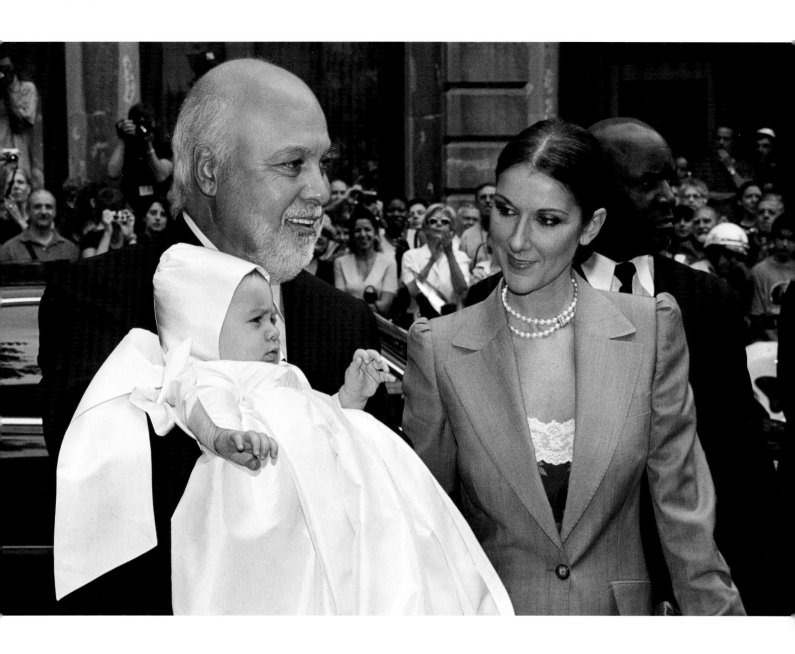

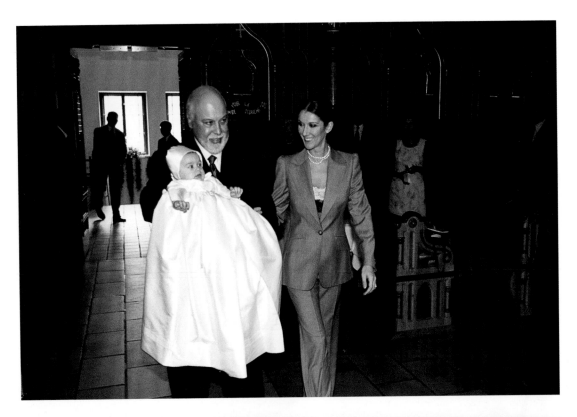

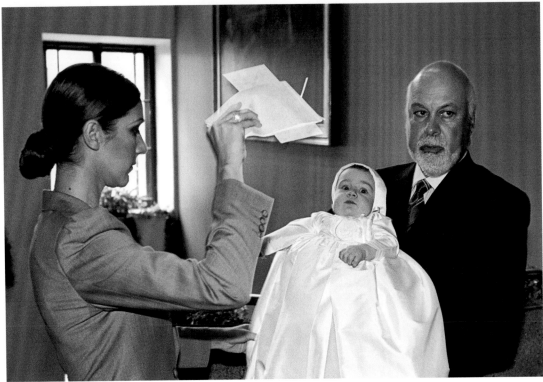

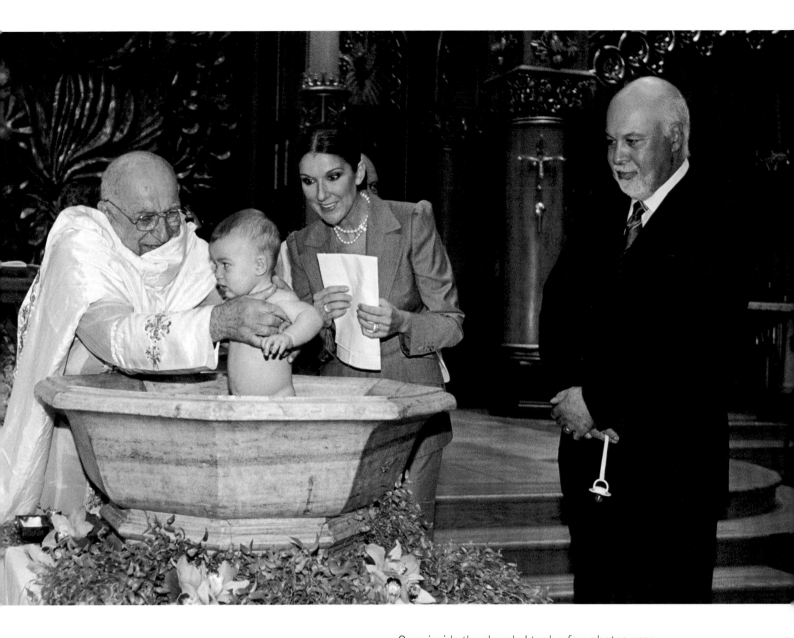

Once inside the church, I took a few photos near the baptismal font. Surrounded by his parents, his godmother, Linda, and his godfather, Alain, René-Charles was submerged in holy water. Click!

Barely two hours later, I arrived at Céline and René's new home on Île Gagnon, where the christening reception was being held, with the developed photos in hand. I showed them to René so that he could choose which one to send to the media. The one of René and Céline looking on proudly as the priest held René-Charles in the baptismal font made the front page of all the newspapers, magazines, and websites.

The sun was shining. I spent the afternoon taking pictures of the children playing on the rides that had been set up in the yard. I also photographed many celebrities inside the tent, including Luc Plamondon, Michel Drucker, and Pierre Lacroix, as well as the doctors who had helped René beat his cancer. René took time out from the party to extend his condolences on the death of my father, whose burial had taken place the previous day. As I watched the celebration of the christening, I thought about how intimately life and death intertwine.

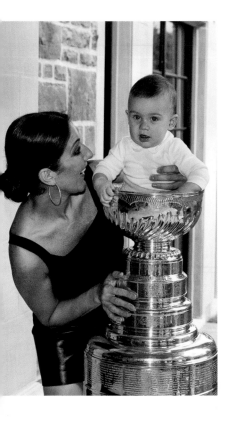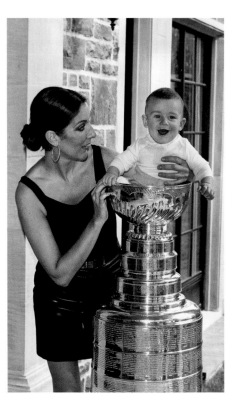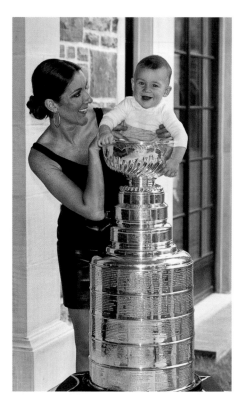

Two days later, I was back again at Île Gagnon, this time to photograph the Stanley Cup, which Pierre Lacroix's Colorado Avalanche had won. Pierre had promised René that he would show him the victorious Cup. Before it arrived, I walked the grounds with Adhémar, Céline's father. I told him that René-Charles has his blue eyes. He was pleased with the compliment and smiled with his usual modesty. In the end, I took a few photos of René-Charles flanked by his parents and the Cup. The spirited baby bubbled with laughter.

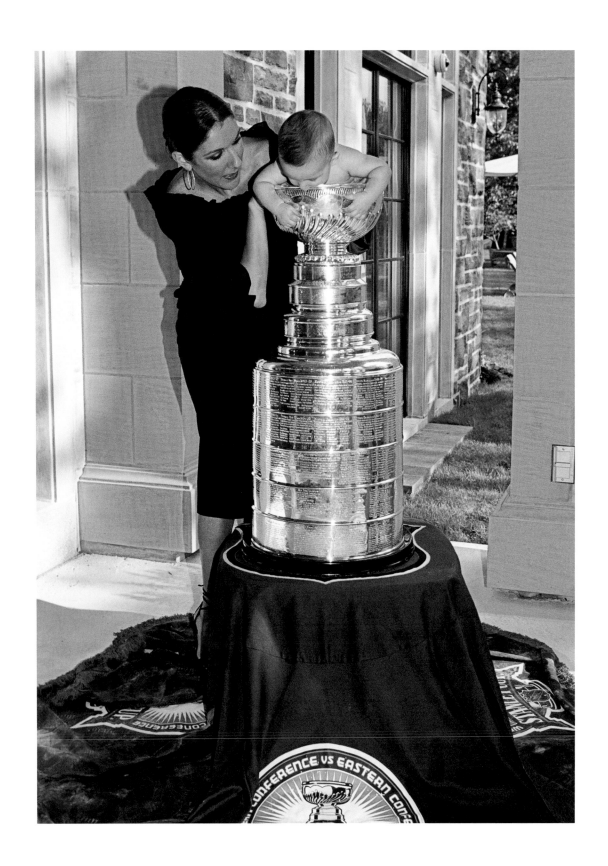

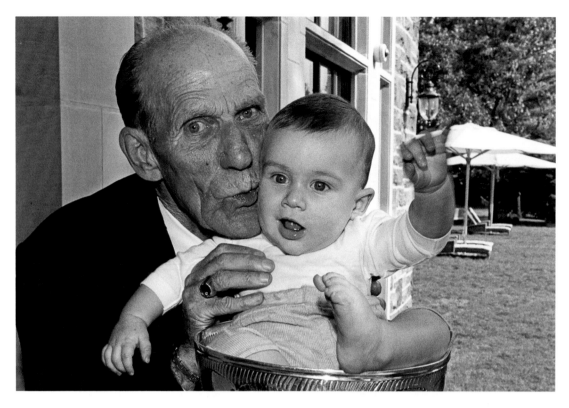

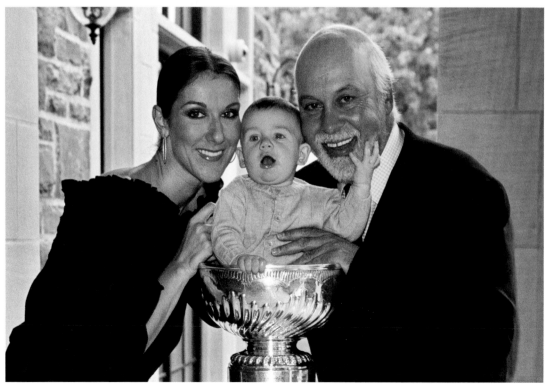

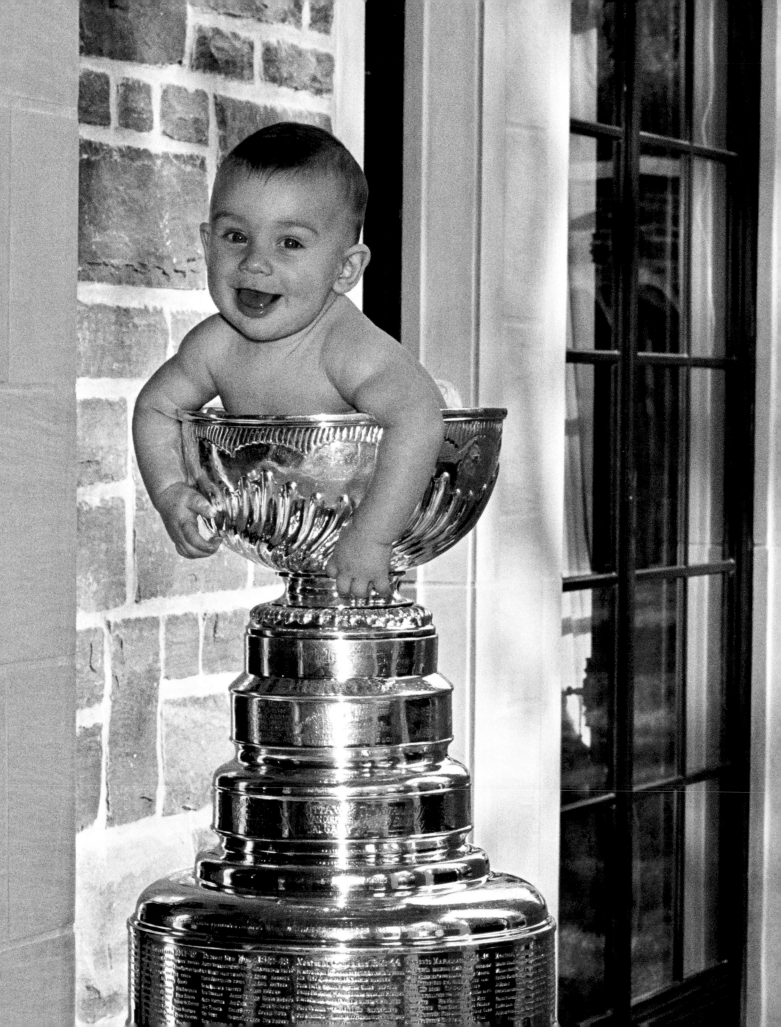

"René asked me if I'd been able to get a good photo. I said no, so he stopped the session so that I could take one. That photo ended up on the cover of the single 'Sous le vent.'"

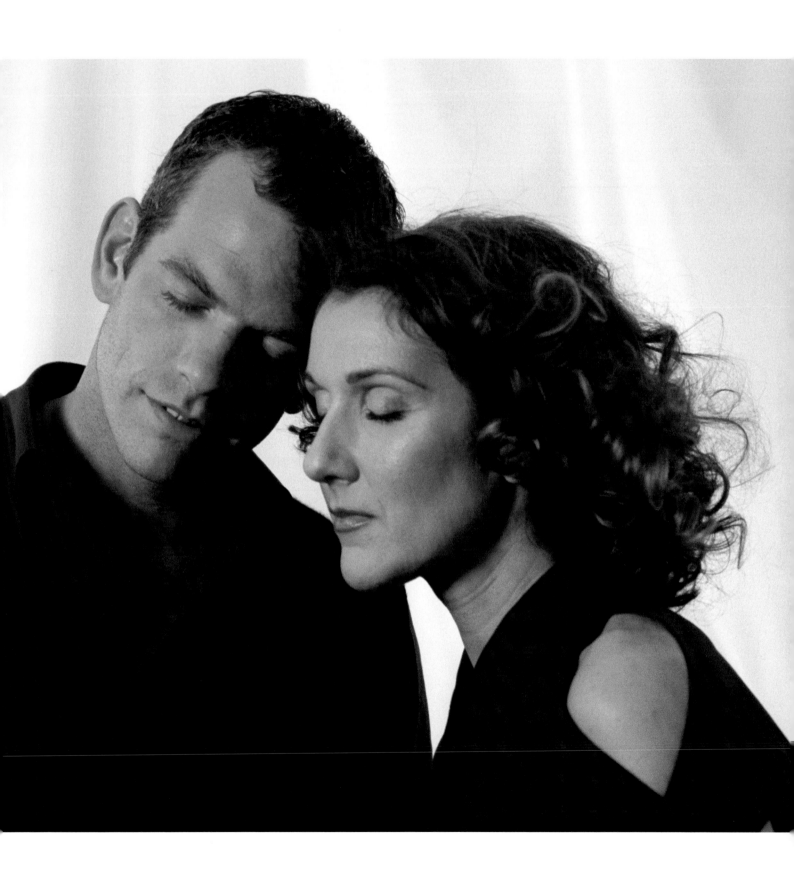

A few weeks later, Céline's sister Manon got married. It was another occasion for a joyful family reunion. During the ceremony, I watched René-Charles fall asleep on Céline's shoulder, giving himself over completely to sleep as only a child can, trusting and peaceful. This photo reminds me of a religious icon. To this day, it is Céline's favourite. I'm very proud of that fact, especially since I'm told she has a collection of more than 100,000 photos.

Not long afterwards, it was Anne-Marie Angélil and Marc Dupré's turn to host the family at the christening of their son, Anthony. In that one year, René had become a grandfather and a father.

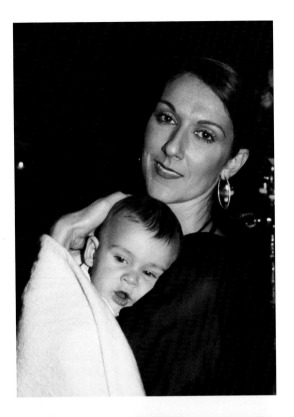

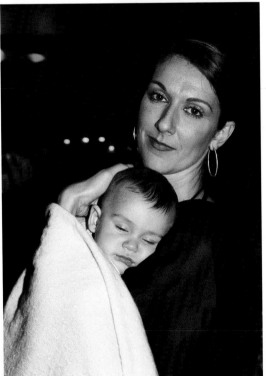

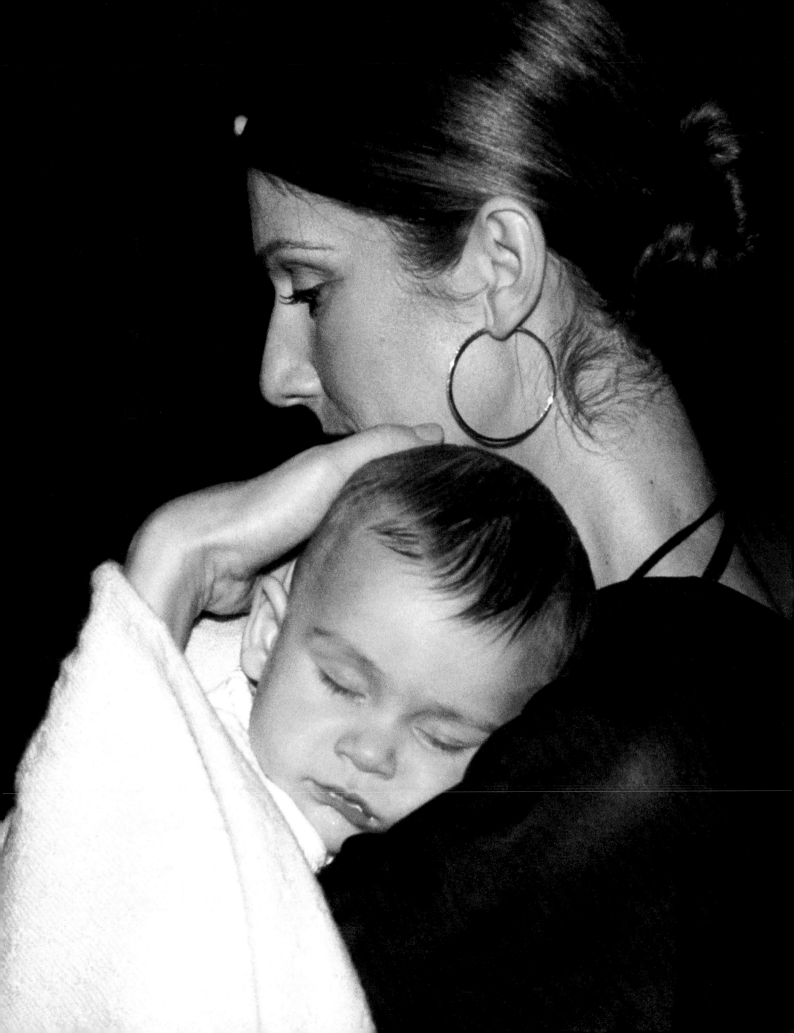

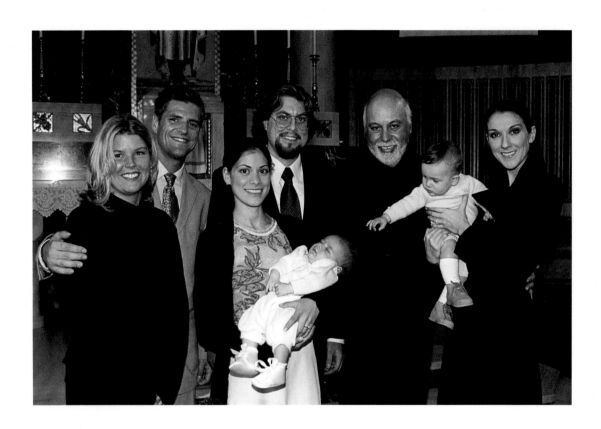

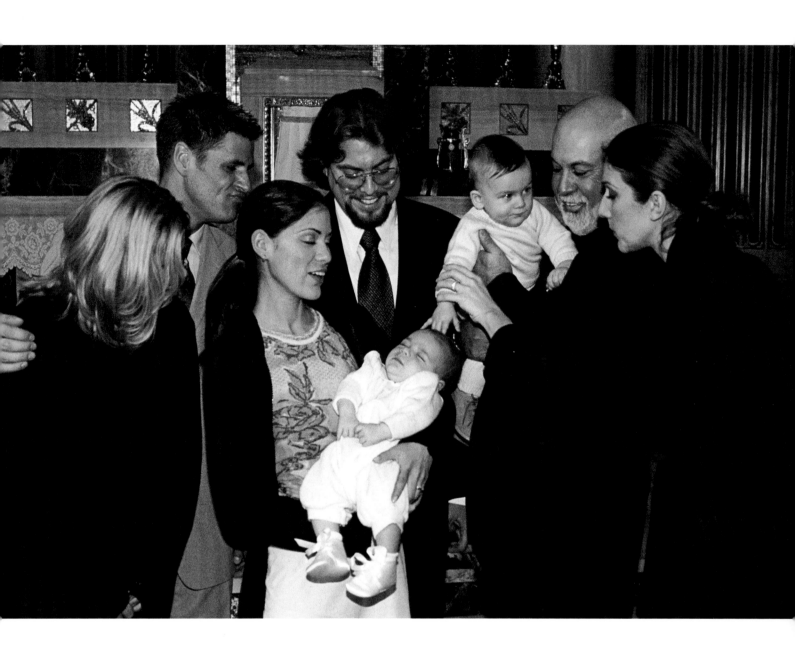

Seduces Me

I don't care about tomorrow
I've given up on yesterday
Here and now is all that matters
Right here with you is where I'll stay.
— "Seduces Me"

That year, 2001, was marked by the return of my back pain. I underwent several tests, including an MRI and a CT scan of the lumbar spine.

In July, my father passed away. My father always told me, "Life's a battle that no one escapes alive."

To which I always replied, "Bullshit. Life's a game."

Reality caught up with me. The doctor prescribed morphine pills for my back pain. Morphine is an opiate, like heroin. It insidiously triggered what I call the autopilot switch in my head. I didn't hesitate to pop pills to get more effect. I ignored the doctor's prescription, even going so far as to photocopy prescriptions so I could take more than the prescribed dose. The pharmacist caught on to what I was doing 18 months later.

Then in August, I started interferon therapy to treat my hepatitis C, traces of which had been detected by a doctor back in July 2000.

"If you don't accept interferon therapy, you have four years to live," he told me.

Twelve years after my initial diagnosis, I thought that ghost was gone forever, but I was wrong. I had to inject the drug into my abdomen every three days for six months in order to stimulate my immune system. I found the interferon therapy very difficult: it made me depressed, worsened my back pain and muscle aches, and caused hair loss. I was lucky, though: in fall 2002, my doctor told me the treatment had been successful.

Just as with the morphine pills, however, my renewed contact with needles provoked an unhealthy association in my mind.

During the illness, I didn't travel very far, though I did manage to make it down to the Kodak Theater in Los Angeles to shoot Céline's return to the stage after a two-year absence. In February 2002, I attended a live taping of a television special to promote the release of the album *A New Day Has Come*. During the show, I was pleased to see a few of my photos projected on a giant screen. I took some new shots, but had little leeway given the 24 video cameras assembled on the set. The evening ended with Céline, clad in a beautiful red dress, signing numerous autographs for fans, something she never forgets to do.

I started drinking again to alleviate the withdrawal symptoms I was experiencing when I stopped taking the morphine pills. My excuse was that it helped with the back pain. I drowned myself completely in the bottle. I needed help. My friend Léo, an addiction expert, convinced me to go to Maison Jean Lapointe, a renowned treatment centre for drug and alcohol addiction. In March 2003, I started a three-week program for prescription drug abuse. I also completed a 12-step program.

On March 25, Céline kicked off her Las Vegas show, *A New Day...*, created by Franco Dragone, which ran until December 2007. I missed opening night. I desperately wanted to be there. I was worried. I wondered whether they would still use my services as a photographer.

I managed to stay off alcohol for a year and a half.

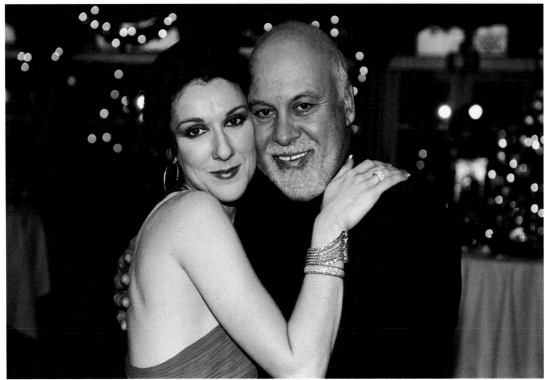

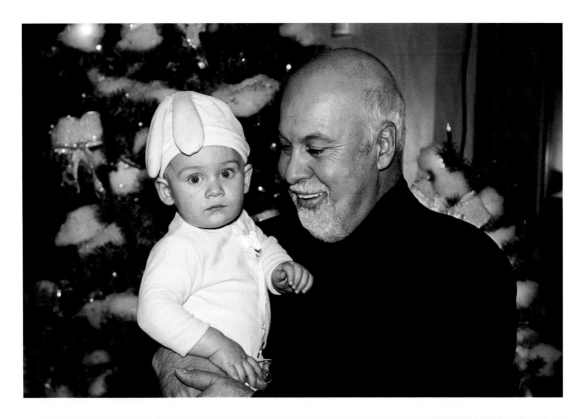

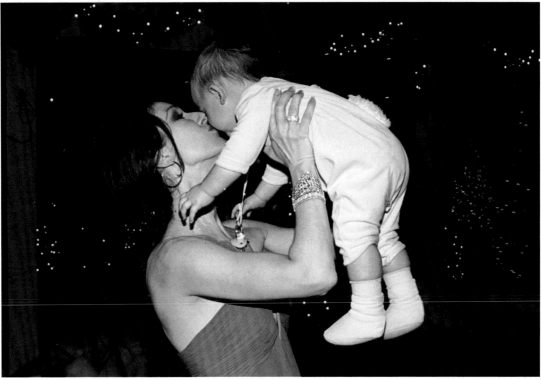

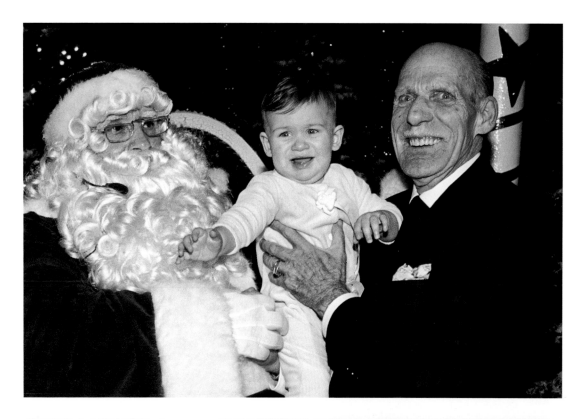

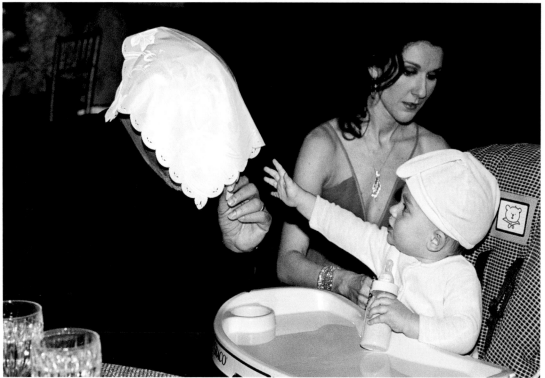

"My two sons were invited to celebrate Christmas 2001 at Le Mirage. They received as many gifts as Céline and René's nieces and nephews. I wasn't doing well at that point, so I was doubly touched by the generous gesture."

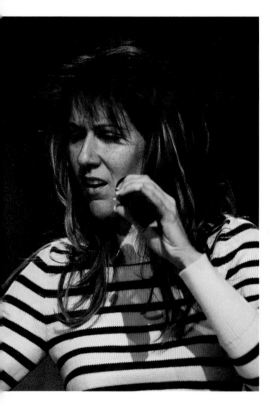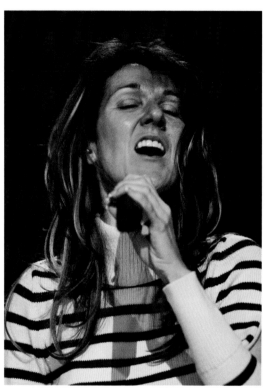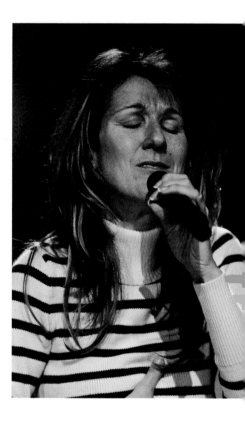

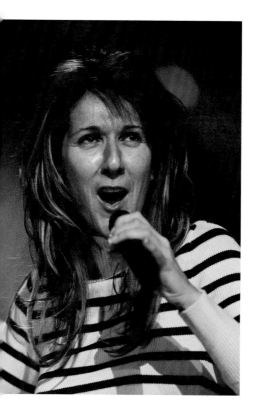 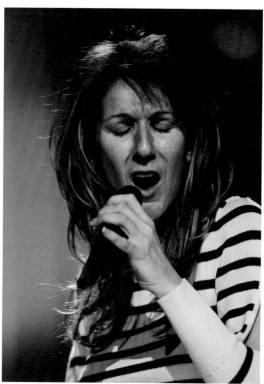 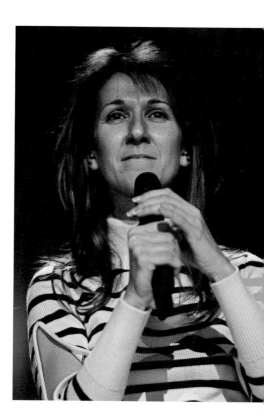

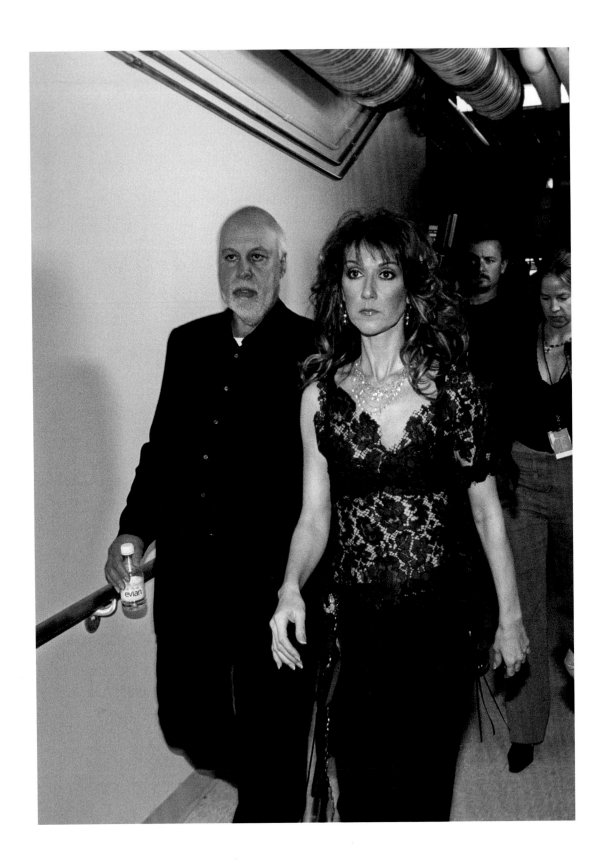

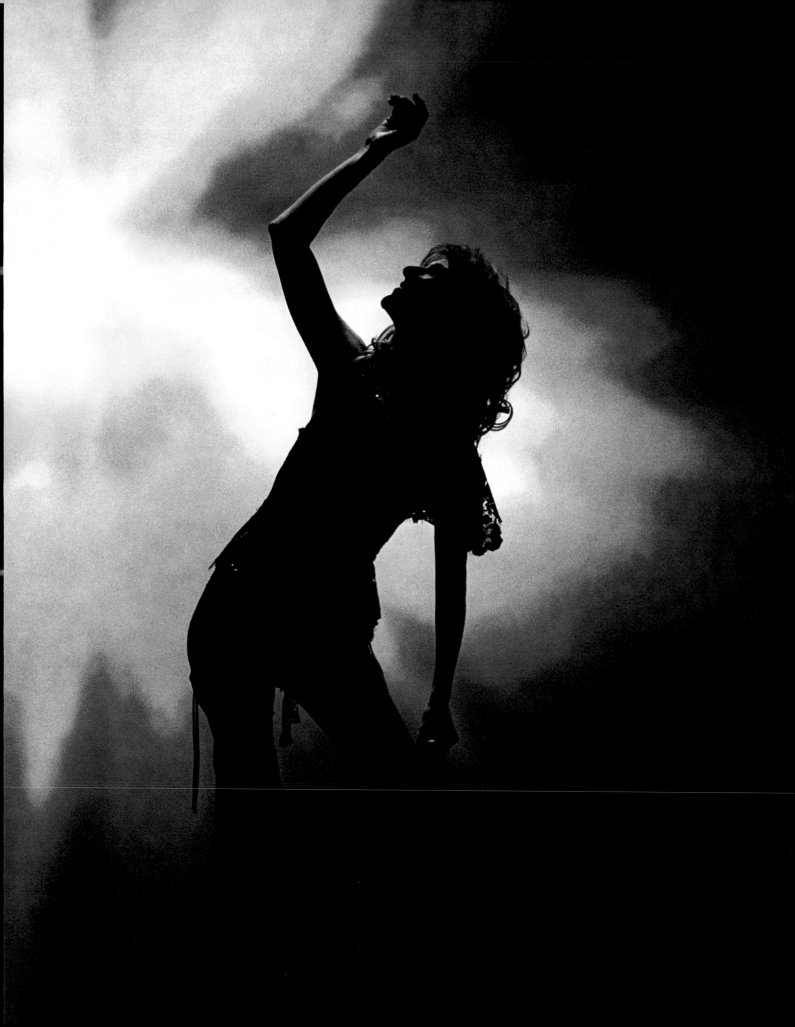

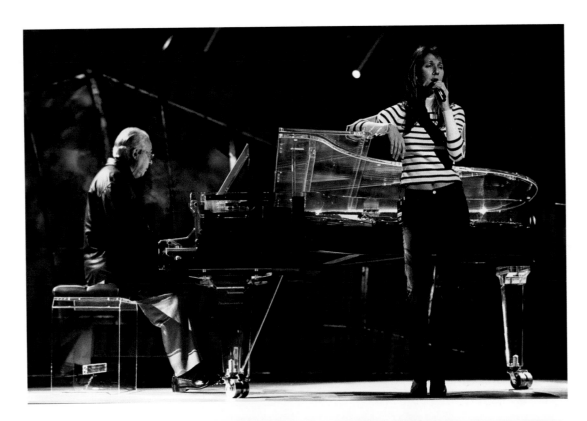

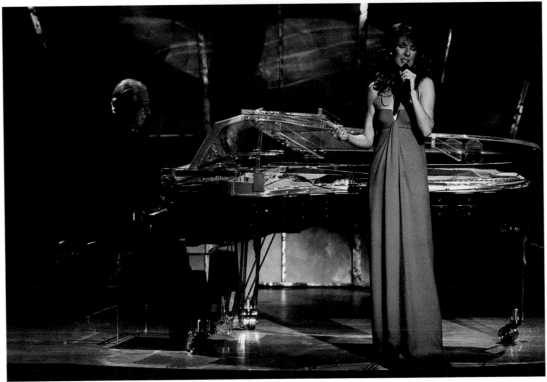

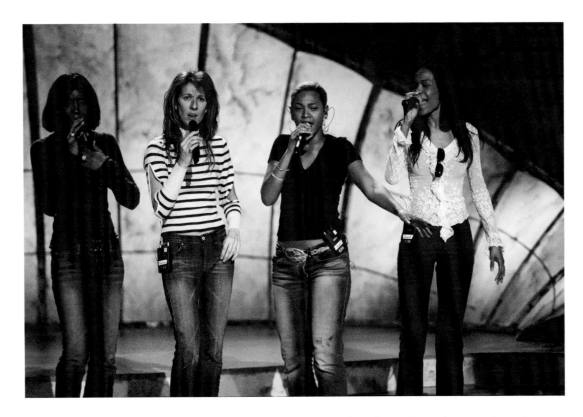

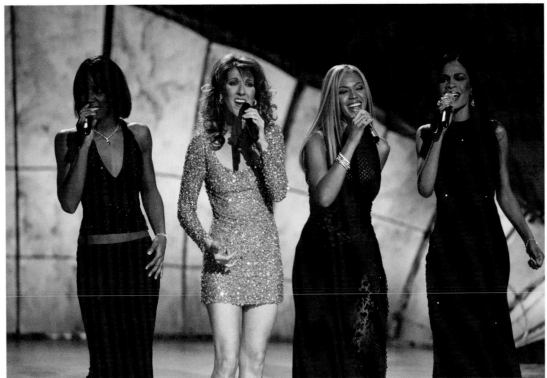

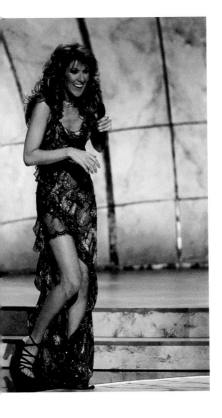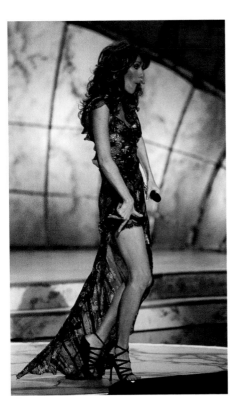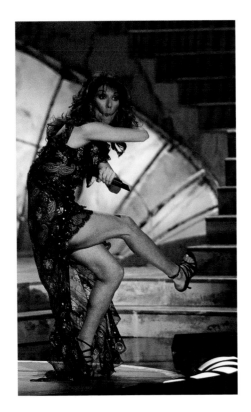

"I thought Céline would be embarrassed by these photos, but she laughed when she was reminded of the small technical glitch during that show."

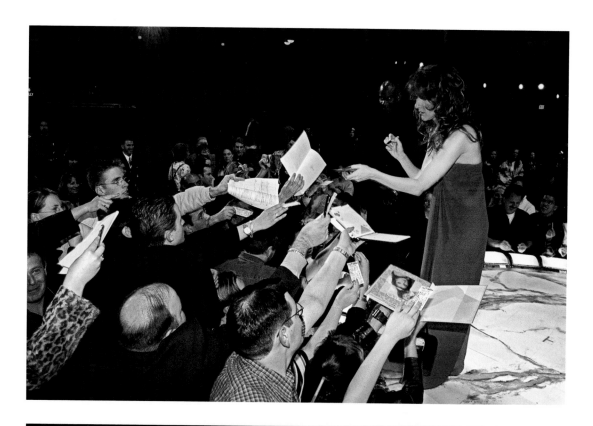

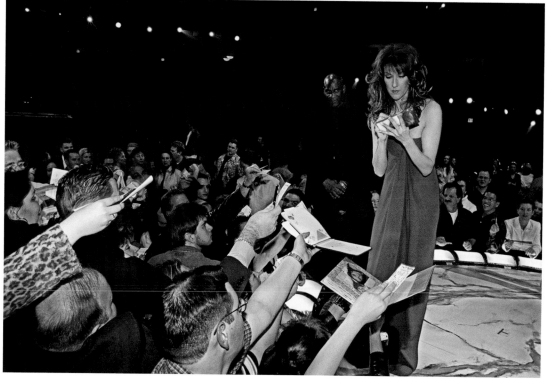

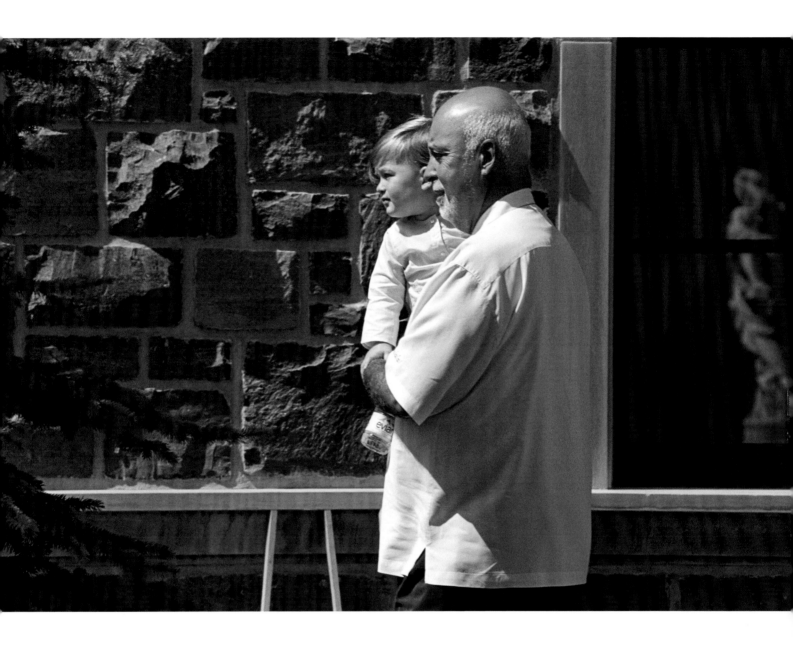

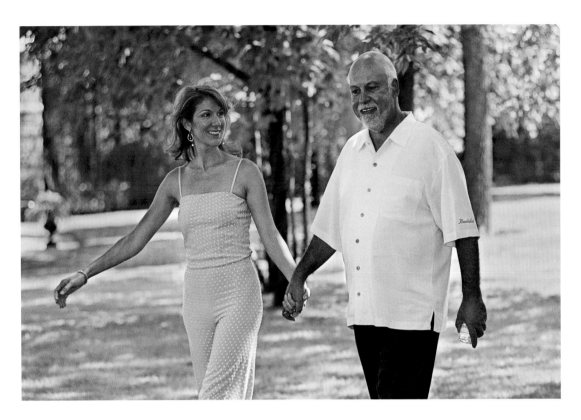

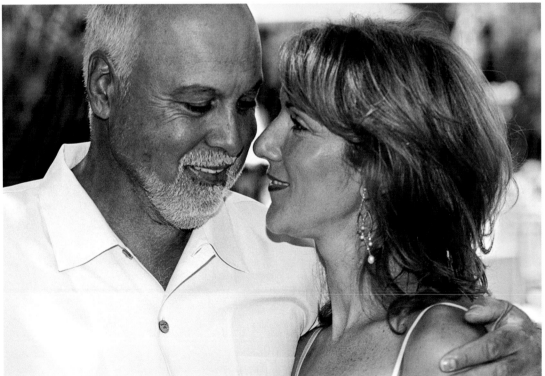

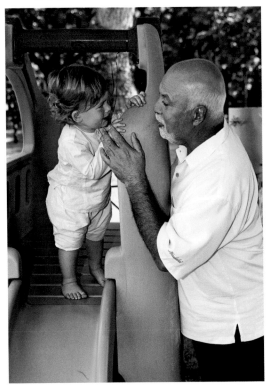

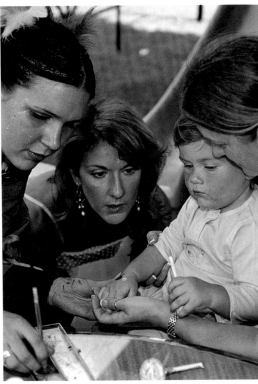

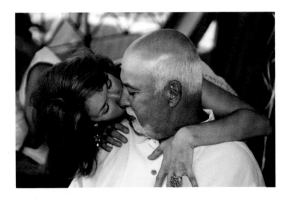

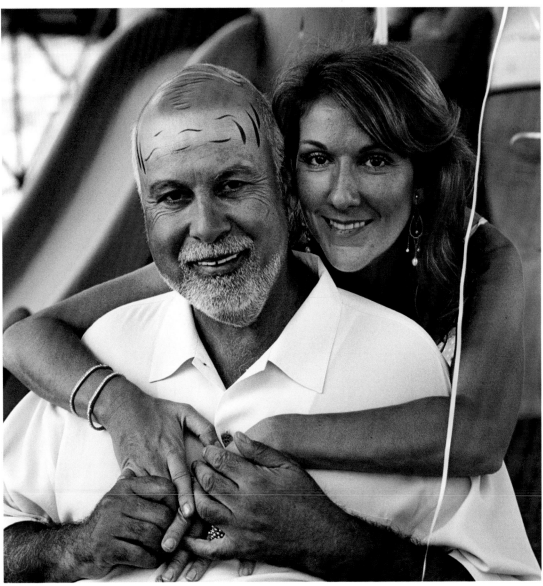

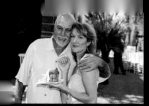

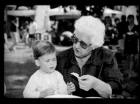

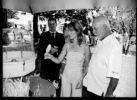

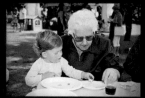

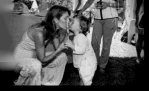
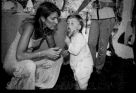
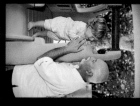

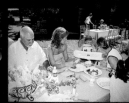
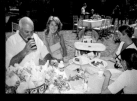
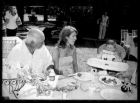
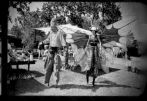

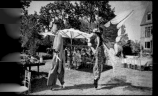
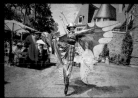
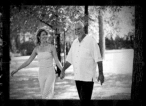

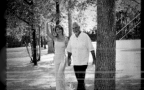

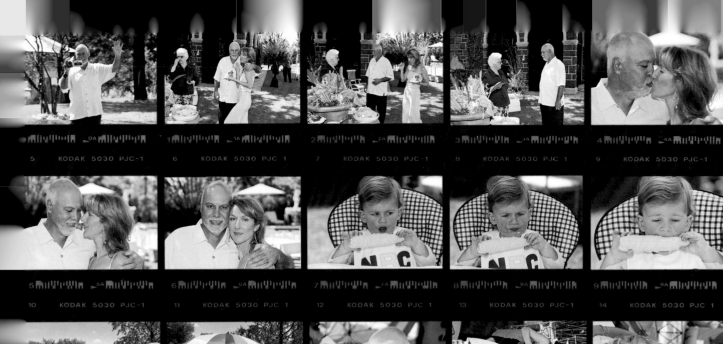

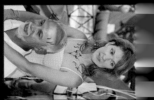

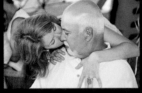

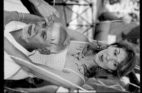

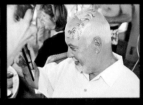

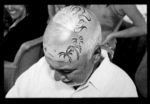

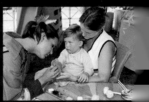
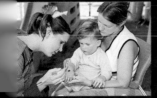
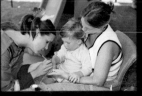
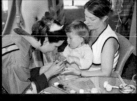
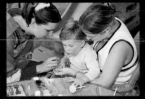
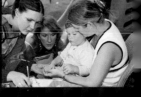

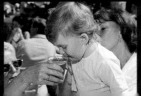

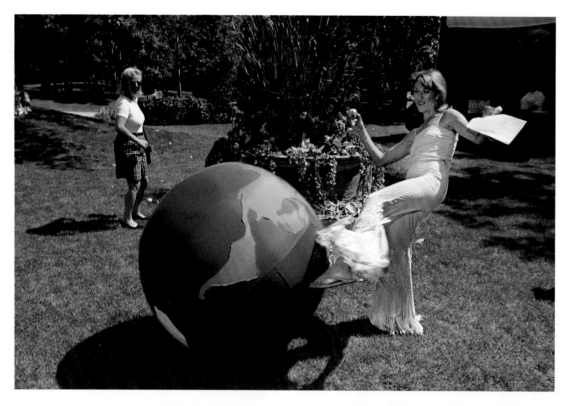

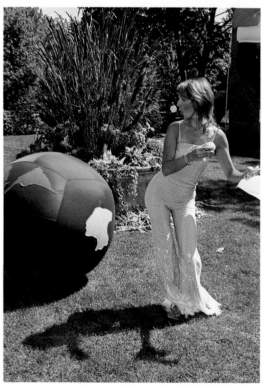

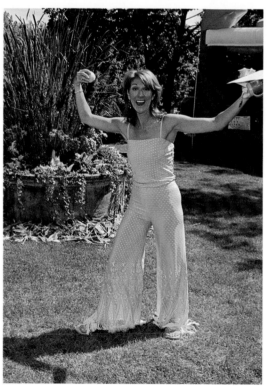

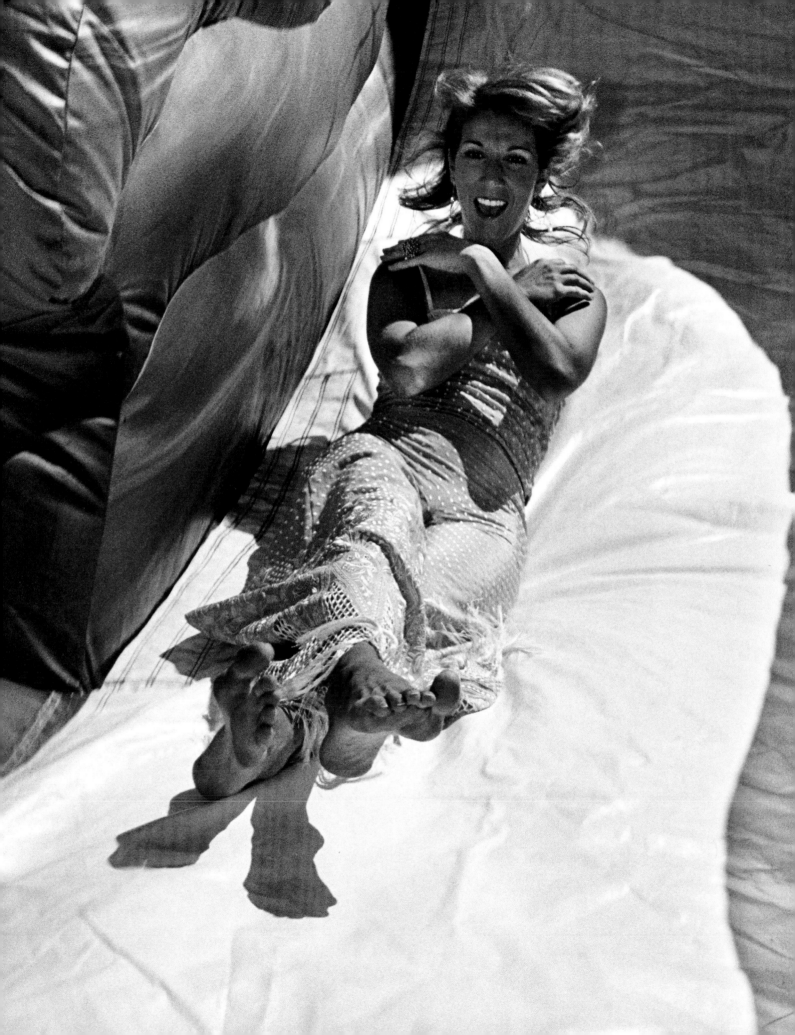

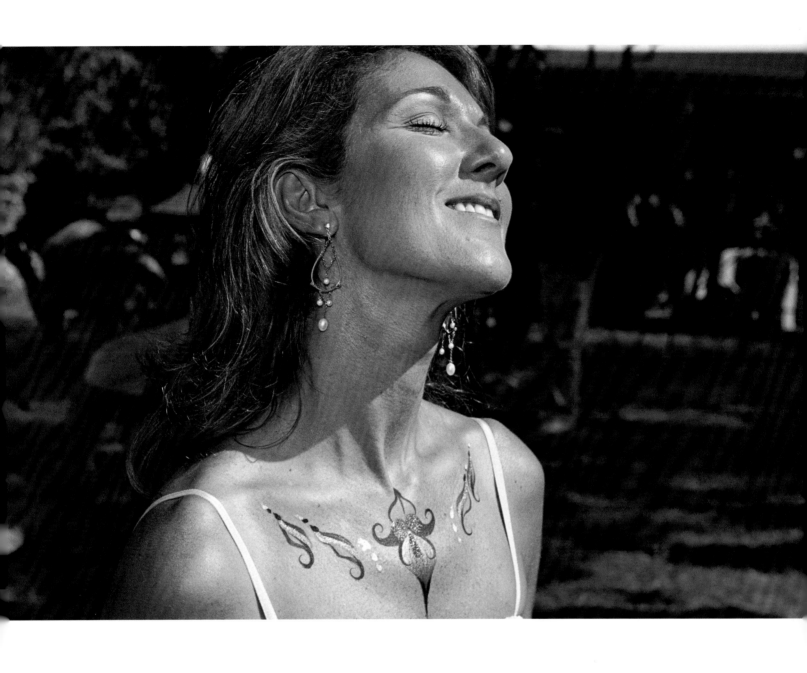

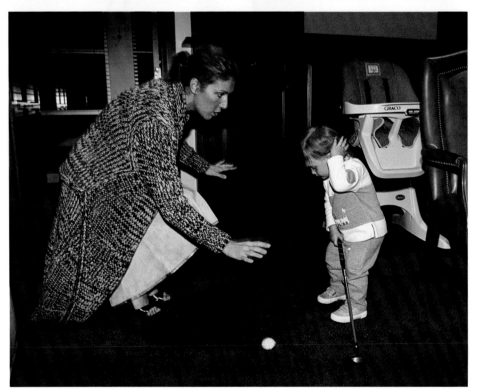

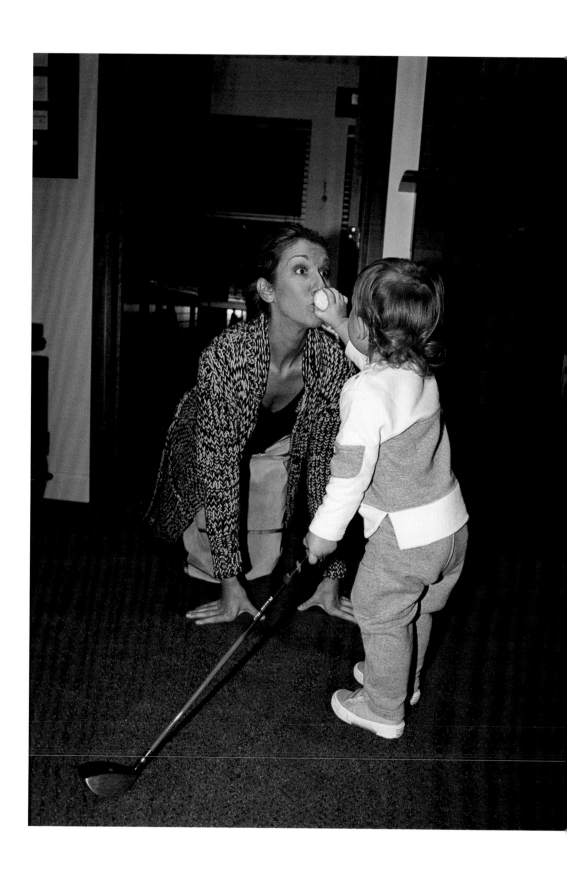

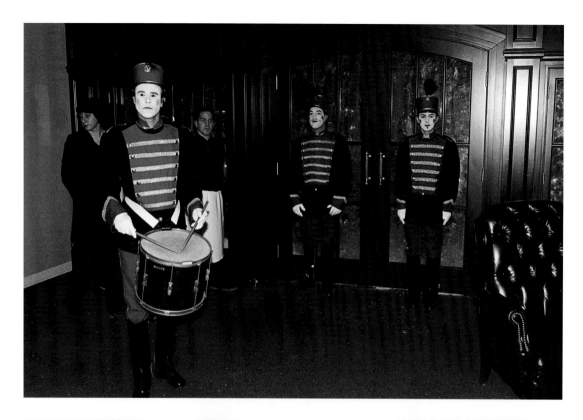

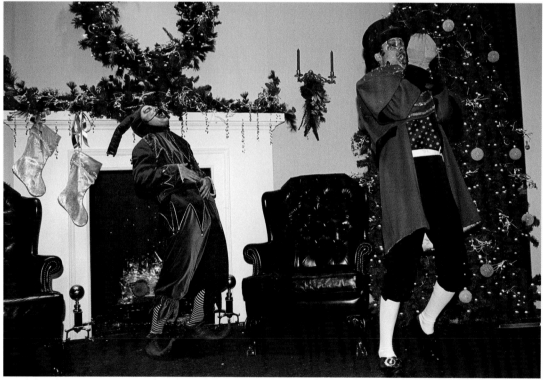

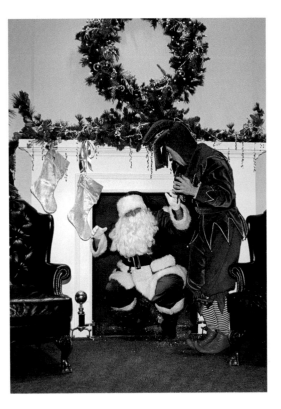

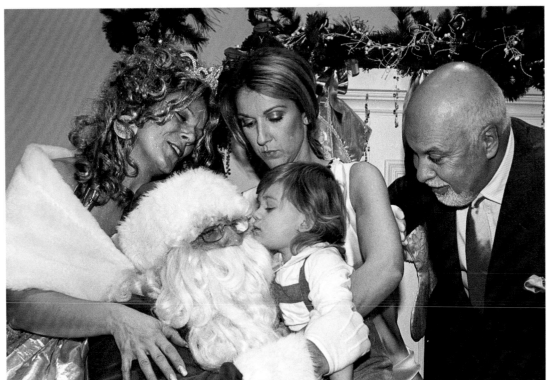

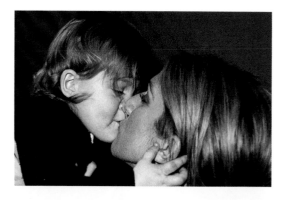

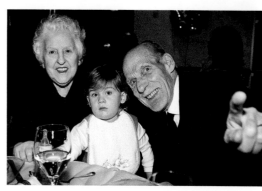

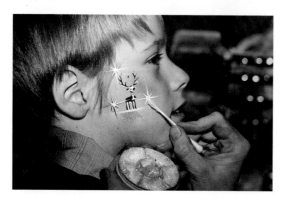

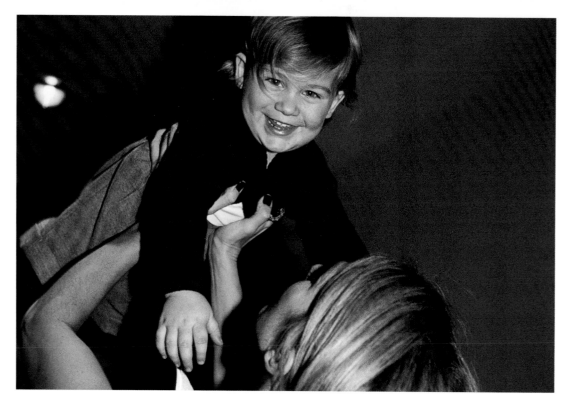

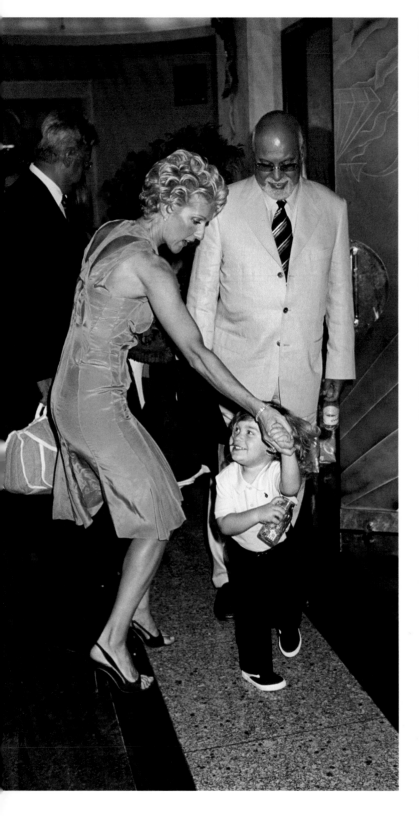
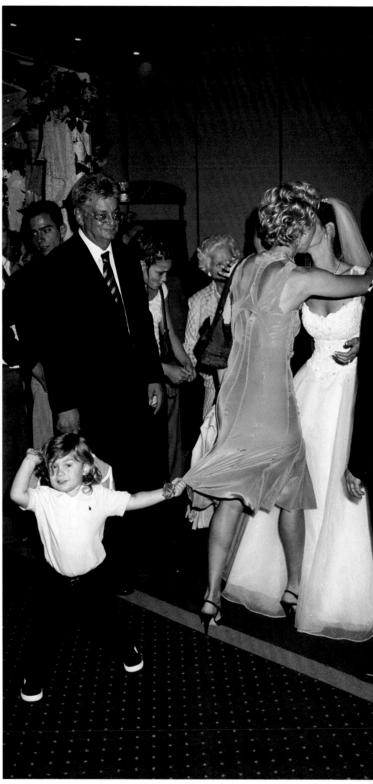

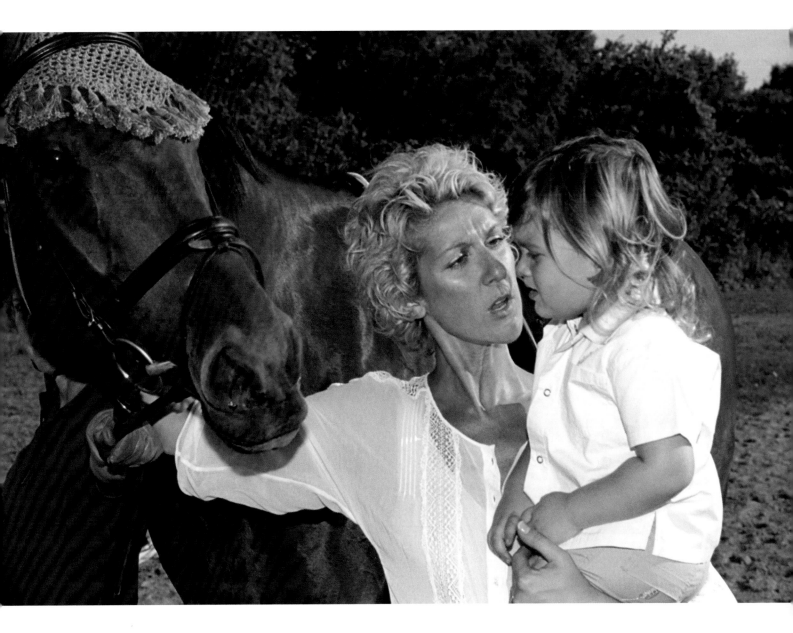

In July 2003, my two sons and I were invited to a picnic with Céline, René, and their son. Céline greeted my boys warmly. I remember her running her hand through their hair as she kissed them. I was happy. The afternoon ended with a visit to a stable where René-Charles befriended a pony. It felt like a vacation day, not at all like work.

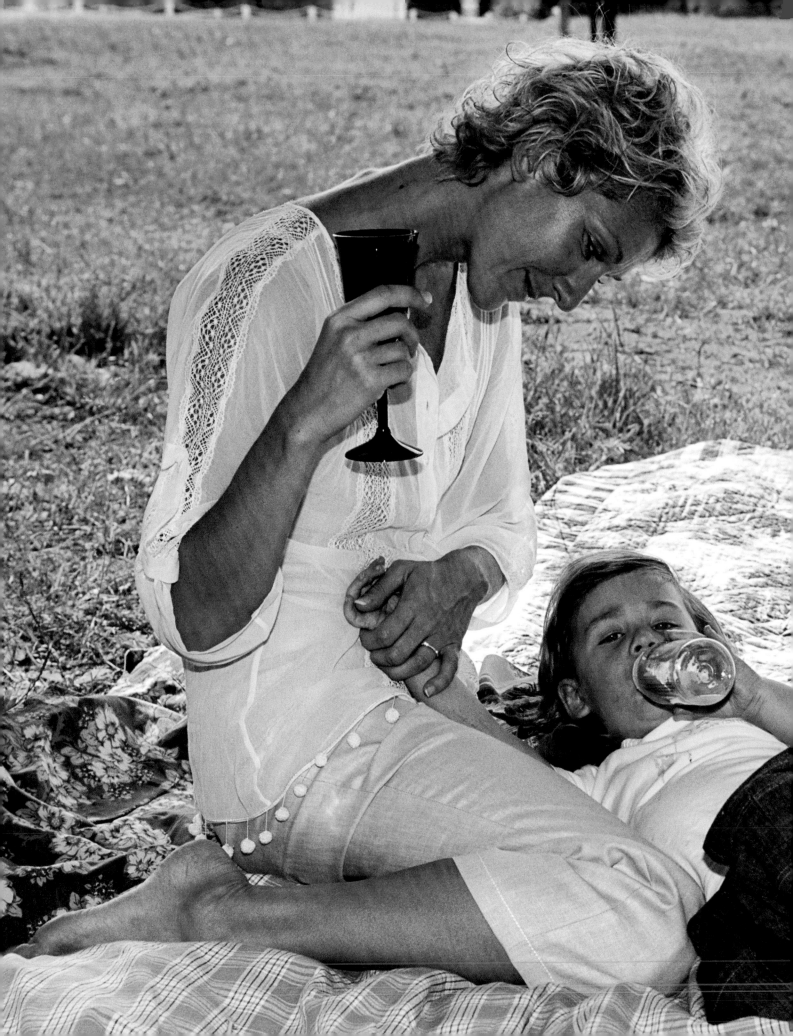

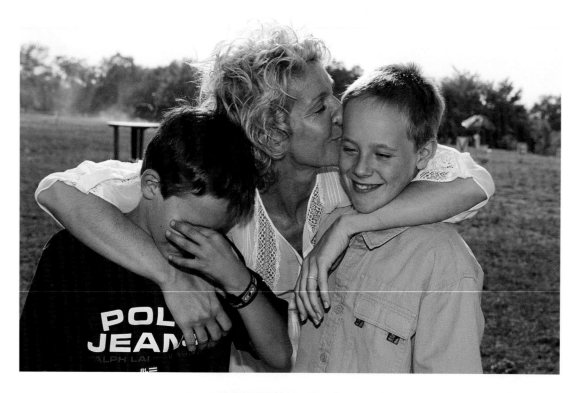

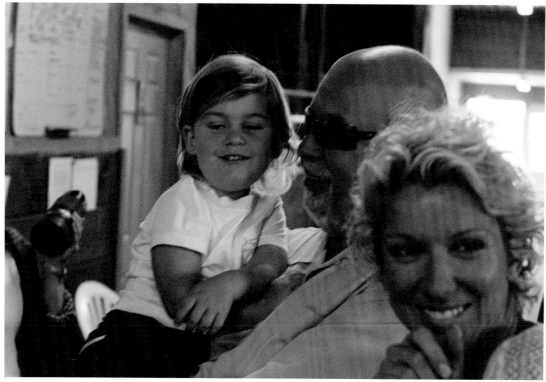

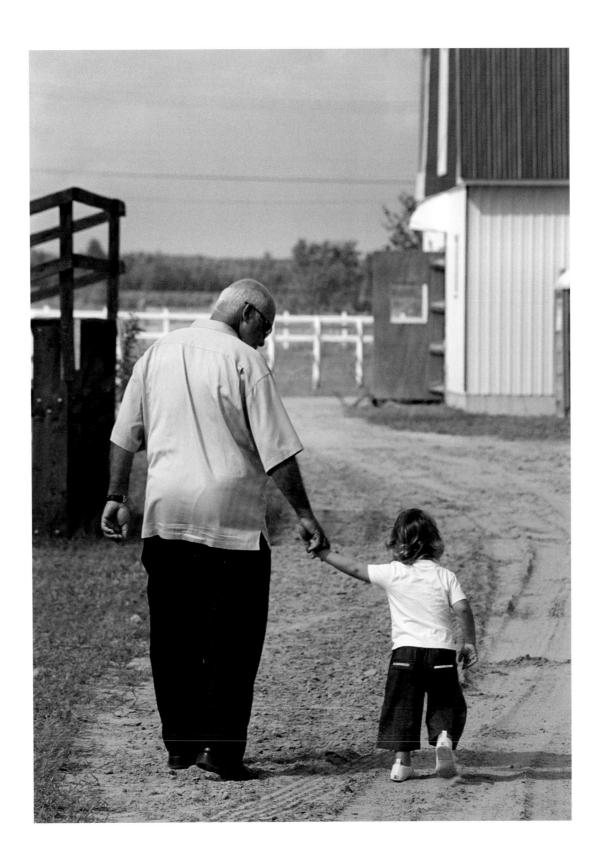

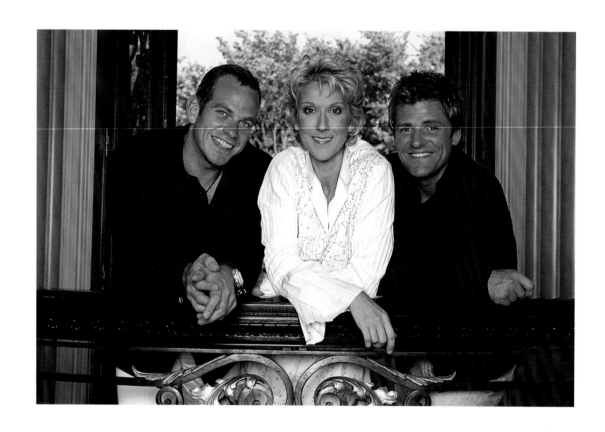

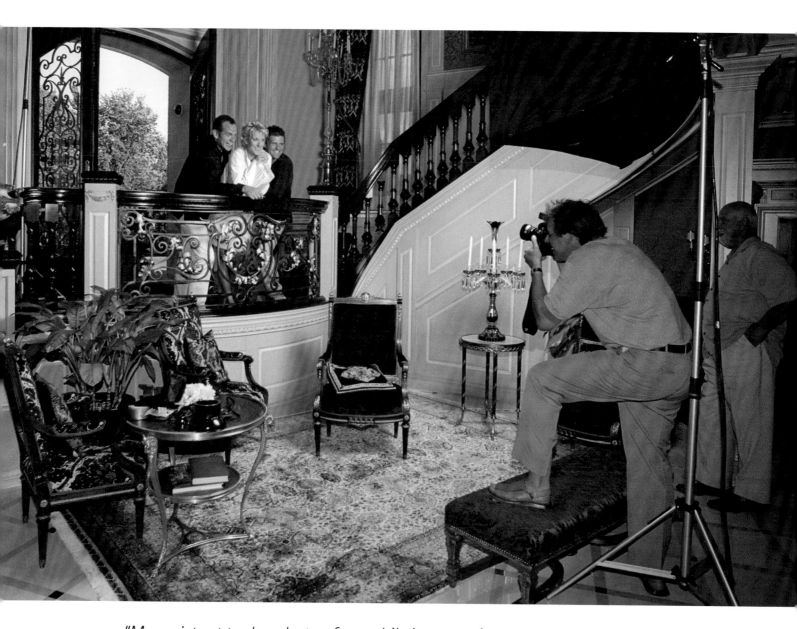

"My assistant took a photo of me while I was setting up a shot. We were all taken by surprise and looked over at him. He defended himself by calling it the making-of. I never imagined that photo would be published one day!"

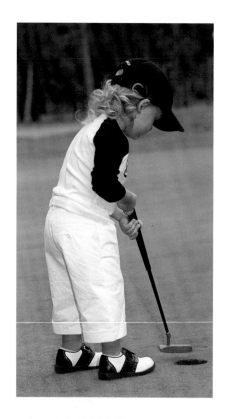

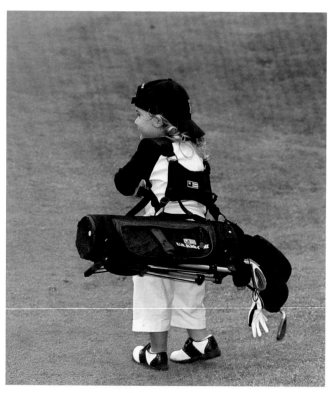

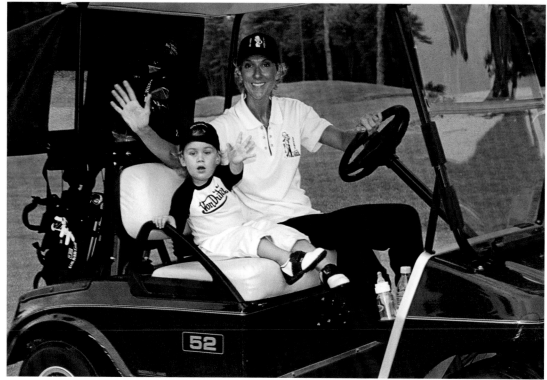

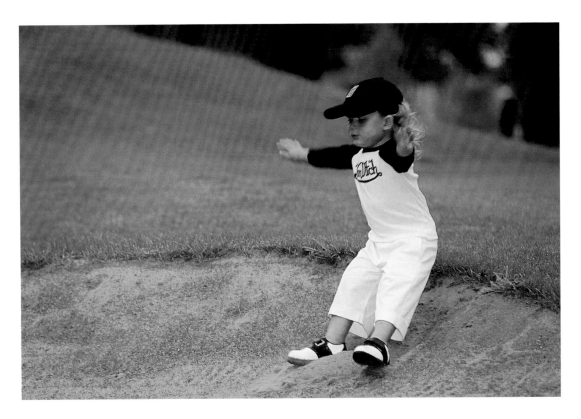

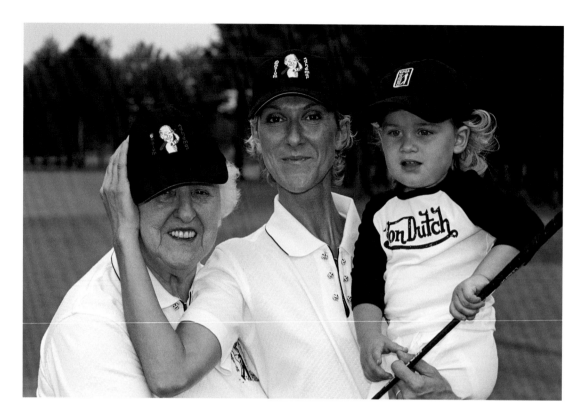

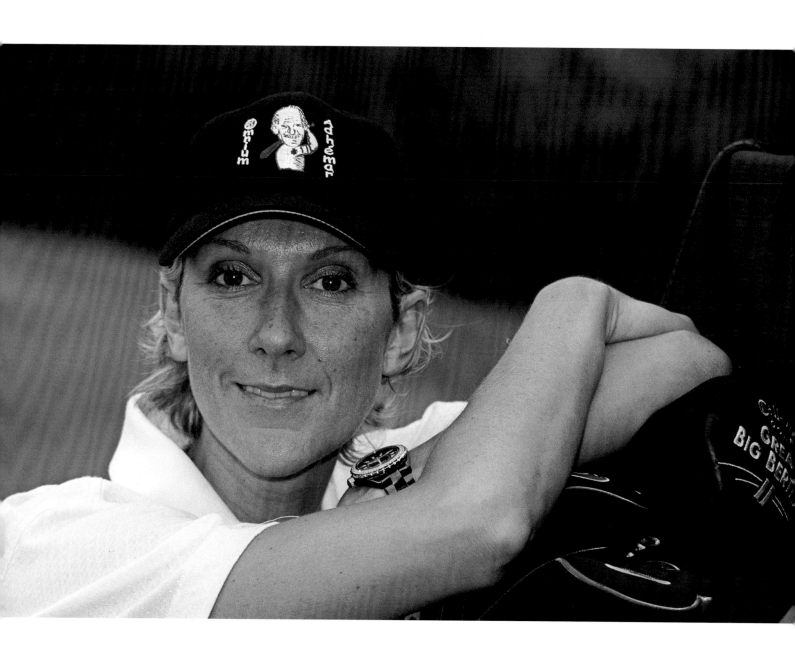

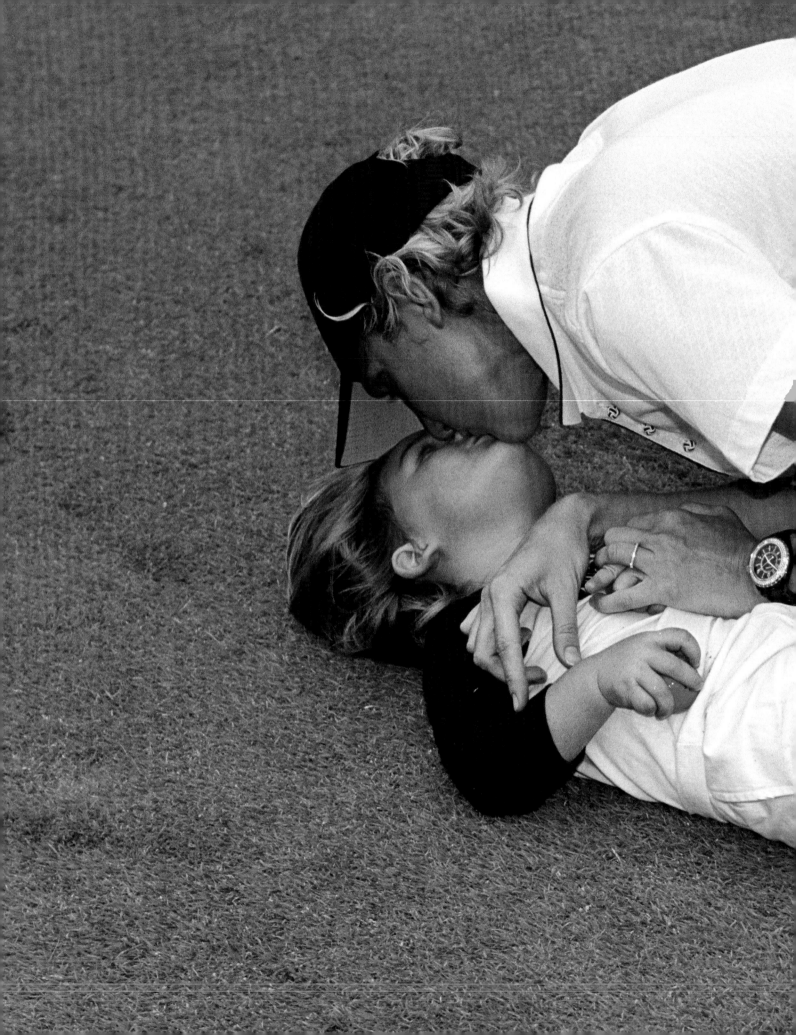

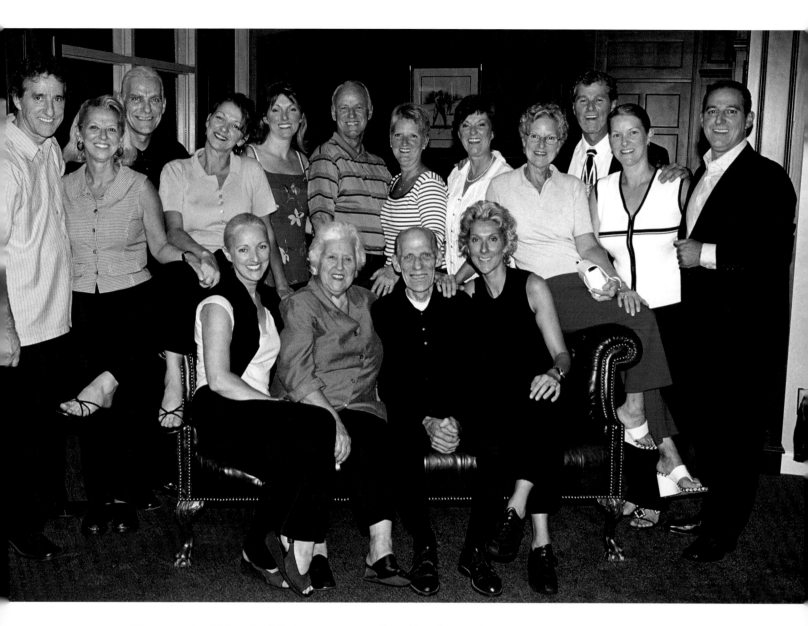

"I'm so glad I took this impromptu family photo. It was the last one of the whole family together, because Céline's father passed away a few months later."

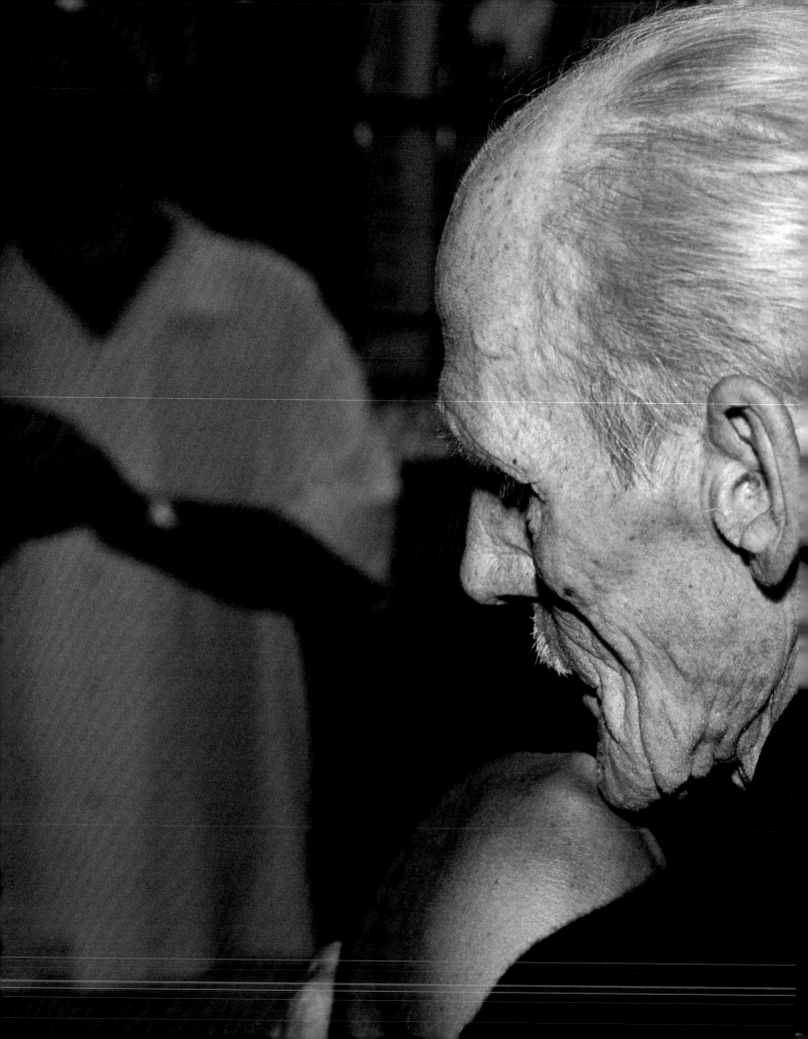

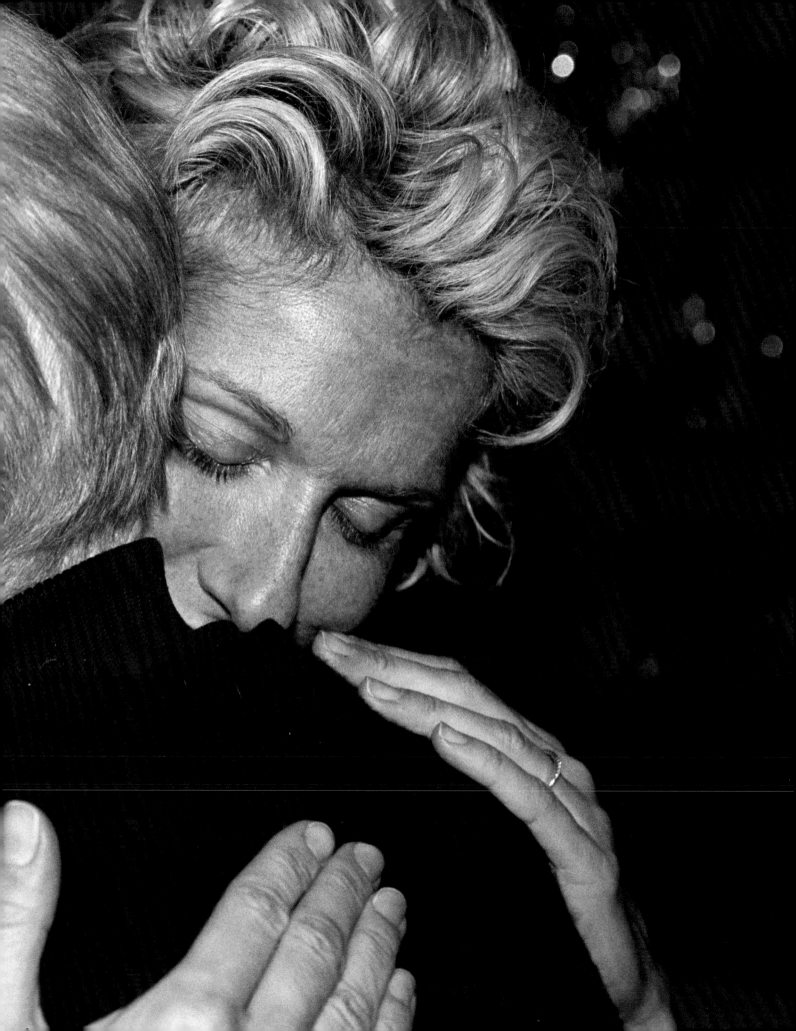

The following October, I travelled to Céline and René's Las Vegas home for a photo shoot that marked the beginning of their first family album.

I saw how happy they were and I hid the fact that, little by little, I was feeling the urge to start drinking again. I struggled to keep it together, in spite of everything, but my taste for the needle kept nagging at me. Alcohol and drugs were linked in my mind, and they were disastrous company.

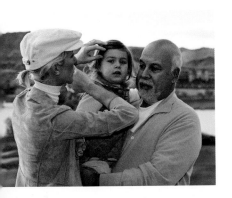 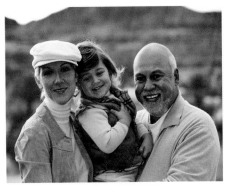 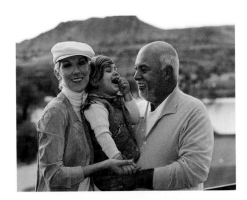

 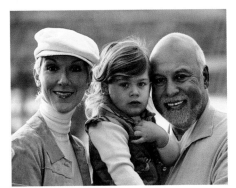 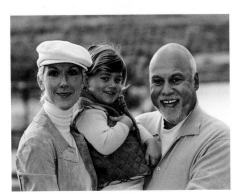

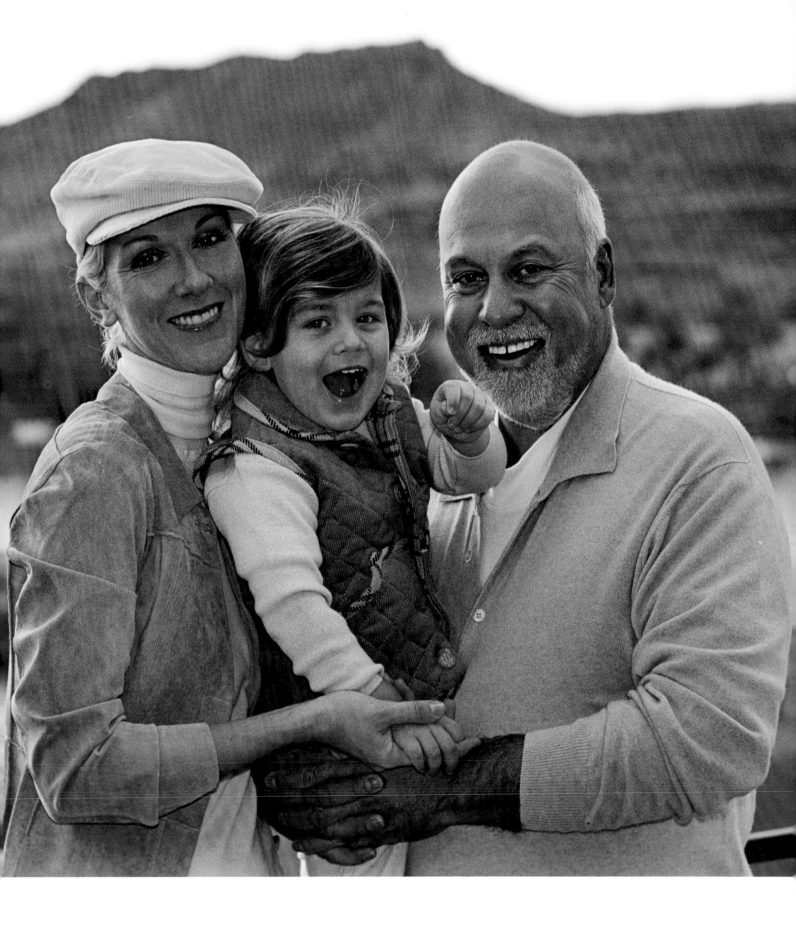

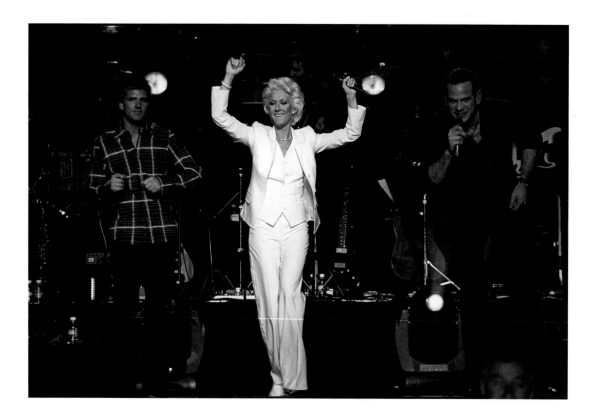

In December, a major fundraising event was held at the Bell Centre in Montreal to raise money for medical research on behalf of the Fondation André-Delambre. André had been Céline and René's accountant and right-hand man for 25 years. He was suffering from amyotrophic lateral sclerosis, a degenerative condition for which there is no cure. The entire Productions Feeling team volunteered to organize the event, which featured a gourmet meal and a performance by Céline, Garou, and Marc Dupré. Tables cost $25,000 each. More than 900 people attended the event. As a thank you, the organization planned to give 250 couples in attendance a photo of them taken with the three performers. With the help of a few photographer friends, I managed to deliver all of the framed photos by the end of the evening. The dinner raised $1 million. André Delambre succumbed to the disease three years later, on January 9, 2006, but the foundation continues to be successful and is now run by Jacques Dion, one of Céline's brothers.

"A moment of panic when I'm caught off guard as my camera jams. Phew!"

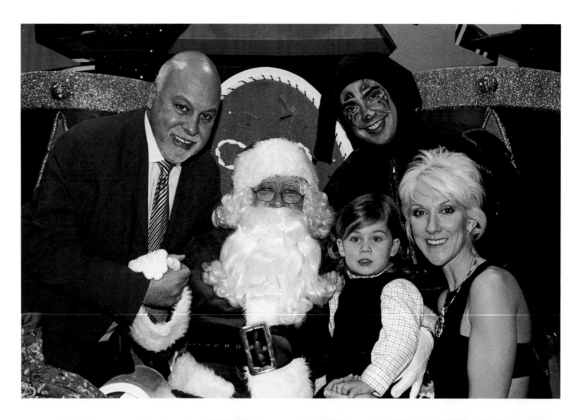

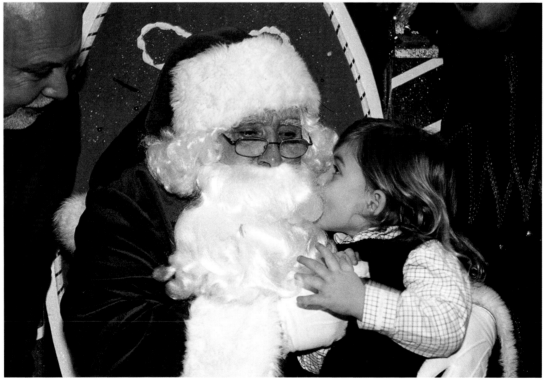

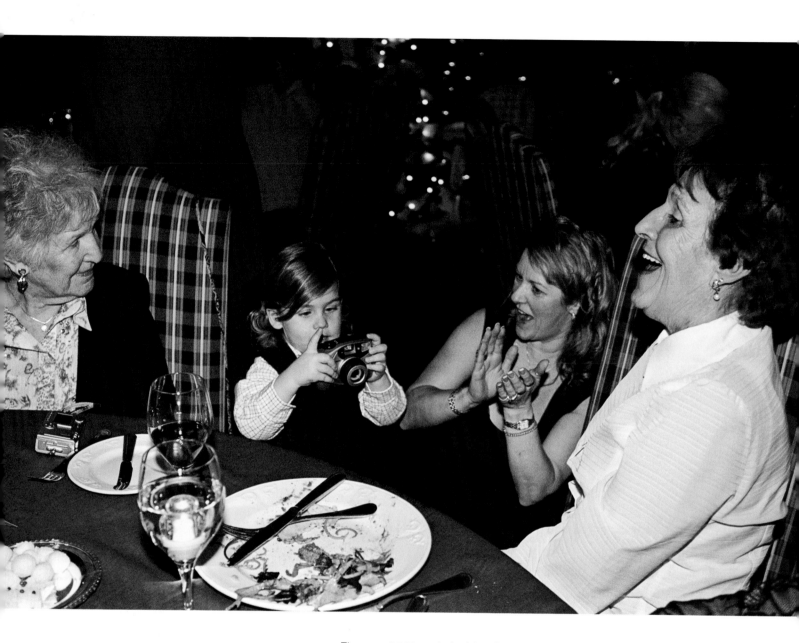

The year 2003 ended with a Christmas party at Le Mirage — my third. As usual, the day was carefully organized down to the smallest detail, following a tradition that repeats itself every year. This time, there were rides on dogsleds drawn by huskies and horse-drawn carriage rides to entertain the guests. Céline played in the snow with her son, something she dreamed of for so long.

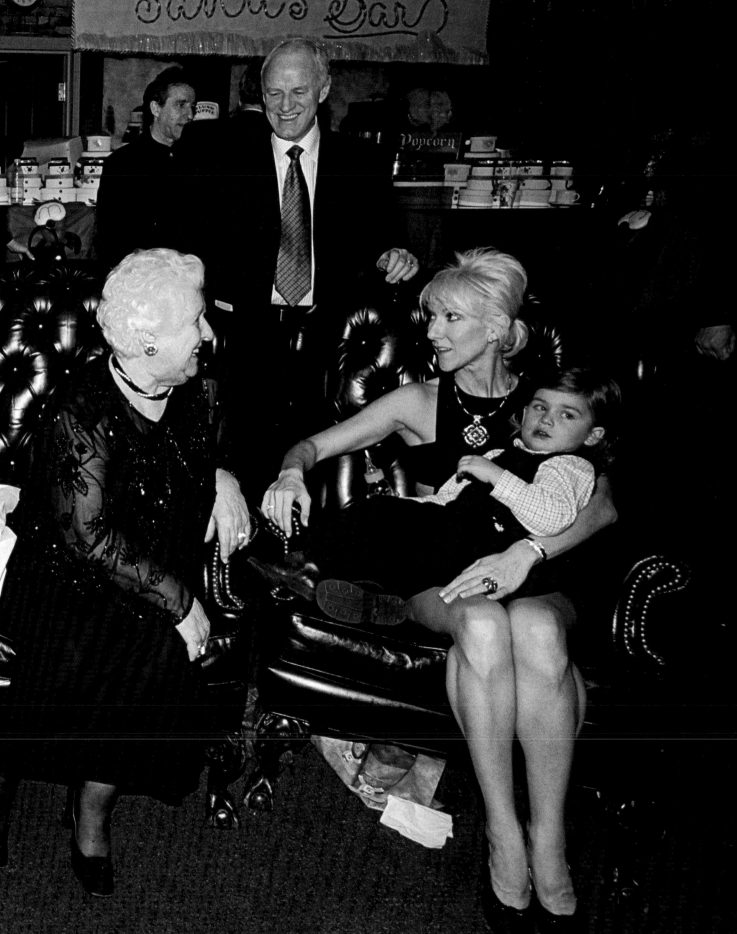

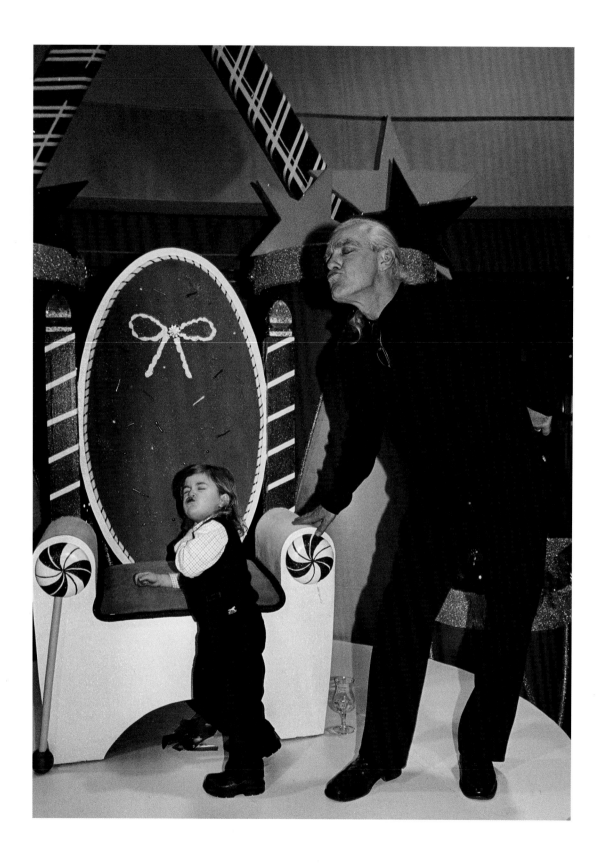

"René-Charles and Céline's brother Michel amuse themselves by imitating Céline's famous scowl. I've captured that expression often, as you can see on pages 35, 93, and 161."

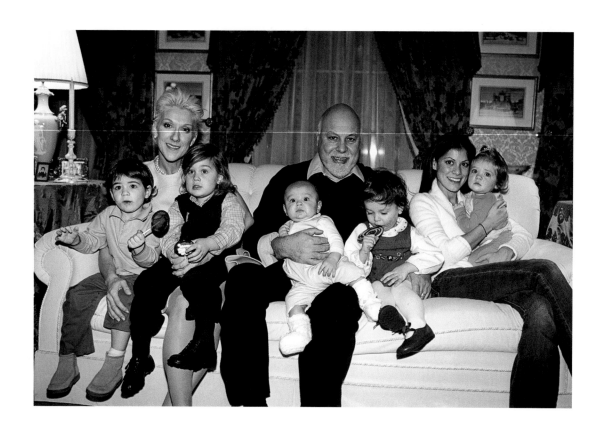

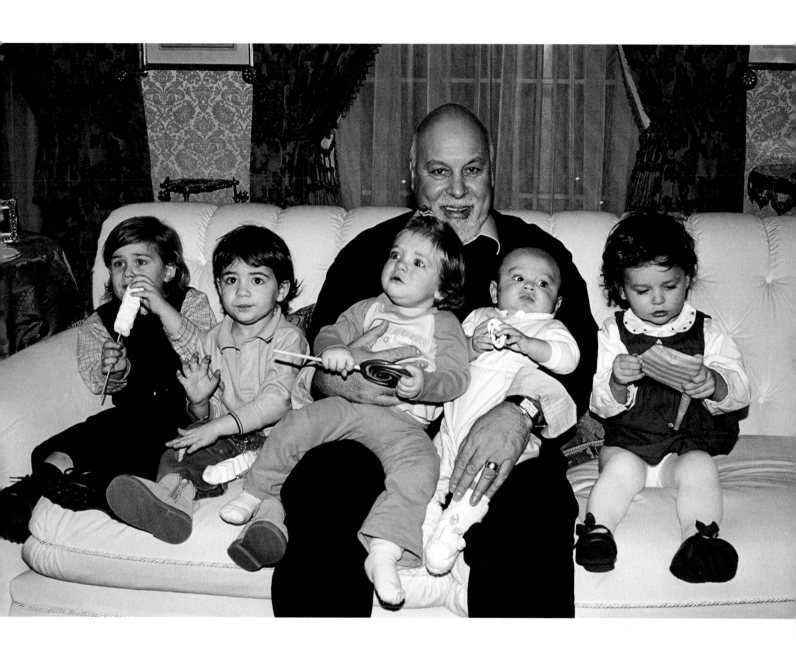

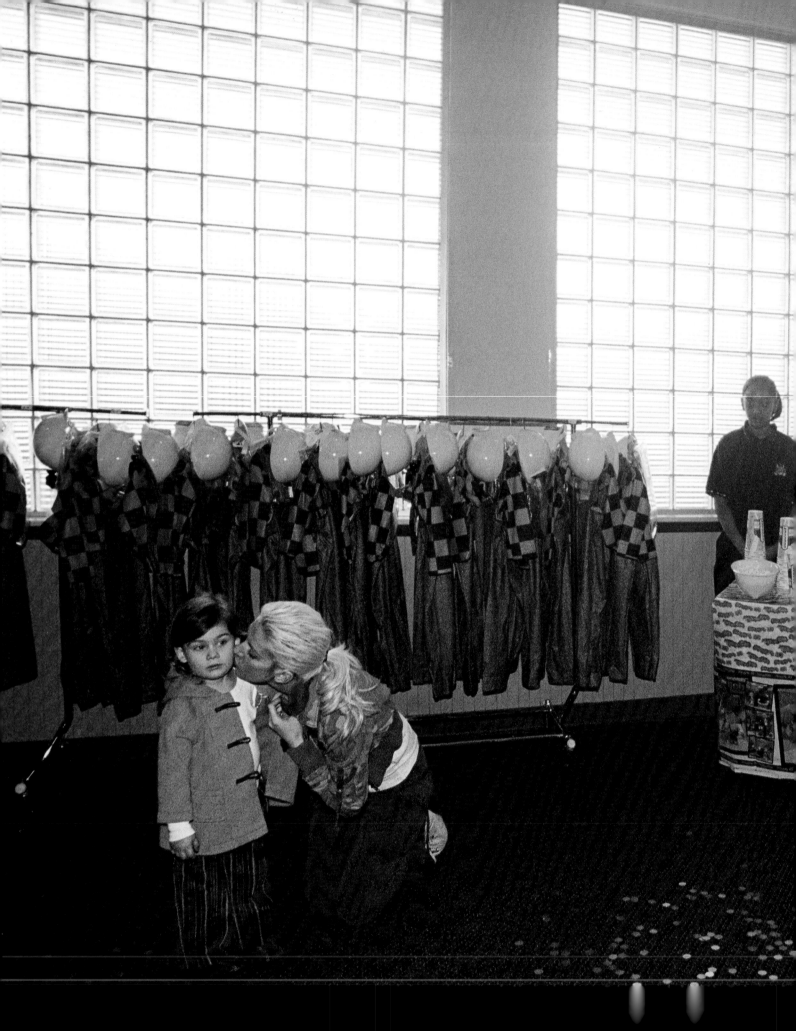

René-Charles celebrated his third birthday on January 25, 2004. One of my sons turned 10 that same day. We were both invited to the celebration in Las Vegas. The Bob the Builder–themed party was attended by many of the children of Céline's Caesars Palace show team. I took photos of the kids enjoying themselves with complete abandon. Céline taught her son how to bowl. Back at our hotel room, my son was greeted with a birthday cake and lots of gifts. I still couldn't get used to this kind of generosity.

Around this time, my obsession with drugs and alcohol grew. I felt my addiction returning. It had been out of sight for 15 years, but now it was looming before me again. Today, I know that many people relapse after 10 years of sobriety because they become too self-assured . . . They no longer feel at risk.

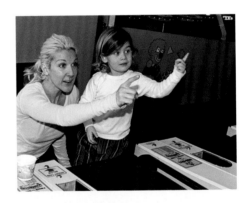

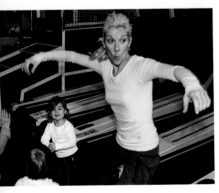
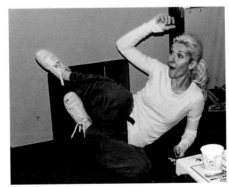
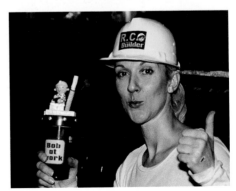

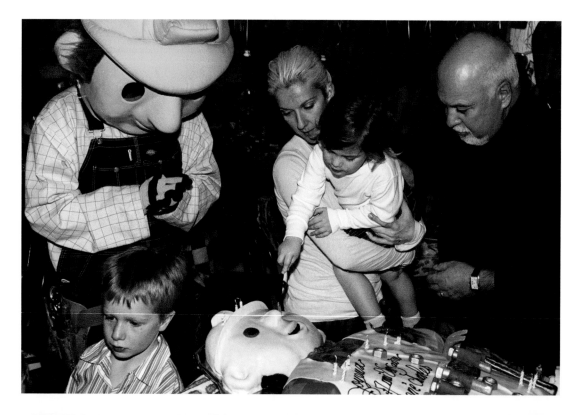

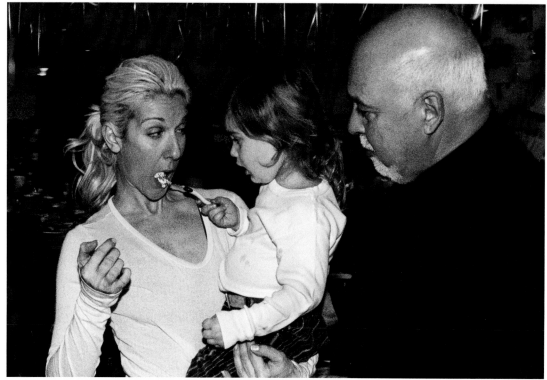

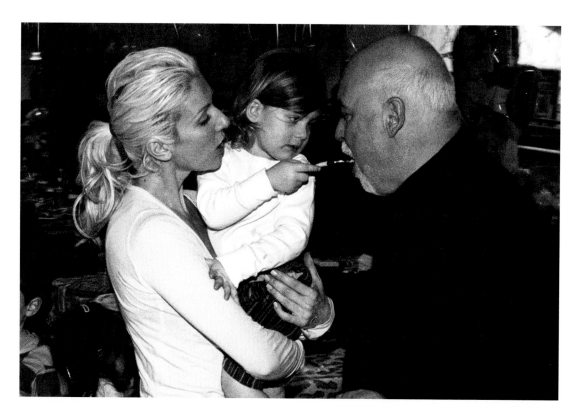

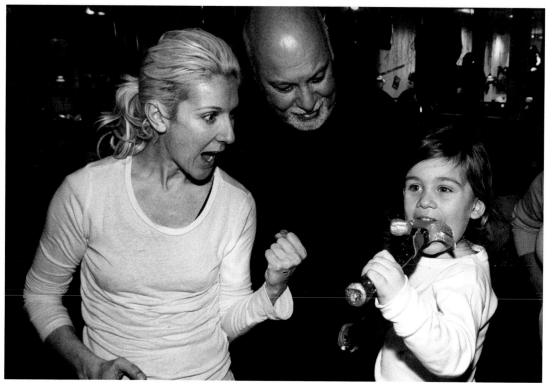

One evening in August 2004, I was dining with an old friend who had been sober for 15 years. I had a drink, and she thought to herself, "Why not have one, too? To celebrate the occasion." Big mistake: a few minutes later, she said to me, "I want some coke."

She insisted — and my old habits came back instantly. A couple of calls later and we were at Jim's, where I bought some cocaine. The downward spiral to hell had started again.

It didn't stop me from going to a golf tournament at Le Mirage that same month to take photos or from attending the family's annual corn roast party. I was doing a good job of fooling people. At least I thought so.

On December 24, I went to Céline and René's home on Île Gagnon to take a family photo. I had a glass of champagne with René, his sons Jean-Pierre and Patrick, and his brother-in-law Alain. When I left, I smoked some crack before heading off to join my wife and kids at my mother's Christmas party.

Crack, or freebase, is crystallized cocaine that you can smoke. It has an immediate effect that resembles the feeling you get when you shoot up. I was spending $1,300 a week on crack. I took a puff every 10 minutes.

The holidays were a blur . . .

In January 2005, my friend Léo drove me to the Nouveau Départ clinic, where I started a recovery program. On the way there, I finished the crack I had left. I wouldn't dream of wasting it! The treatment consisted of an intensive four-week detox program. While there, I behaved like a child who craves attention. I walked around carrying a Buddha figurine in my hand. I shaved my head. My confrontational attitude toward authority figures attracted the attention of a recovering drug addict and alcoholic named M-C. I fell in love with her, not for the better. I was clean again and, on March 7, I checked myself out of the clinic. I managed to stay off drugs until July. Those six months felt like an eternity.

M-C went back to her native Switzerland. I missed her. The distance was hard on both of us. She came back to Montreal in October. By that point, I had decided to leave my wife. M-C and I flew to Switzerland in November, two carefree lovers. There we were, two addicts trying to get clean. We figured we understood what the other was going through

and that it would be easier to help each other. But when a couple experiences a down, it's easy to give in to the addiction. Relapse is always lurking. We returned to Montreal for the holidays. We celebrated Christmas, just the two of us alone with crack and booze.

In February 2006, M-C went back to Switzerland. She was very sick. She was taking a lot of pills and drinking non-stop. I managed to stay sober for a little while, but her absence weighed on me; I missed her. I flew over to see her for a few weeks in June. She wasn't doing any better. She was picking fights and freaking out about everything. I realized that what we had was leading nowhere. I returned to Montreal heartbroken.

In July, the needle became my friend again. It was all I lived for.

With every fix, I tried to relive my very first high. I never found it. It was a pointless quest. Every relapse was a call for help. I felt like yelling, "Take care of me!" I needed to draw attention to myself, just like when I was young and wanted my brothers to take me everywhere with them.

At the end of August, I overdosed on coke after concocting a big hit. I fell unconscious on the wood floor so hard that I broke my teeth. A friend came over and called 911. I stayed a short time in the emergency room until my condition stabilized. If it hadn't been for the bill I received for the ambulance ride afterwards, I wouldn't have known it had ever happened. When I got home, I noticed that there was still coke on the table. I shot up.

A kind soul brought me back to the Nouveau Départ clinic. I stayed for four weeks and followed up as an outpatient for another three weeks. This time, I befriended a Lebanese man. When we got out, we were two addicts who thought we could stay clean and help each other. Less than a month later, we were taking magic mushrooms, a hallucinogen that can't be detected in a urine test. Relapse! In mid-November, I shot up coke again. A cousin of heroin, it can be just as deadly. I overdosed again.

I couldn't go on like this.

This was how I found myself at a sumptuous party at Le Mirage on December 17, 2006, in a complete state of relapse.

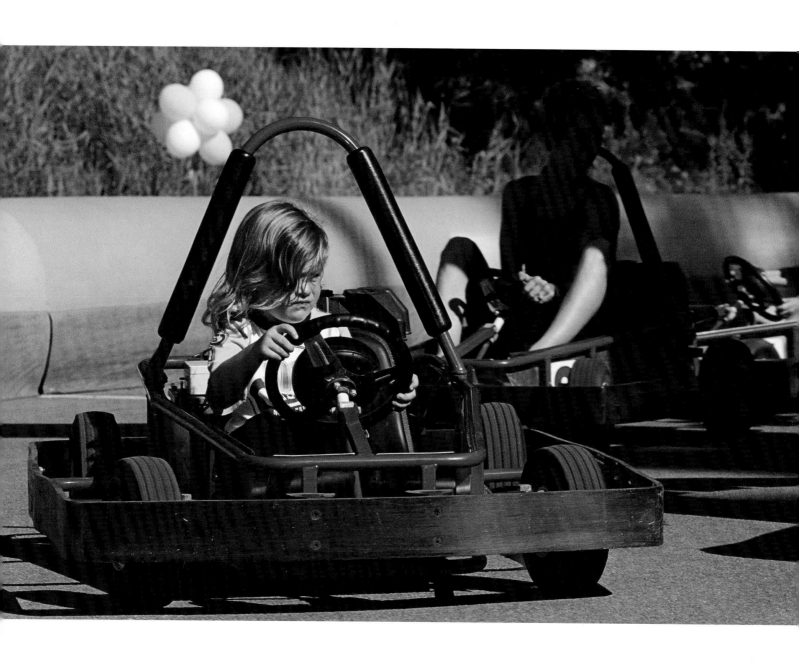

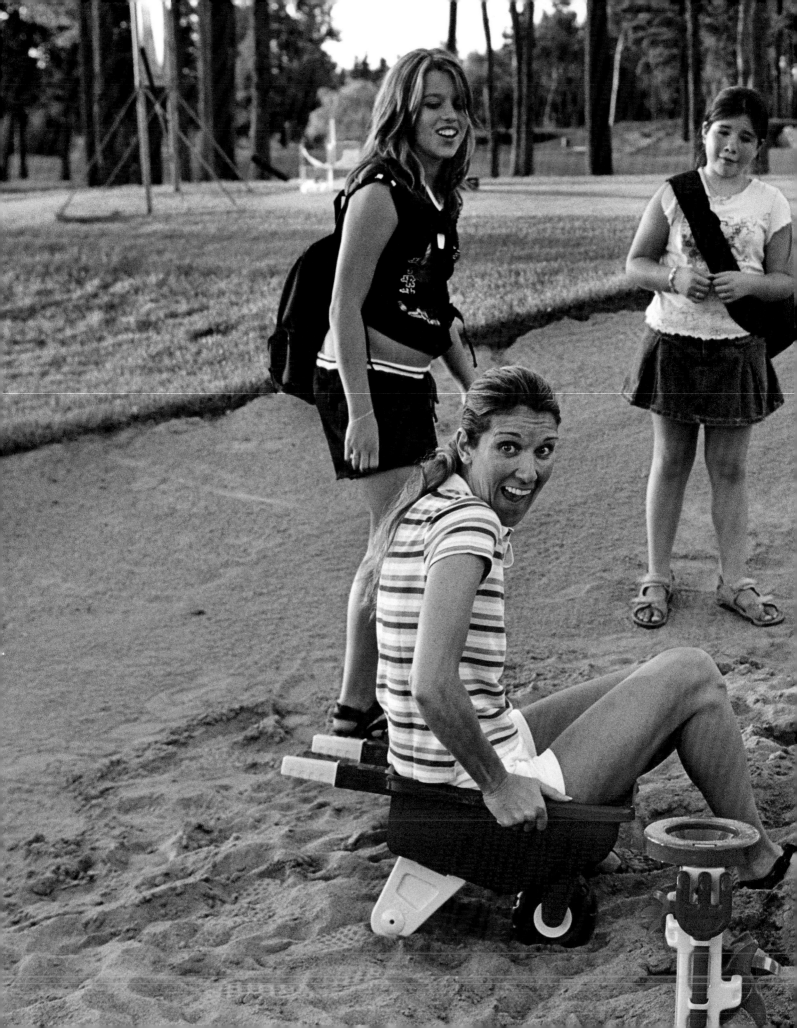

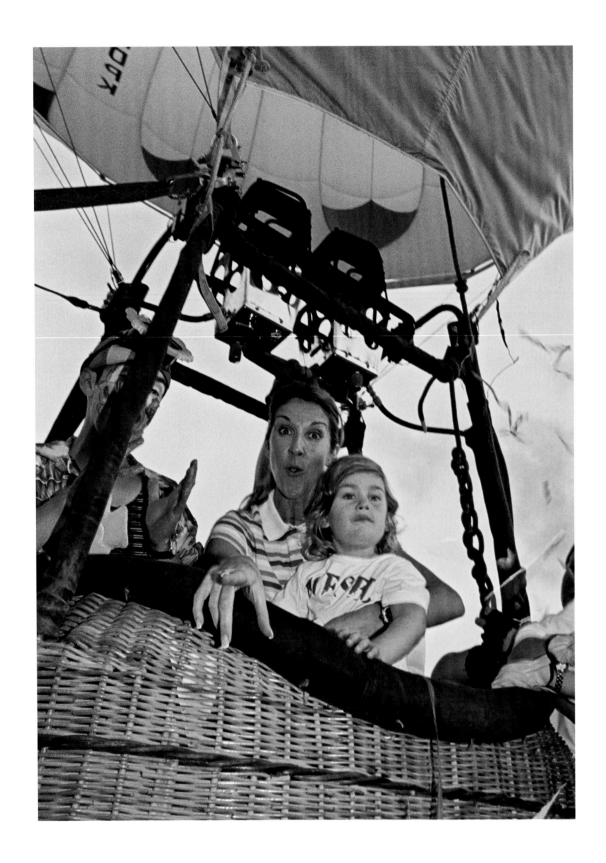

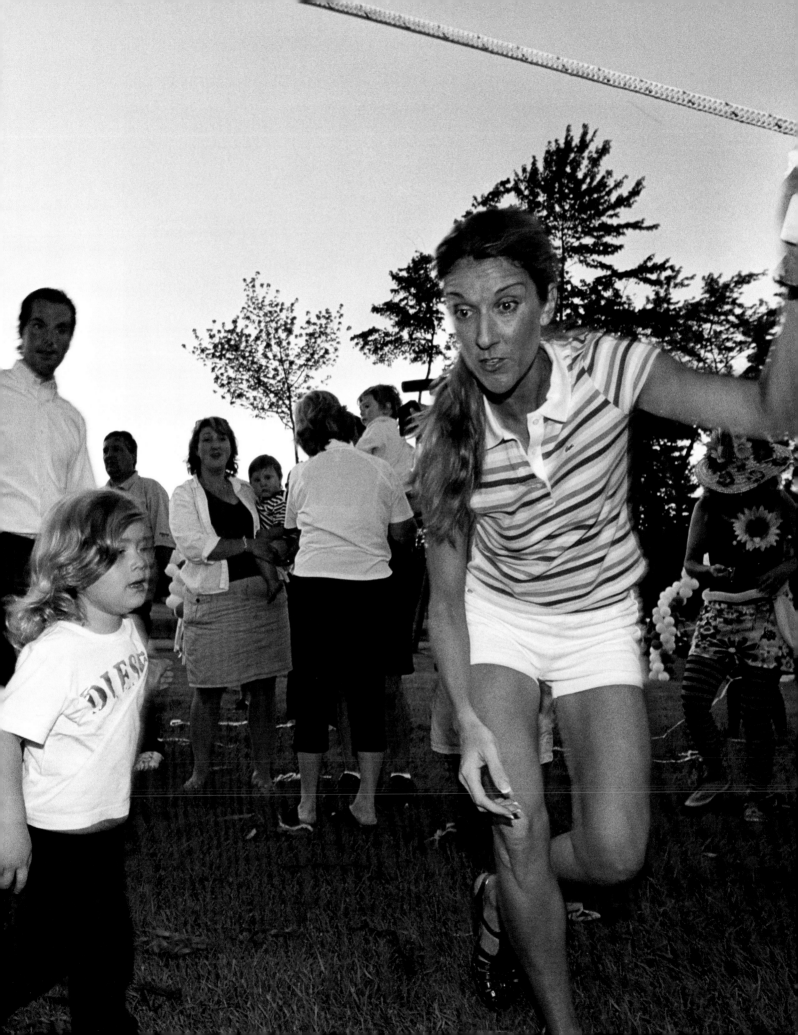

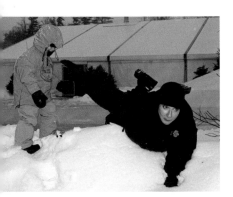 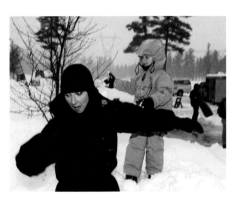 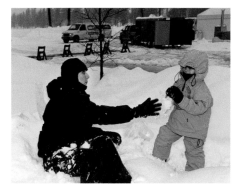

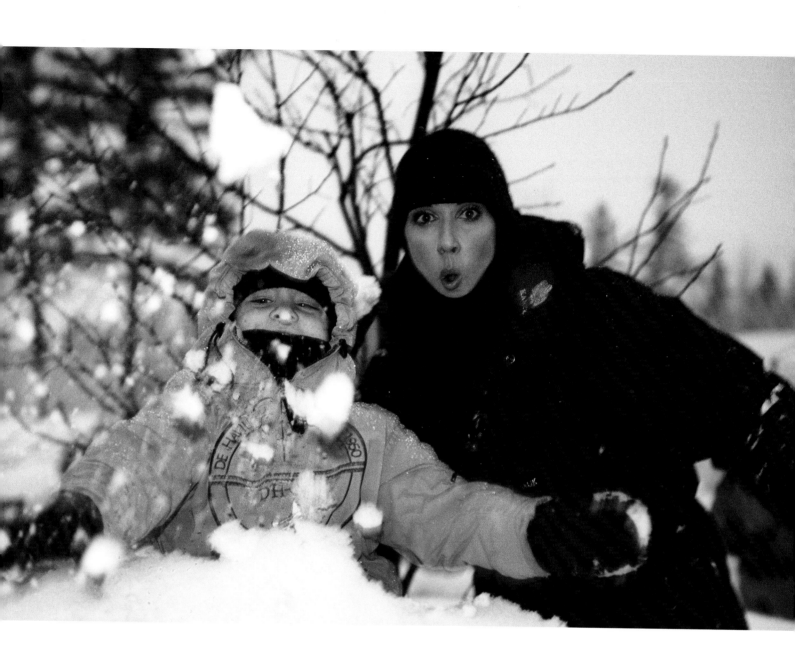

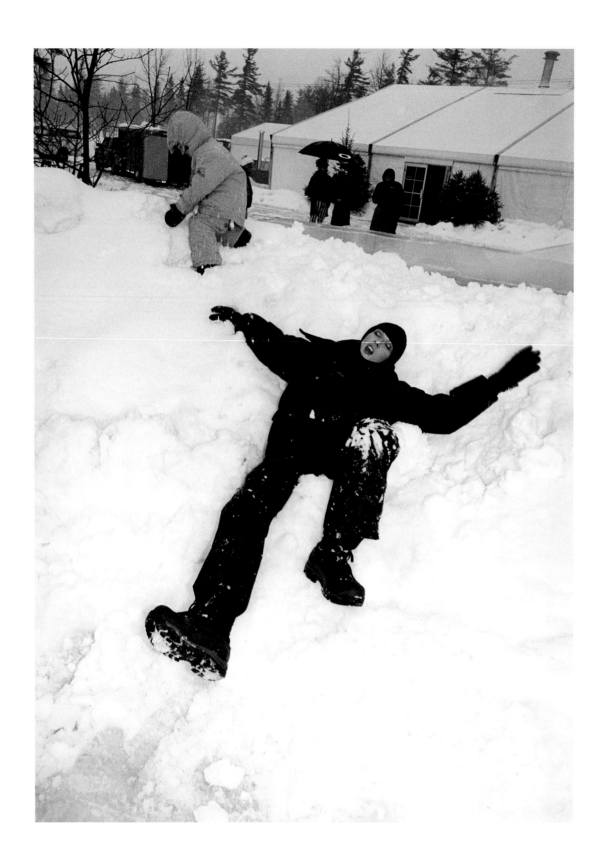

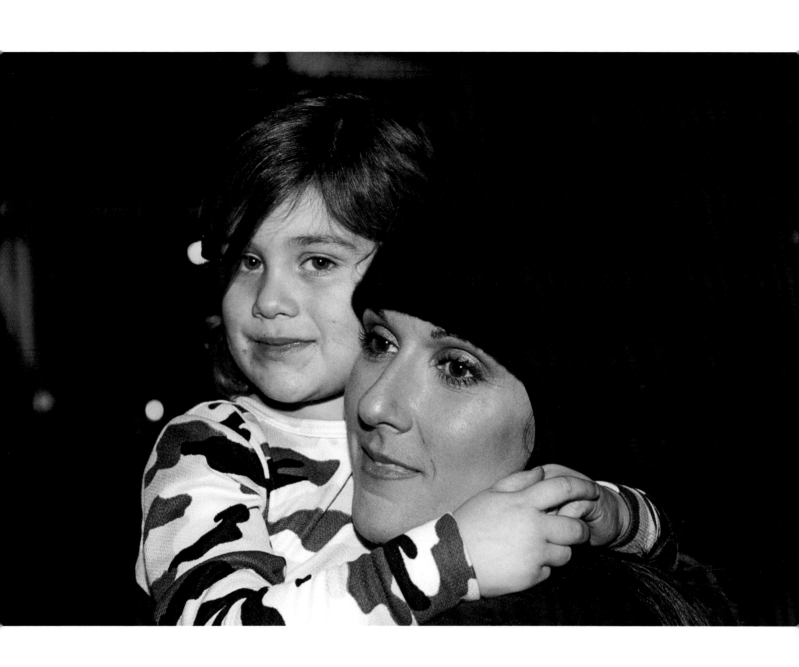

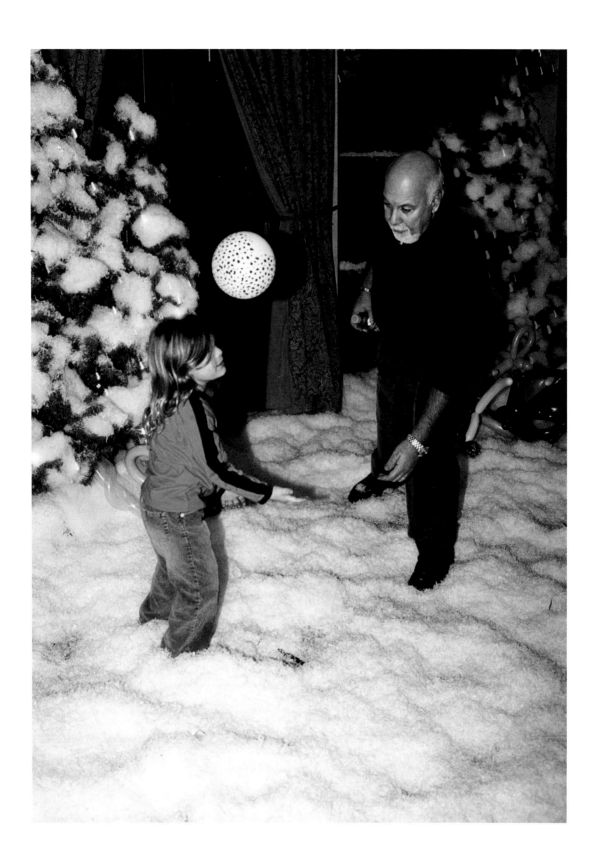

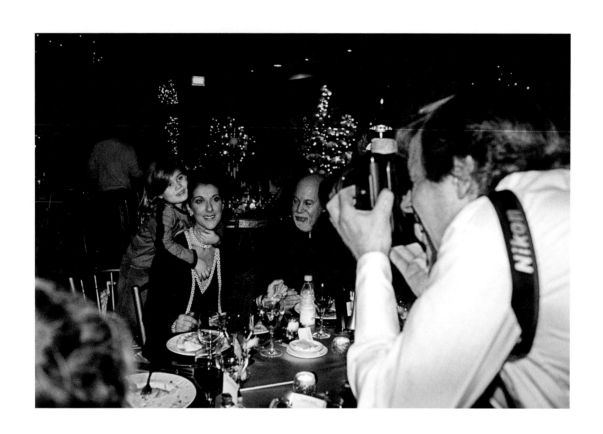

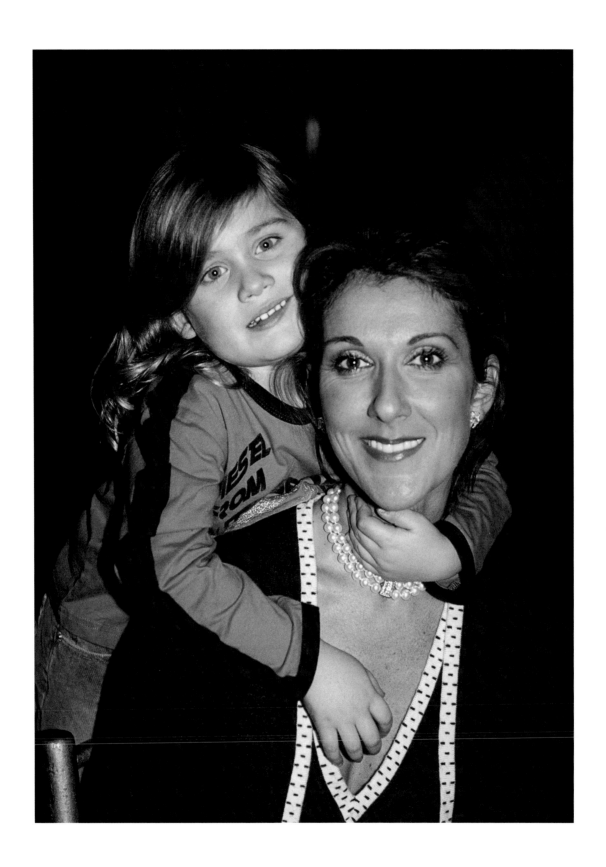

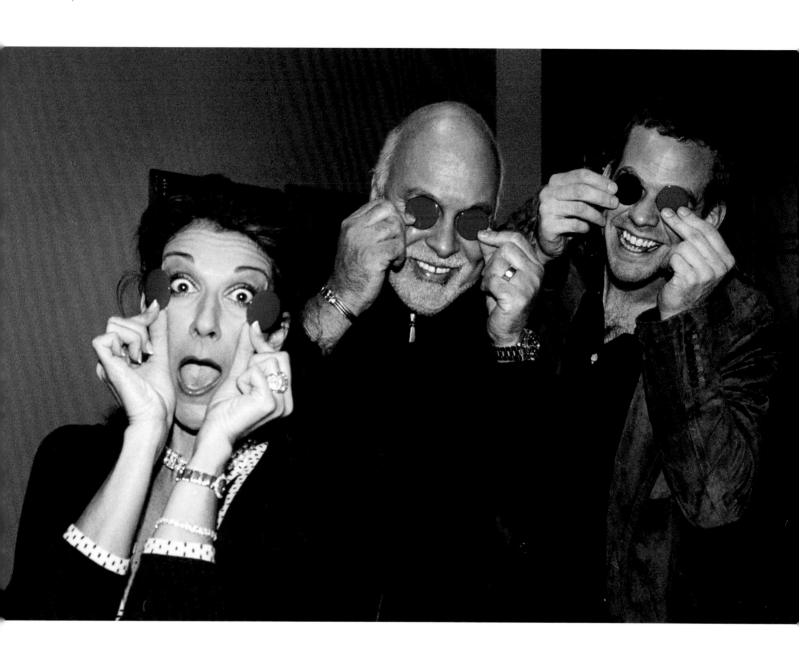

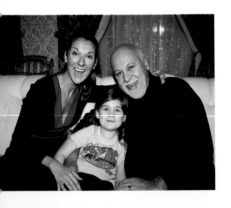 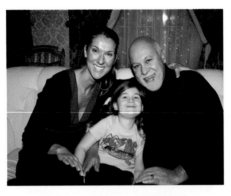 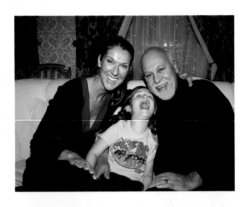
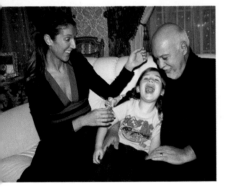 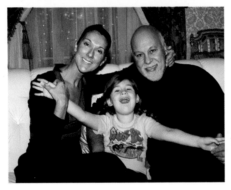 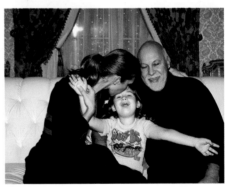

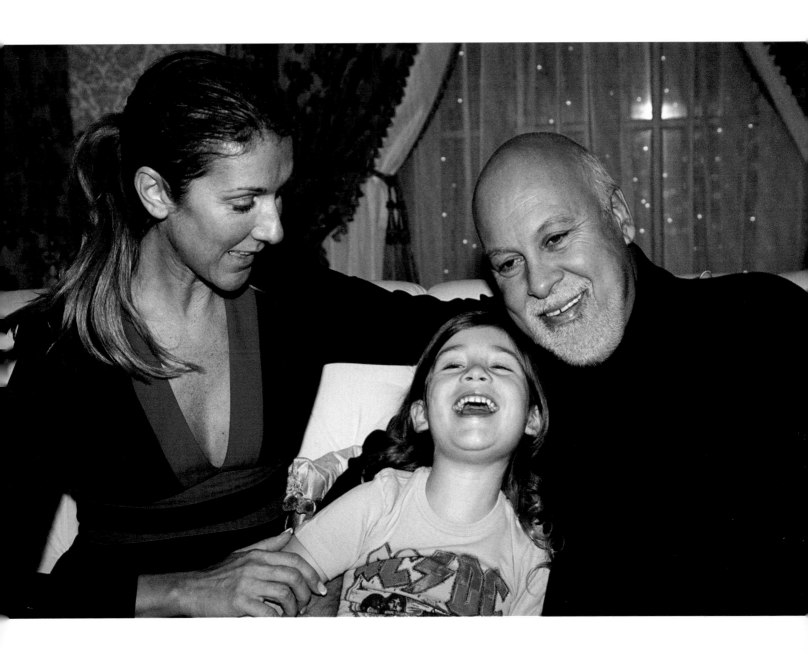

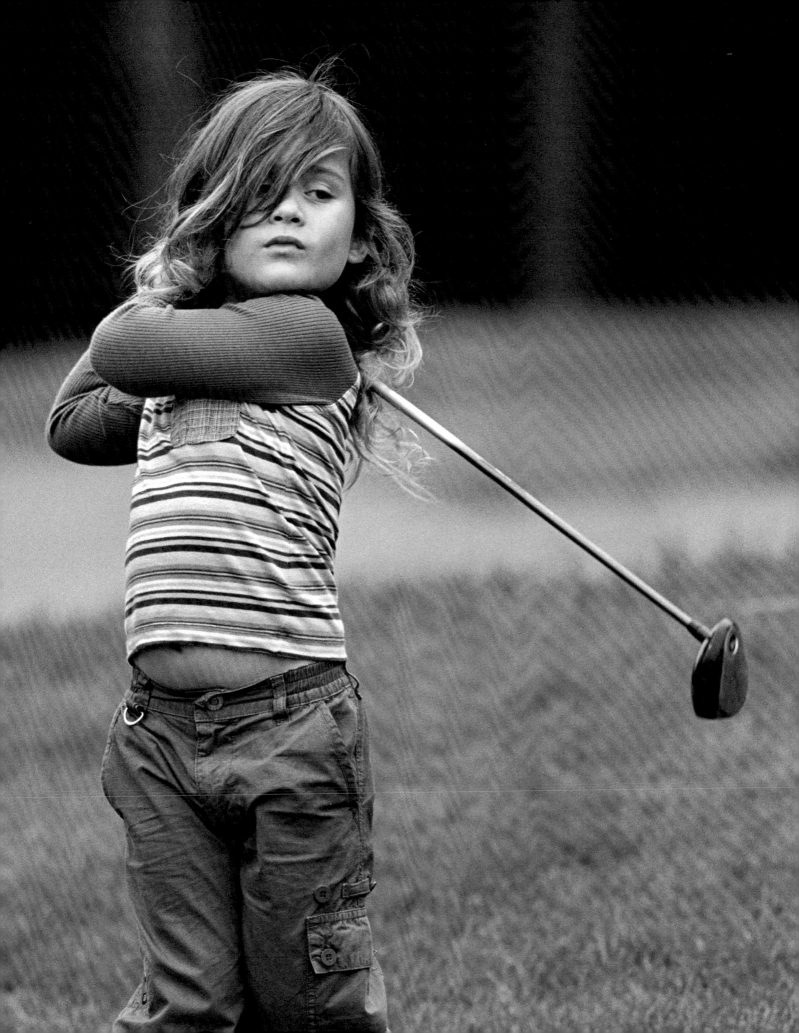

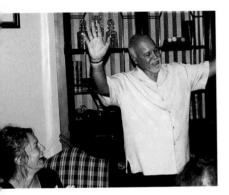

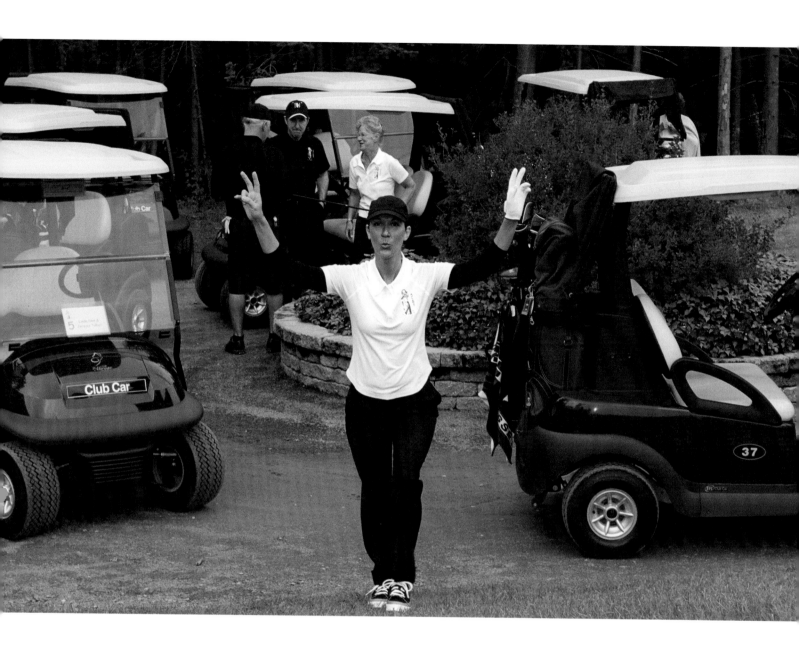

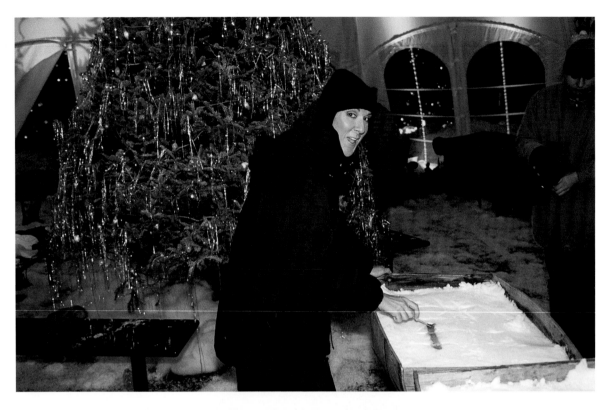

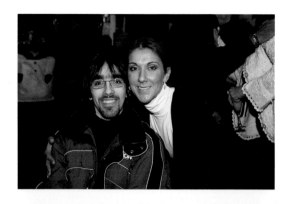

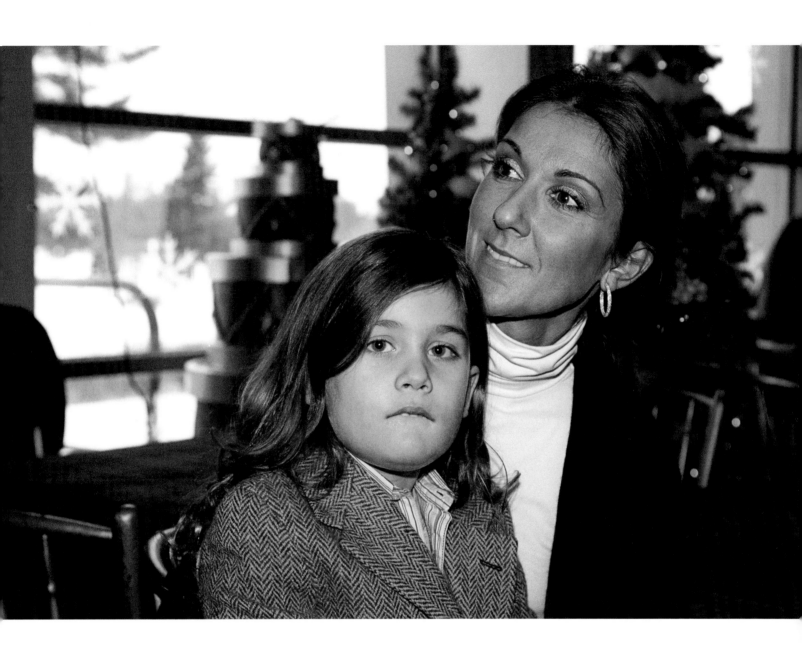

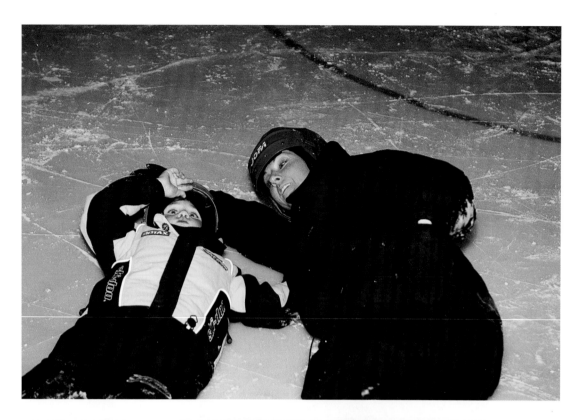

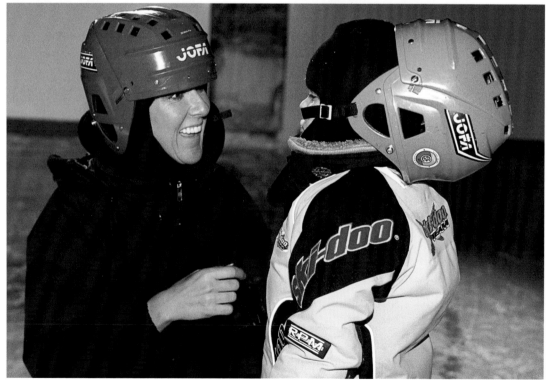

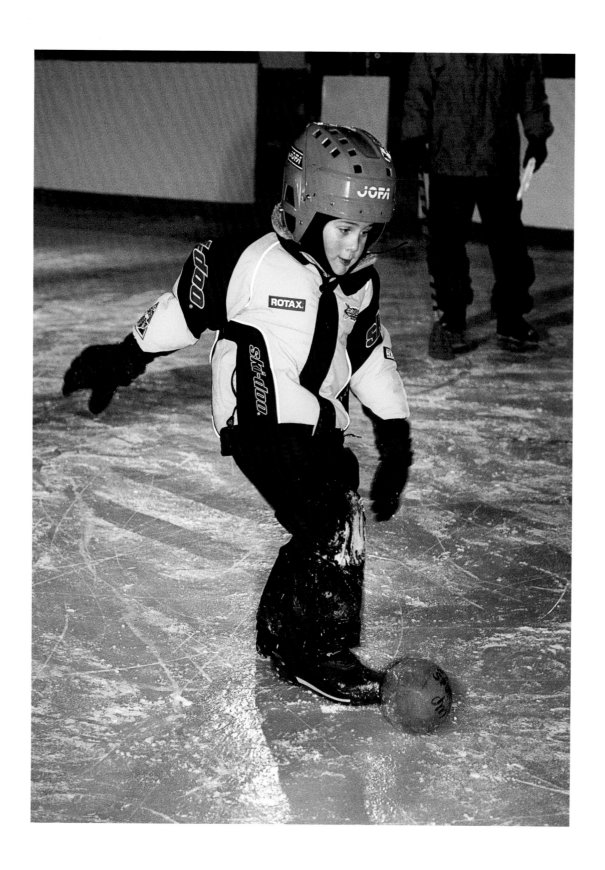

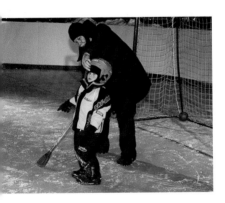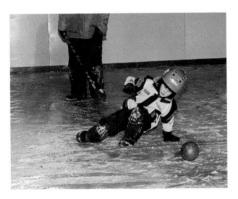

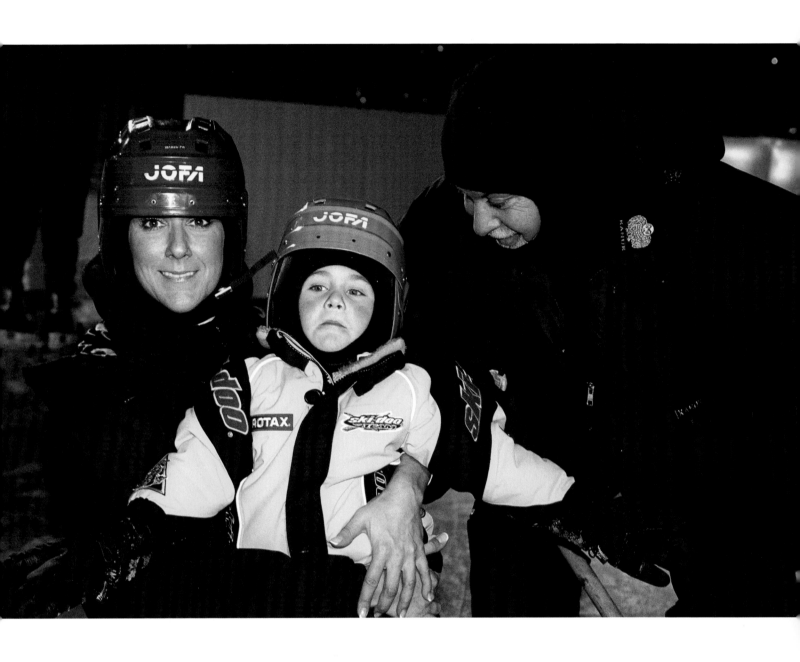

 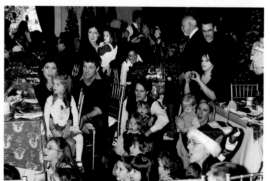

If It Were Enough to Love

S'il suffisait qu'on s'aime, s'il suffisait d'aimer
Si l'on pouvait changer les choses un peu rien qu'en aimant donner
S'il suffisait qu'on s'aime, s'il suffisait d'aimer
Nous ferions de ce monde un rêve, une éternité.
— "S'il suffisait d'aimer"

It was Monday, February 15, 2010, the day after Valentine's Day. My girlfriend had left me, and I had just spent the weekend alone. Not that long ago, I would have taken refuge in drugs and alcohol. I turned on the TV, searching for something to distract me. Larry King was interviewing Céline on CNN. I was happy to see her and to hear her voice. She spoke eloquently, in a quiet tone that was sincere, open, and confident. I admired her. I listened attentively. She uttered a sentence that held meaning for me:

"You don't lose your passion for performing. You die with it . . ."

Her words stirred something in me. I reflected deeply on them. I wondered why she had never wavered in her passion. I couldn't help comparing her story with mine.

In a way, artists are intoxicated by their love of audiences, the exhilaration of success. They get high on adrenalin, on performing, and on outdoing themselves. After a show, for example, artists have to manage all the energy they get from thousands of fans and, alone in their dressing room, decompress and quietly come back down to earth. They have to negotiate with success and, sometimes, with the lack of it. Some can't pick themselves up after a fall. For those who revel in the glory and drugs, like Jimi Hendrix and Janis Joplin, the road is even shorter.

I often saw Céline in that state, between heaven and earth, between the artificial world of show business and real life. She has always been able to walk a tightrope and keep her sense of balance. Still every night, she puts herself at risk, challenging herself

with every show, seeing how well she measures up, like the title of her last tour, *Taking Chances*. She needs to get back up onstage, to feel the thrill.

How many times has she thought about taking a break only to put off the decision? Why stop when the machine is working so well? When fans always ask for and want more?

Well before the end of the five-year run of *A New Day...* in Las Vegas, it was Céline who suggested following it up with a world tour. Back in December 1996, with an extended vacation already planned, she set off on a tour of Asia in January. She needed the emotional high she gets from performing. She needed to feel the connection to her fans, to receive all that love. She couldn't resist the call. And her fans were insatiable, always asking for encores.

It's hard to live without that stress, that fever pitch, that stage fright . . .

Like a junkie who always needs a bigger and bigger dose to face and overcome his fears, it's as though you need to be in danger to live!

I thought about René, too. He doesn't like being alone with nothing to do. He loves taking risks, always setting the bar higher. Céline's brilliant career is proof of that. It is also a well-known fact that, for years, he has loved to gamble, especially on extreme poker. Only he knows how many times he's won and lost at the casino. He can lay down a large bet, risk everything, and then try to redeem himself. He needs to get out of his comfort zone. He loves the thrill.

Both of them need powerful sensations. Both have their weaknesses, but they manage to keep them under control or, at least, to keep both feet firmly planted on the ground. Their weaknesses don't hurt them. They are in charge of their success. They are able to connect with their emotions, both sad and happy, and return to the things that seem simple but that are vital to keeping balance in their personal lives. They both have their hearts in the right place as the expression goes. I know: I've been on the receiving end. Most important of all, Céline and René have what really counts: to love and be loved.

I sabotaged my success. I let drugs take over my life. I wanted to go further, to see what was behind the mirror. For a long time, I denied my illness, but I acknowledge it now. I will never be cured.

I have an extreme personality. I've followed every self-destructive path into total decline . . . into my veins.

When I look back, I wonder if what I'm seeing is my survival instinct or a death wish. When you do drugs, you're negotiating: you're dealing with life and death. Many never return from the brink.

Today, my friends think I'm lucky or exceptionally resilient. I've fallen so many times. And I've had to get up just as many times. As good as I was at hurting myself, I wasn't one to stay at the bottom of the abyss. I know the cycle of highs and lows all too well. I'm trying hard not to relive it.

I fight despair with vitality. I have a new outlook on life and I'm trying to stop my emotions cold. I take the blows. I connect with my pain. I don't run from it anymore. I fight to dispel my inner emptiness. For four years now, I've been working at feeling good without using drugs or alcohol, and living on very little money. I'm paying off my debts. Drugs never helped fill the void. Now I live with the emptiness, not inside it, and I do everything I can to avoid a relapse. At 50, I'm getting to know myself. I'm maturing at my own pace, not to impress others but to choose my own path.

Sometimes, the best way to measure the importance of living life each day is to make the most of where we are instead of trying to understand where we're going.

I am making amends.

I try to be a little more giving to myself, even though I still often lack self-confidence. I work on it every day. I pay more attention to the feelings of others, especially when they have a certain resonance for me. Caring for others and trying to understand what others may be going through helps me feel less alone. Give and you will receive; I can now testify to the truth of those words.

In this new stage of my life, I am working on acquiring a quality that I have long lacked: discipline. I meditate for 15 minutes every night. I swim three times a week. I try to read even though it's still very challenging for me. I read slowly. I go to two support group meetings every week where I listen to others and share my emotions. These meetings help me remember where I come from. I can't afford to forget because, if I don't feel in danger, I risk a relapse. It takes a long time to break free of drugs, and it takes even longer to free oneself from all the rituals associated with drug use. For example, a simple teaspoon will jog my instinctive and spontaneous memory, the one that can't be explained but that is always there, subconsciously. That urge, that harmful reflex, can cause you to give in. Looking at the teaspoon, I see, in a mad sort of way, the tendril of smoke that I associate with drugs, then the tools, the syringe, the needle.

Now I'm even able to support a friend, a former dealer. I helped him get clean and gave him a place to stay. He often comes to support group meetings with me. That's a major achievement for me. It's easy enough to fall on your own, but you need a friend to help you get up again. We deal honestly with each other. Like golfers, we try to remember only the good shots. I have an advantage because there are lots of memories for me to draw on . . .

I'd like to tell young people who are attracted to drugs to beware. The illegal and forbidden air surrounding drugs is a magnet to anyone who is rebelling inwardly. Maybe if drugs had been legalized, and I say maybe, I might not have been so drawn to them. When I was young and selling to my friends, they looked up to me as a hero. They'd say, "Laurent is so *cool!*"

It encouraged me, fed my ego.

It was an illusion, a lure. That's truer now than ever, given all the junk that's put and cut into drugs these days.

All my years of despair often brought me to the brink of death. I almost died from drug abuse. If I'm not dead, it's not for lack of trying. Why did I mess up? I'm still looking for the answer. There's no such thing as fate.

I chose a difficult path, a very different one than my parents wished for me. I caused them a lot of pain, guilt, and anger. My drug habit turned their world upside down.

A new-found faith has replaced my thoughts of emptiness and relapse. I'm on a spiritual quest. It helps me to focus on what's ahead. And the more I look ahead, the more I believe in myself. I'm as focused as a golfer, feet in position, eyes on the ball, completing a natural swing toward the horizon . . . I'm flying without drugs.

I can't help but be grateful and say thank you for what life is offering me again.

Epilogue

I have rediscovered the path that leads to the home that is my heart. My heart never lies. For four years, I have been learning to probe deeper, to see what is going on inside me. I have been trying to put things into perspective with clarity, not complacency.

I can now say it: no heroin or cocaine buzz can beat the joy of being sober.

Knowing that I survived failure, as Céline and René survive success, is admitting that life is a constant battle. No one is spared. You have to face it to be truly alive.

I will never forget, in spite of the fog that filled my mind, that on December 17, 2006, Céline saved me from certain death. I had hit rock bottom.

A year later, when I suggested this book project to Céline in Las Vegas, she had tears in her eyes when I told her, "Céline, it's thanks to you that I'm still here."

On that day in December 2007, only minutes after I had told Céline about my dream project, she walked out on the stage at The Colosseum. I was sitting behind the sound console, just one of the audience.

When she sang "S'il suffisait d'aimer," I felt as if she were singing to me. To this day, it is still my favourite song.

Without Céline and René, two exceptional human beings, I would not be here. And you would not be holding this book. Clearly without their support, belief in me, and respect, I would never have been able to reach out to you.

S'il suffisait d'aimer

S'il suffisait qu'on s'aime, s'il suffisait d'aimer

Si l'on pouvait changer les choses et tout recommencer

S'il suffisait qu'on s'aime, s'il suffisait d'aimer

Nous ferions de ce rêve un monde

S'il suffisait d'aimer

Acknowledgements

I wish to thank everyone who helped, from near and far, to make this book possible, as well as all the people, famous and unknown, who appear in the photos of this book.

Thank you to my old friends for their collaboration and professionalism: Michel Cantin for being my photographic assistant and allowing me to use some of his photos in the book; Roger Blanchette and the team at QuadriScan; Richard Bull and Patrizia Ames at Just Bull; poet Paul-Georges Leroux; Peter MacDonald at Macco; Sasan Mirab and Mohsen Gorji at Photo Westmount; and Benoît Blain at Photo Des Moulins.

Thank you to Luc Houle, Mathieu Picard, and Sylvain Leclerc for their constant support and attentiveness; to Diane Dubois for assisting me so well with office duties — your easygoing personality, kindness, and ability to do so much with so little are a daily inspiration.

Thank you to Maharaji Prem Rawat, Stéphane Goldberg, and Michel Morin for their guidance; to Luc Chabot and all the support organizations and the dedicated people who work for them; to the late Adrien Perron and Bruce Parker for helping me to understand the importance of sharing.

Thank you to my mother, Claude-Anne, for her unconditional love and support, and to my father, Daniel, for his values and sense of humour; to my brothers, Jean-Claude, Michel, and Éric, for being by my side during the tough times; to my sons, Bruno and Frédéric, for reminding me of what's really important and for always believing in me — I love you so much.

Thank you to Denis Courtemanche for his contributions to my Rainbow Swing project; and to Luck Mervil for lending an ear and giving me advice.

Thank you to the musicians and the touring team of *Let's Talk About Love* for all the moments we shared; to the entire Productions Feeling team: Dave Platel, Gilles Lapointe, Sylvie Beauregard, Maryse Mathieu, and a special thanks to Mia Dumont for her involvement, particularly for taking care of details that made a huge difference.

Thank you to the all the team at Éditions des Intouchables: Michel Brûlé for having believed and invested in my project; Jimmy Gagné for his excellent artistic guidance; Marie Leviel and Mathieu Giguère for their help; Marie-Nöelle Gagnon for her understanding and flexibility; and Dominique Spénard and Géraldine Zaccardelli for their professionalism.

Thank you to Barbara Creary and the team at ECW Press.

Thank you to Diane Massicotte for having done such a magnificent job of putting the story of my life into words and expressing my emotions and feelings so well.

Thank you to Chantal for her involvement and support every step of the way, for the love and confidence she gives me, for her understanding and patience. Thank you for teaching me to see and embrace little everyday joys and to celebrate life using all the senses nature has given us, in joy and simplicity. I admire you and I love you.

Thank you to Marc-Antoine Pelletier for his friendship and great generosity. Thank you for having taken on my project and brought it to life with determination, perseverance, and unmatched talent in spite of difficulties along the way. Thank you for having come back into my life at just the right moment. You made all the difference. I am immensely grateful.

Finally, thank you to Céline and René for believing in me and respecting me in spite of everything, without ever judging me. A thousand thanks.

Laurent Cayla
laurent@laurentcayla.com

Song List

L'amour existe encore Luc Plamondon – Richard Cocciante

Brown Sugar Mick Jagger – Keith Richards

Le monde est stone Luc Plamondon – Michel Berger

The Power of the Dream David Foster – L. Thompson

Because You Loved Me Diane Warren

Give Peace a Chance John Lennon – Yoko Ono

These Are Special Times Diane Warren

I'm Your Angel R. Kelly

Blue Christmas Jay Johnson – Bill Hayes

Ave Maria Gounod

We Wish You a Merry Christmas Sixteenth-century English carol

Feliz Navidad Jose Feliciano

Les cloches du hameau Anonymous

I'm Alive Kristian Lundin – Andreas Carlsson

Let's Talk About Love Bryan Adams – Eliot Kennedy – Jean-Jacques Goldman

Heroes David Bowie – Brian Eno

My Heart Will Go On James Horner – Will Jennings

All the Way J. Van Heusen – Sammy Cahn

It's Only Love Bryan Adams – Jim Vallance

When You're Gone Bryan Adams – Eliot Kennedy

(Everything I Do) I Do It For You Bryan Adams – Mutt Lange – Michael Kamen

When I Fall in Love Edward Heyman – Victor Young

Le blues du businessman Luc Plamondon – Michel Berger

J'irai où tu iras Jean-Jacques Goldman

A New Day Has Come Aldo Nova – Stephan Moccio

Seduces Me Dan Hill – John Sheard

S'il suffisait d'aimer Jean-Jacques Goldman

Taking Chances Kara DioGuardi – David A. Stewart

Photo List

WITH MUHAMMAD ALI AT LE MIRAGE GOLF CLUB, 1997...............................28

PHOTO SHOOT AT LE MIRAGE, 1998...............................34

WITH SYLVESTER STALLONE, 1998...............................44

PHOTO SHOOT AT LE MIRAGE, 1998...............................46

WITH ANNIKA SÖRENSTAM, 1998...............................51

RECORDING *THESE ARE SPECIAL TIMES*, 1998...............................53

ON A SHOOT IN CHARLEMAGNE, 1998...............................64

RECORDING *THESE ARE SPECIAL TIMES*, 1998...............................70

LET'S TALK ABOUT LOVE TOUR, 1998...............................75

WEDDING OF LINDA, CÉLINE'S SISTER, 1998...............................98

LET'S TALK ABOUT LOVE TOUR, 1998...............................100

AT THE MOLSON CENTRE WITH MAURICE RICHARD, 1998...............................120

HOCKEY GAME AT THE MOLSON CENTRE, 1998...............................129

CHRISTMAS AT LE MIRAGE, 1998...............................134

LET'S TALK ABOUT LOVE TOUR, 1999...............................137

PARTY AT CÉLINE'S FLORIDA HOME, 1999...............................156

THE MILLENNIUM CONCERT, 1999...............................165

RENEWAL OF VOWS IN LAS VEGAS, 2000...............................182

MAMAN DION'S GOLF TOURNAMENT AT LE MIRAGE, 2000...............................194

CÉLINE'S BABY SHOWER IN FLORIDA, 2001...............................198

CHRISTENING OF RENÉ-CHARLES, 2001...............................208

THE STANLEY CUP AT CÉLINE'S, 2001...............................214

FILMING THE VIDEO FOR "SOUS LE VENT" WITH GAROU, 2001...............................218

CHRISTENING OF RENÉ'S GRANDSON, 2001...............................222

CHRISTMAS AT LE MIRAGE, 2001...............................226

A NEW DAY HAS COME TV SPECIAL, 2002...............................230

CORN ROAST AT CÉLINE'S, 2002...............................238

AT LE MIRAGE, 2002 .252

CHRISTMAS AT LE MIRAGE, 2002 .254

WEDDING OF CÉLINE'S NIECE, 2003 .258

PICNIC, 2003 .260

PHOTO SHOOT AT CÉLINE'S, 2003 .266

GOLF TOURNAMENT AT LE MIRAGE, 2003 .268

AT CÉLINE'S LAS VEGAS HOME, 2003 .278

FUNDRAISING CONCERT AT THE BELL CENTRE, 2003 .280

CHRISTMAS AT LE MIRAGE, 2003 .282

CHRISTMAS AT CÉLINE'S, 2003 .288

RENÉ-CHARLES'S BIRTHDAY IN LAS VEGAS, 2004 .290

CORN ROAST AT CÉLINE'S, 2004 .298

CHRISTMAS AT LE MIRAGE, 2004 .306

CHRISTMAS AT CÉLINE'S, 2004 .318

GOLF TOURNAMENT AT LE MIRAGE, 2005 .320

CHRISTMAS AT LE MIRAGE, 2005 .324

CHRISTMAS AT LE MIRAGE, 2006 .334

WEDDING OF CÉLINE'S NIECE, 2003 .343

Published by ECW Press
2120 Queen Street East, Suite 200, Toronto, Ontario, Canada M4E 1E2
416-694-3348 / info@ecwpress.com

Library and Archives Canada Cataloguing in Publication

Cayla, Laurent
Céline: beyond the image / Laurent Cayla and
Diane Massicotte.

Translation of: Céline : au-delà de l'image.
ISBN 978-1-77041-092-3

1. Dion, Céline—Pictorial works. 2. Singers—Québec
(Province)—Pictorial works. I. Massicotte, Diane II. Title.

ML420.D592C3713 2012 782.42164092 C2011-906953-9

Artistic supervisor: Jimmy Gagné, Studio C1C4
Graphic design: Jimmy Gagné, Marie Leviel, Mathieu Giguère
English translation editor: Veronica Schami Editorial Services, with special thanks to Rita Cloghesy

Photo credits: Michel Cantin: pages 25, 267, 280, 281, 302, 303, 314, 316, 343
PhotoGraphex/André Tremblay: pages 172, 179
Louise Labranche: page 152 and back cover

The publication of *Céline: Beyond the Image* has been generously supported by the Canada Council for the Arts
which last year invested $20.1 million in writing and publishing throughout Canada, and by the Ontario Arts Council,
an agency of the Government of Ontario. We also acknowledge the financial support of the Government of Canada
through the Canada Book Fund for our publishing activities. The marketing of this book was made possible with the
support of the Ontario Media Development Corporation. We acknowledge the financial support of the Government
of Canada, through the National Translation Program for Book Publishing for our translation activities.

Printed and bound in Canada